Captured By the Light

THE ESSENTIAL GUIDE TO CREATING
EXTRAORDINARY WEDDING PHOTOGRAPHY

David A. Ziser

Captured By the Light
Book Team

EDITOR
Cindy Snyder

CREATIVE DIRECTOR
Felix Nelson

TRAFFIC DIRECTOR
Kim Gabriel

PRODUCTION MANAGER
Dave Damstra

**GRAPHIC DESIGN
AND PRODUCTION**
Jessica Maldonado

PROOFREADER
Trisha Van Koughnett

PHOTOGRAPHY:
David A. Ziser or staff of
David A. Ziser Photography,
unless otherwise noted

**GRAPHIC ELEMENTS
COURTESY OF:**
iStockphoto.com

Published by
New Riders
New Riders is an imprint of Peachpit, a division of Pearson Education

Copyright ©2010 by Kelby Corporate Management, Inc.

First Edition: February 2010

Composed in Avenir, Goudy Old Style, and Mayfair by Kelby Media Group.

Trademarks
All terms mentioned in this book that are known to be trademarks or service marks
have been appropriately capitalized. Peachpit cannot attest to the accuracy of
this information. Use of a term in this book should not be regarded as affecting the
validity of any trademark or service mark.

Warning and Disclaimer
This book is designed to provide information about photography. Every effort has been
made to make this book as complete and as accurate as possible, but no warranty of
fitness is implied.

The information is provided on an as-is basis. The author and Peachpit shall have
neither the liability nor responsibility to any person or entity with respect to any loss or
damages arising from the information contained in this book or from the use of the discs
or programs that may accompany it.

ISBN 10: 0-321-64687-8
ISBN 13: 978-0-321-64687-3

9 8 7 6 5 4 3 2 1

www.kelbytraining.com
www.peachpit.com

*To all my mentors who have shared their
knowledge with me over the years, all my
friends who have encouraged me and challenged
me to always give it my best, and especially to
my wife and devoted friend, LaDawn, who has been
by my side throughout the entire creative process.*

Foreword & Acknowledgements

Every photographer has his own unique story as to how he became involved in one of life's most interesting and exciting professions. My interest in photography hit me in 1960, when I was 12 years old. I was rummaging through the basement of our home and stumbled on some old photo processing trays, a contact printing frame, a ruby red safelight bulb, and a few books on processing your own film that my dad had used as a hobbyist. These small books were not the latest, greatest editions—I remember that they were published in the early to mid-1940s. Nevertheless, that early discovery was my entry into photography.

But that is only part of the story. Coincidentally with my discovery of my father's rudimentary photo processing gear was the fact that I had a keen interest in a TV show titled "Man with a Camera" that starred Charles Bronson as Mike Kovac and ran 29 episodes, from 1958 until 1960.

I remember lying on the floor in my family's living room watching those black-and-white episodes every week. I enjoyed the story, the drama, and how photography was used to help solve the mystery. But what I remember most are those moments near the end of every show when Mike Kovac would put the exposed paper into the developer and the image would slowly appear—to me, it was magic!

Now, I could possibly work Mike Kovac's magic, too. I still remember my first visit to a local camera store, Provident Camera, when I purchased a quart can of Kodak Dektol developer, a quart of fixer, and 25 sheets of Kodak Azo contact printing paper. I couldn't wait to process my first image. Back in those days, my parents shot with a Brownie Hawkeye camera, an inexpensive, fixed-focus, medium format camera that shot large 120 or 620 rolls of film. The negatives were pretty big: 2¼ x 3¼".

We set up the trays, processing chemicals, and ruby red safelight in my buddy Russ Rigdon's mother's kitchen late one night, and were ready to go. I had "requisitioned" a few of my family's 620-size negatives for our first tests. Under the dark red glow of the very dim safelight, I loaded a negative and Azo printing paper into the contact printing frame and closed the back tightly.

Russ was on light switch duty. On my command, he hit the wall switch and turned the kitchen light on, I counted off a number of seconds, and signaled him to turn the lights back off (very scientific back then). I still remember removing the photographic paper and looking at it in that dim ruby-red light. It was totally blank, but somehow the magic solutions in front of me would reveal the secrets it contained.

I pushed the paper into the developer just like Mike Kovac, and waited...and waited...and waited. It seemed like forever, but it was only about 30 seconds before I saw the faintness of an image slowly appear on the paper. After a few more seconds, the image came into full view. I remember being transfixed by what I saw before me—it was Harry Potter magic, long before the days of Harry Potter! After moving the paper through the stop bath and fixer, we turned the lights back on. There it was, my first real photographic image. I was hooked.

Our next experiment involved making images larger than the original negative size, all the way up to a 5x7" print. One more trip to Provident Camera for some Kodak Kodabromide enlarging paper, but where was I to get an enlarger? Coincidentally, Kenner Products, located in Cincinnati, Ohio, had just announced a brand new toy: the Give-A-Show Projector. It was a battery-operated projector in which you inserted a filmstrip of cartoon characters and projected them on the wall.

Where could I get one? My little sister! She had received one as a gift. I carefully "borrowed" it one evening, cut out one of the cartoon characters from the filmstrip, and added one of the family negatives. You guessed it—success—we had created our first enlargement. It was a "Eureka!" moment, and the rest is history.

By age 15, I managed to book my first wedding. A friend of my father's, whose daughter was getting married, was looking for the best price in town. I offered and was hired. I barely remember shooting that wedding, but I do remember knowing I had to be sure to get the bouquet toss. The rest of the day is a faded memory.

As I amped up my photographic hobby with bigger trays, print dryers, better safelights, enlargers, etc., I caused quite a stir at home. I kept blowing the fuses in our older home and my father was not happy. I had a mutual high school friend, Bill Donnermeyer, who was also involved in this magical hobby. His father was upset with him because he was using too much water when washing his processed prints. (His dad was a plumber—that might have been part of the problem.)

Anyway, we, two 18-year-olds, together with our fathers, who were not happy at all with our photographic endeavors, decided we needed a change of venue if we were going to pursue our interests. We decided to open a photo studio. Yes, at age 18 we found a space for $75/month, split the rent, and opened London Photo Studio. Now I was a studio owner shooting portraits and weddings!

This lasted for the next three years or so, as we completed high school and started college. Although we eventually closed the studio, I continued to support myself with photography, paying the rent, buying the books, etc., until I graduated with two degrees—one in physics and the other in engineering.

My love of photography never left me, though. I continued to shoot for friends and family long after my college graduation in 1971. With so many requests from friends and acquaintances, in 1978 I decided to leave engineering and strike out on my own in photography. Now I'm in my 31st year of owning my own studio. My father always wanted me to get a "real job" after leaving engineering, but I never did. Instead, I have constantly and consistently strived to offer my clients the absolute best wedding photography possible. And, yes, the passion is still there.

I always wanted to learn more about photography. I continued to study with the wedding masters of the time—Bill Stockwell, Rocky Gunn, and the legendary Monte Zucker. I attended every program, seminar, and workshop I could, honing both the craft and art of wedding photography. I continue to do that even today. We can never stop learning.

So, how did I end up here, writing a book? It was about two-and-a-half years ago when I invited my friend, Scott Kelby, to come to Cincinnati and cover a wedding with me. He, too, is the consummate student, wanting to learn all things photographic, including wedding photography.

After the wedding, we headed back home to drop the gear and crash. We ended up talking about many things, but eventually the topic of blogging came up and we continued our discussion until about three o'clock in the morning. He was the master blogger and I was "grasshopper." Anyway, a week later I started my blog, *DigitalProTalk.com*.

I took Scott's advice from that evening to heart: "If you don't feed the monster, it will die." And, I have continued to feed the "monster" daily—five days a week, week after week, month after month, and two-and-a-half years later, year after year.

It was during a quick email check early one Sunday morning before heading out to church that I received an email from Scott. It read simply: "So, are you ready to write your book yet?" The message stopped me cold. Was I ready? I had never thought about it, but now I did. I wrote Scott back and said I was.

With the help, encouragement, and support of Scott's team at Kelby Media Group and my wife LaDawn's patience and support, the book project was put into motion—unfortunately, I think slow motion at times. As I look back over these past several months at what has transpired, I can't believe it's finally finished. Since writing the book, I tell people, "It's a lot like cross-country skiing; it sounded like such a good idea at the time." But now the book is complete, and as I look back over the words, pages, and chapters, I think, "Wow! I did it, and it looks pretty good!" But, folks, that is only the beginning of what goes into writing a book.

The rest of the story needs to include those defining moments in my life that first set me on a life course of not just shooting weddings, but also training others to take better photographs. Who were those people instrumental in that process for me? First, I would have to thank my father for letting me "borrow" those first processing trays, the safelight, and the contact printing frame.

(Continued)

Next, I want to acknowledge my lifelong friend, Russ Rigdon, who hung in there with me during those very early, formative years, helping me with my experiments in processing and printing. We were even doing our own color processing in 1968 when, after booking a high school prom and promising to deliver two 5x7s and four wallets, we worked until the very early hours of several mornings trying to complete the job.

I want to thank Bill Donnermeyer for taking the chance with me of opening our first photo studio in the late '60s. We were teenagers, but heck, what did we know? We were confident we could pull it off, and we did. Our first studio—London Photo Studio—was named after the London music invasion of the mid- to late 1960s.

When I opened my first solo studio in 1978—a pretty scary time in my life—I looked for an assistant to help me on my wedding jobs. My girlfriend at the time recommended her 15-year-old brother. I want to acknowledge Steve Bitter, who was with me through thick and thin in the early learning/business years. Steve was the perfect assistant. He could read my mind and, many times, it seemed that he had three hands as I was changing lenses and film backs during the shoots.

My studio continued to grow and I had to hire more help. My next employee was Don Moore, one of the most talented photographers I know. Don was my studio manager and covered the business as my lecture career started to gain traction in the mid-1980s. Don and his wife Lona continue to be good friends and trusted confidants today.

During those early years, I met two people also in the beginning stages of their photography businesses: Kent Smith, from Columbus, Ohio; and Mark Garber, from Dayton, Ohio. We three were equally passionate about our work and wanted to do anything we could to make our work exceed that of our competition. We formed what Mark called "our brain trust," and constantly challenged each other to be the best. We continue to remain close friends and today all of us own very successful studios.

I also want to acknowledge those photographers I have trained under and who helped me understand nuances of technique, style, and creativity: First, the legendary, Monte Zucker, one of my first photography teachers. He gave me a solid grounding in the classical techniques of lighting and posing that photographers and painters have used for years to flatter their subjects. Next, Rocky Gunn, master pictorial wedding photographer, showed me how to see differently and how to use the beautiful surrounds to create a distinctive outdoor wedding portrait. Finally, Al Gilbert, one of the top photographers in Canada, showed me how to use wide-angle optics to create wonderfully innovative and dramatic portraits.

My thanks, too, to so many other photographers, teachers, instructors, and trainers who have helped me gain a greater understanding of all facets of the craft and art of this profession.

As my studio gained popularity in the greater Cincinnati area, my work started to gain some attention and receive accolades at state and regional conventions. I began to get invitations to lecture about wedding photography. My thanks to Wayne Byrne and Bill Duty, who together provided my first opportunity to do just that in 1982, traveling to 10 cities throughout the Midwest, from Buffalo, New York, down to Memphis, Tennessee.

My thanks to Lisle Ramsey, founder of the International Professional Photographers Guild, who had the confidence to invite me to speak and present my program to photographers in New Zealand and England. His invitation, after only being in business for four years, was quite a thrill.

I can't forget to mention my friends at Eastman Kodak Company, Paul Ness and Terry DeGlau, who several times over these many years have asked me to represent Eastman Kodak at some of the most exciting venues around the world.

Also, thanks to all the wonderful people at Professional Photographers of America, Wedding and Portrait Photographers International, and especially the National Association of Photoshop Professionals, whose legions of instructors have continued to hone my photographic and digital skills.

I also want to thank Cindy Snyder, my editor at Kelby Media Group, who, as Scott says, is simply wonderful. When I had no clue what I was doing, no clue how to tie things together, just no clue how I was going to get the book together, Cindy offered her calming advice that always gave me the confidence to write another chapter. If any author ever needs a psychiatrist, Cindy is the best at helping you get through the challenges of writing a book.

My thanks, too, to Jessica Maldonado at Kelby Media Group, who somehow pulls all the words, images, diagrams, and notes together, so that they reach an understandable cohesion in the final result. I am

amazed at the entire Kelby Media team, as they work in what seems an almost effortless fashion to complete the many publishing projects they produce each year.

I can't miss thanking Peachpit/New Riders, my publisher, who also agreed to be part of this project. There have been many others involved in the process who have taken time to review, edit, and suggest improvements to it. Those special folks include my staff (Sharon, Jennifer, and Martha), my good buddy, Michael Jonas, and so many others that helped me tie together all the loose ends to bring the book to completion.

I've reserved my biggest thank yous for last. As we talked that late July evening after the wedding in 2007, Scott Kelby gave me that indispensable piece of blogging advice: "If you don't feed the monster, it will die." I took it to heart and started to do what I have always found the most difficult of disciplines for me—writing.

I thank Scott for recognizing the fact that I might have a book in me, and also thank him for encouraging me to write it. More importantly, I thank Scott and all the people in his wonderful organization, Kelby Media Group, for supporting the project and giving me the encouragement along the way to press on. Without that one short email on that special Sunday morning, this book would never had been written. Thanks Scott.

Now, I want to thank that special person in my life that has given me her love and support throughout this entire book writing process. Without her insights, suggestions, recommendations, and most of all, her patience throughout the many, many months of the process, the finished work would not be what it is today. I love you LaDawn.

Finally, I want to thank all the readers of this book. I sincerely hope it gives you a road map to take your wedding photography to a brand new level. Whether you shoot weddings or find your interest in other types of photography, I hope the information contained within these chapters will open the doors to your own creativity, bringing a sense of adventure, excitement, and possibility to your joy of photography.

Thank you all.

-David

About the Author

David Ziser, an internationally renowned portrait and wedding photographer, has shared his knowledge with tens of thousands of photographers in five languages, and in 14 countries worldwide. He has been one of the leading trainers in the industry for more than 20 years, and his Digital WakeUp Call tour was acclaimed as one of the best-ever seminars on digital photography.

David is a regular featured lecturer at the Photoshop World Conference & Expo, Wedding and Portrait Photographers International (WPPI), and Imaging USA/Professional Photographers of America. He also provides training classes on DVD and online through Kelby Training.

In July 2007, David launched *DigitalProTalk.com*, a blog dedicated to the aspiring professional photographer looking to enhance his/her photography, Photoshop, Lightroom, and business skills. It has been called one of the best photo blogs out there. Readership continues to grow and is in excess of 110,000 page views per month.

He is a regular monthly contributor to the award-winning *Professional Photographer* magazine, has been honored as a Kodak Mentor, and is one of 98 people worldwide who holds the distinguished honor of Fellow, bestowed by the American Society of Photographers.

Table of Contents

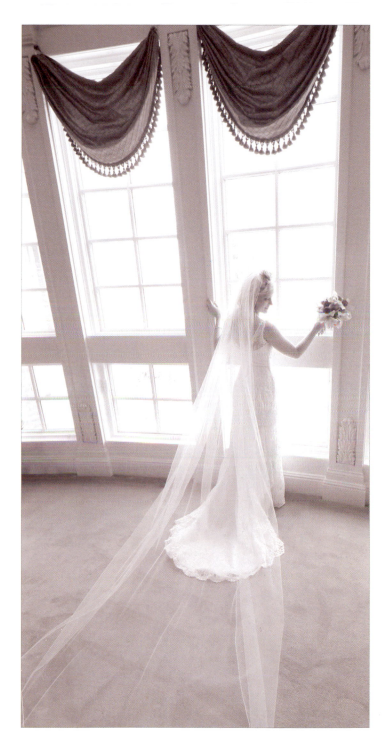

Chapter Four 49

Kicking Your Lighting Into High Gear
Off-Camera Flash Lighting Techniques

Chapter Five 97

Kickin' It Up a Notch
Make Your Wedding Shots Sing with Backlighting

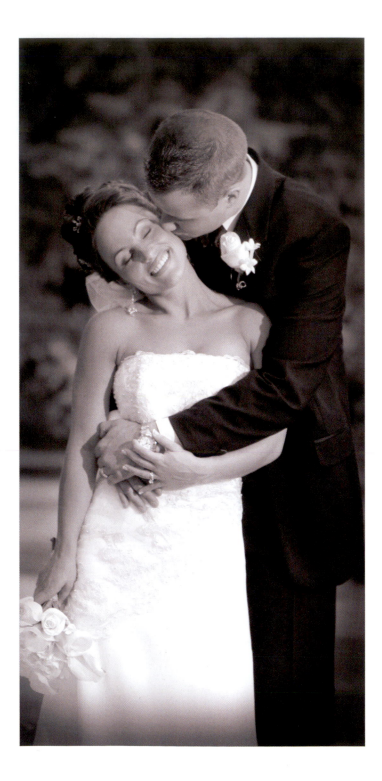

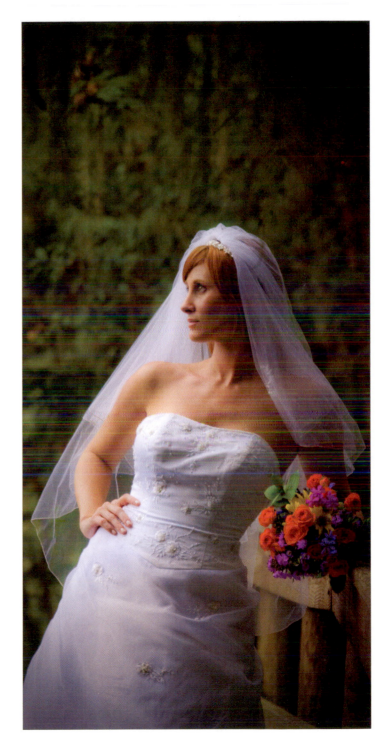

Chapter Nine

Walk with Me

My Workflow at the Wedding

185

Chapter Ten

Talk with Me

My Workflow at the Reception

209

Chapter Eleven

Bringing It All Together

The Final Presentation

251

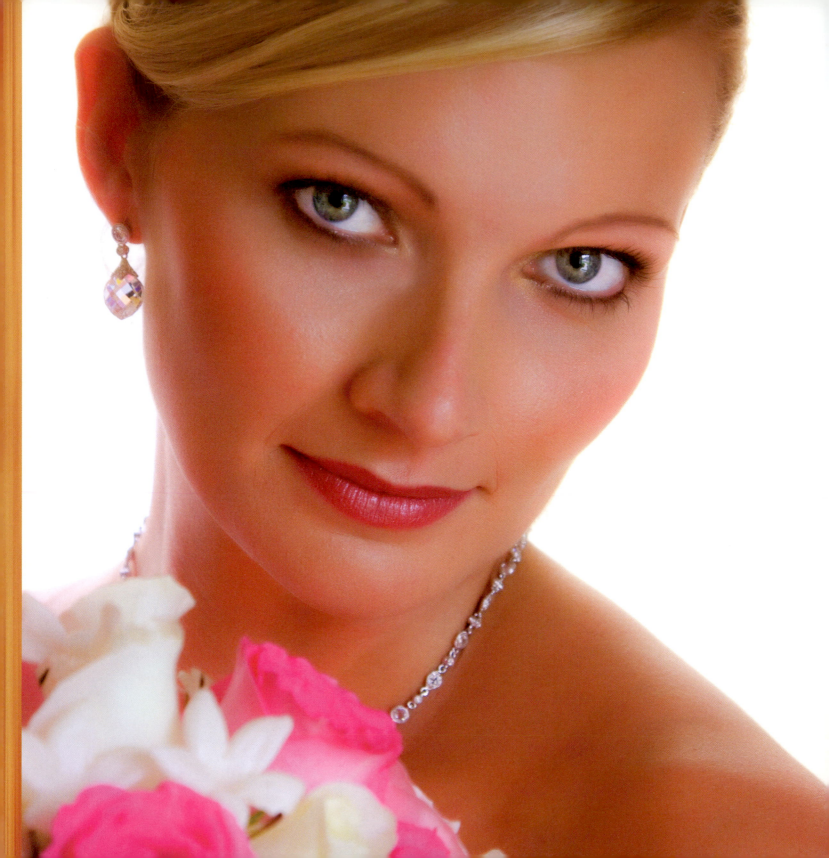

If It Was Good Enough for Rembrandt, It's Good Enough for Me

Making Your Clients Look Good

We hear all the time that people don't want to be bent, turned, or twisted into some kind of uncomfortable, fake-looking pose for their wedding pictures. But, the bottom line is this: people want to look good in their photographs. How many times have we heard someone say, "Oh, don't take my picture. I take a terrible picture"? The reason is most people see themselves in photos taken by people who just grab a camera and shoot without really trying to flatter or enhance the person they're photographing. Consequently, the resulting image is often not a pleasing one of the subject.

Brides and grooms, who often are nervous and may feel uncomfortable dressed in formal wedding attire, still want to be flattered in their wedding photos, and it behooves us as wedding photographers to make them look their best on the most important day of their lives. But, the fact of the matter is that having the knowledge to do just that, the skills to produce good portraits, is quickly becoming a lost art in the wedding photography profession. The rules for getting wonderful photographs of our wedding day subjects are really quite simple. It's not brain surgery, it's not painful, it's not difficult, and I believe the final results speak for themselves when the clients tell us how much they love their wedding images.

Famous artists, like Rembrandt, knew how to flatter their subjects on canvas (they better have known what they were doing, because most of the time they were being paid by royalty—kings and queens—and if they got it wrong, well, the consequences quite often were a bit more harsh than just getting fired. They often entailed imprisonment, or even death), and in this chapter, we are going to discuss how to create flattering photographs of our subjects. I'm going to keep it simple and easy by following just a few basic rules that will allow you to go out and produce repeatable results at each of your wedding and portrait sessions.

Secrets of the Masters—Part 1

How hard can it be? There are only three main views of the face: (1) full-face, (2) two-thirds, and (3) profile.

Full-Face View

Let me show you some examples of the full-face view. Let's look at ❦ *Figure 1a*. This image of the cute little ring bearer demonstrates exactly what you want to see in a full-face view. Look at the bride in ❦ *Figure 1b*. Same thing here—the eyes are coming right back at you.

Here are the basic rules for capturing the full-face view:

Rule 1:
The axis of the subject's face should be in line with the camera lens axis (❦ *Figure 2*).

Rule 2:
The pupils of the eyes are centered within the eye sockets, and there is an equal amount of white on both the left and the right sides of the pupil, as shown in ❦ *Figure 1b*.

So that's it. That's what we mean by a full-face view. It's when the subject's face, normally determined by the direction that the nose is pointing, is pointing directly back to the camera and is in line with the lens axis. Take a look at ❦ *Figure 3* for another example.

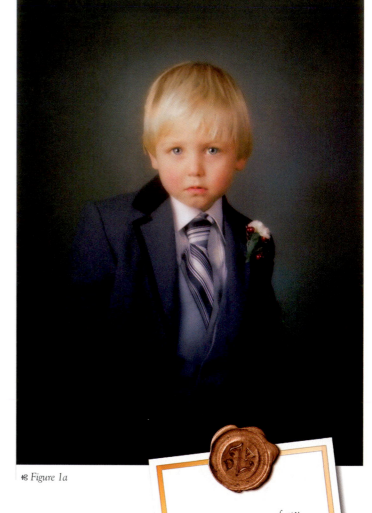

❦ *Figure 1a*

I like this image of my little ring bearer and I have to tell ya, it's been with me a long, long time—he's now nearly 30 years old and has his own little ring bearers running around the house.

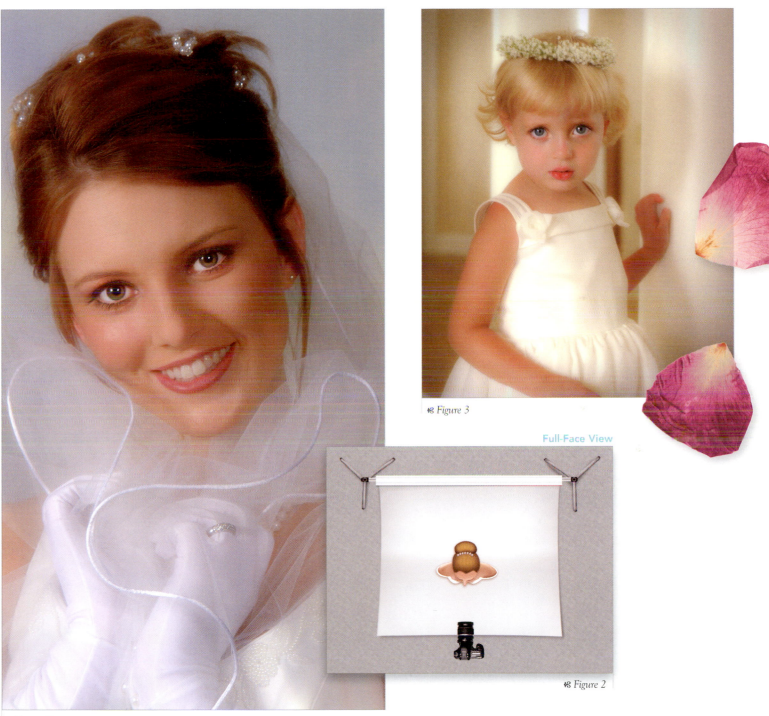

Full-Face View

Figure 1b

Figure 3

Figure 2

(Continued)

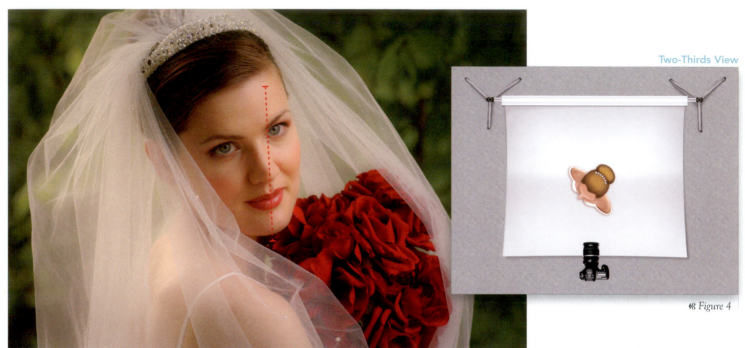

Two-Thirds View

❧ Figure 4

❧ Figure 5

Two-Thirds View

The two-thirds view is also pretty easy to understand. It's really just when we turn the subject's head slightly away from the camera (see ❧ *Figure 4*). But how far should we ask them to turn their head? Here are the simple, basic rules:

Rule 1:

Turn the subject's head away from the camera until you line up the inside corner of the eye with the outside tip of the nose, as you can see in ❧ *Figure 5*. This is the approximate positioning of the face for the two-thirds view.

Rule 2:

You want to have that far eye contained by the far part of the face (see ❧ *Figure 6*). If you have the eyeball hanging out in space, it simply doesn't flatter the subject.

Rule 3:

You never want to have the nose breaking the cheek line, or even getting close to the cheek line (❧ *Figure 7*). If this happens, you create the Pinocchio effect—you exaggerate the size of the nose as you get it closer to (or break) the cheek line. No one wants to appear to have a larger nose!

So, those are the basic rules for the two-thirds view. Remember, it's the inside corner of the eye lining up with the tip of the nose.

Just having this little bit of insight into what helps you make people look good, really makes your job easier on the wedding day.

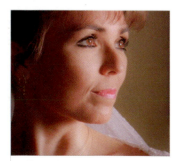

❧ Figure 6

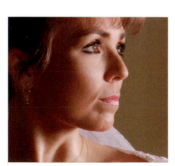

❧ Figure 7

Modified Two-Thirds View

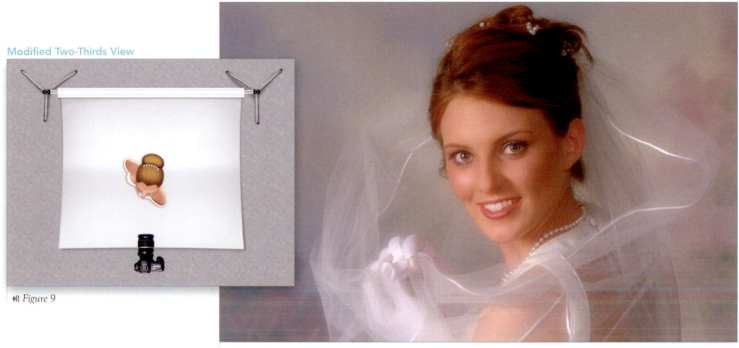

Figure 9

Figure 8

Modified Two-Thirds View

I've added an extra facial view here, which I call the "modified two-thirds view," that I think works beautifully for most female subjects, especially brides. Here is a quick peek at what it looks like (see *Figure 8*). It's very easy to set up. Here are a few rules that I follow:

Rule 1:

I bring the subject's head just slightly back towards the camera—just slightly. Check out *Figure 9.*

Rule 2:

I have my subject direct their eyes back into the camera, as well. Now that the eyes are looking back into the camera, what happens is this: the pupils aren't centered in the eye sockets anymore, and I have a whole bunch of white on one side of the eyes, but not the other. This actually draws the viewer's attention to the subject's eyes, because

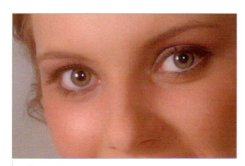

Figure 10

that's the brightest, lightest part of the face now. See *Figure 10*, which is the eyes close up from Figure 8.

Rule 3:

I also like to tilt the chin down ever so slightly. That puts a little white under the pupils, as well. I think it is a beautiful way to photograph female subjects. Whether they are brides, mothers of the bride and groom, grandmothers, whether they're seniors, or whoever they happen to be, this head position flatters our subjects quite nicely.

(Continued)

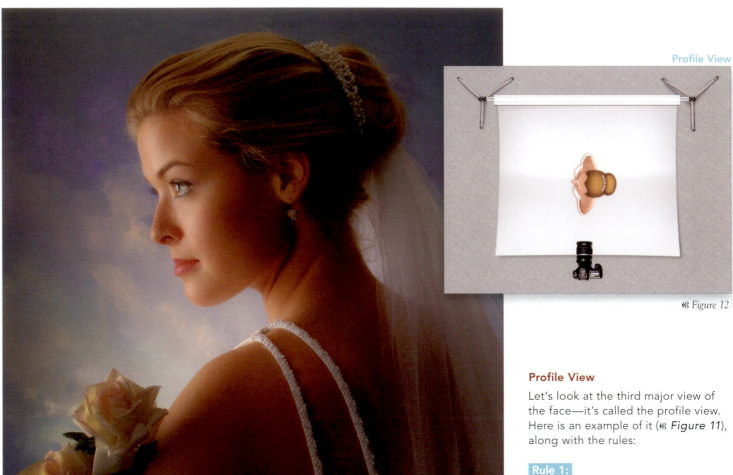

Figure 11

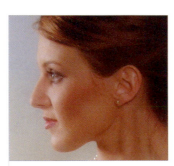

Figure 12

Profile View

Let's look at the third major view of the face—it's called the profile view. Here is an example of it (*Figure 11*), along with the rules:

Rule 1:

In the profile view, I want to see exactly half of the face. It is literally defined when the axis of the subject's face is perpendicular to the camera lens (*Figure 12*).

Rule 2:

If I'm going to have my subject turn their face to the profile view, I don't want the eyes looking straight ahead. If the eyes are looking straight on, I'll see too much of the white of the eye closest to the camera (see *Figure 13*). Instead, I'm going to have the subject look slightly toward the camera, as shown in *Figure 14*. No matter whether you are photographing the subject with a left or right profile, the eyes need to be looking slightly, very slightly, toward the camera position. This gives the illusion that the pupil is centered with respect to the camera view.

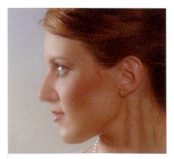

Figure 13

Figure 14

If you're going to have the veil in the photograph, just be sure that it starts at the very top of the forehead and gives you the background for the entire view of the face, from around the nose, to the lips, to the chin, as shown in ❧ Figure 15.

❧ *Figure 15*

Rule 3:

Here is another thing that's important in a profile view: you'll want a nice clean profile from the top of the forehead, down around the nose, around the lips and chin, and down the neck. You never want to see any of the veil sticking out or other distractions behind the profile. Also, be sure that the bride has no hair showing on the far side of her nose. Now, I don't mean nose hairs; I mean hair from her hairstyle coming out from behind the profile.

Rule 4:

You never want to see the far eye, or even the eyelid (see ❧ *Figure 16* for this no-no), nor do you want to see the far cheekbone in the profile view. You also have to remember that everybody's facial physiology is different: some people have flatter faces, some have more elongated faces, some have cute button noses, and some have longer, sharper features. If your subject has a fuller figure, then asking them to lean slightly forward while in profile position and extend their chin forward will help disguise and eliminate the unflattering double-chin problem.

❧ *Figure 16*

(Continued)

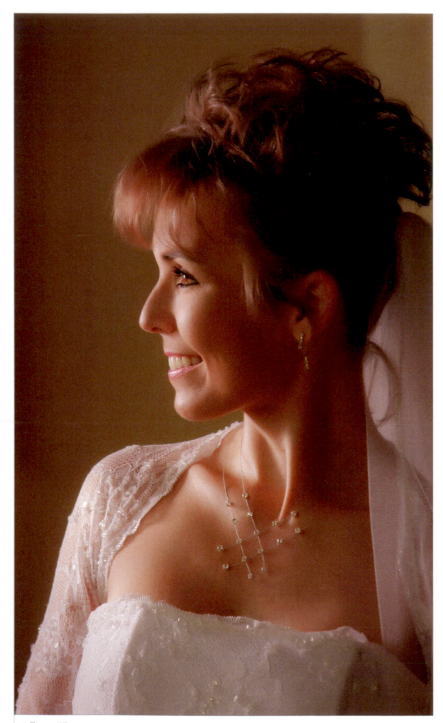

✦ *Figure 17*

There are two ways to photograph a profile. The first is represented in ✦ *Figure 17*. Notice how the light is hitting the top part of the gown. That's because of how I have her shoulders facing the camera. She is turned, so that part of the light falls on the dress. Since this part of the image is also illuminated, we are telling the viewer to look here, too.

Now, what happens if I ask the bride to turn her shoulders, so that I see the back of her gown? The back of the gown is now in the shadows (see ✦ *Figure 18*). But, look how the "feel" of the image changed. Our eyes go right to the bride's face, as it's now the brightest part of the scene. Pretty cool how that works, isn't it?

Well, folks, that is basically everything I know about posing. I told you it was pretty simple. The bottom line is if we can follow these basic rules, we can really create a much better set of portrait images—ones that enhance and flatter our sub-jects—than if we are just running and gunning the entire wedding day, with no regard to making the client look good when we have the opportunity to do so. Sure, I'm also going to capture the spon-taneity, the emotions, and the feelings of the wedding day through a series of candid images, but I feel it's so important to flatter the subject in timeless portraits, as well.

Now, I know many people say they don't want to be posed, but are we really spending large amounts of time and effort posing our subjects? Remember what I mentioned at the beginning of this technique: most people hate to get their photograph taken because most photographs they have seen of themselves have not been very flattering. With just a little bit of direction, we can create some great images of our clients— images that they will be thrilled to see and will treasure from their wedding celebration.

Figure 18

Figure 19

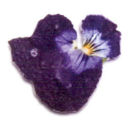

Of course, with every rule there is the opportunity to break it. So, if you're looking through your camera's viewfinder and your subject falls into a beautiful, natural position, then by all means, take the shot! See Figure 19. You can always refine the pose later if you like, but you may really love the natural pose, too.

Secrets of the Masters—Part 2

Okay, here is another five-minute lesson for you. Let me tell you everything I know about lighting: lighting can be complex or lighting can be simple—it's your choice. It's interesting to me, in this day and age, to see so much more discussion about lighting. I come from the old school, where lighting was super-important in getting the best-looking images for our clients.

Now that digital cameras are so readily available, and more people want to try to make a few extra bucks shooting weddings, we've actually had a watering down of decent lighting techniques in wedding photography. Yet, it is interesting to note that these days, particularly when looking at so many blogs, Flickr groups, and mainstream photography magazines, there has been a resurgence of interest in the importance of quality lighting, portrait or otherwise. Decent lighting was quickly becoming a lost art, but has been resurrected by a few talented photographers and bloggers like David Hobby at Strobist.com. David has an entire blog dedicated to using small flashes to create a direction of light on a subject.

When it comes to wedding photography, I keep my lighting pretty darn simple. The classic portrait painters had it figured out hundreds of years ago—they'd put their subject next to a window or take them outdoors and paint away. The result always showed a beautiful direction of light. All we have to do is take what we learned from them and apply it to wedding photography. Let me show you how:

The Five Lighting Secrets

There are five basic classical lighting patterns with which to illuminate your subject(s): (1) butterfly lighting, (2) loop lighting, (3) Rembrandt lighting, (4) split lighting, and (5) rim/accent lighting. With the images here (all with the full-face view I described earlier), I'll show you how the directional light relates to the facial axis in creating each of these five lighting patterns.

Butterfly Lighting

In the butterfly lighting pattern, we have the light directly in front of and above the subject (❦ *Figure 1a*). It casts a little butterfly shadow under the subject's nose (see ❦ *Figure 1b*).

Butterfly lighting is a lighting pattern that's been used by fashion photographers for years. Although flattering on fashion models, it adds weight to the subject because the full facial plane is illuminated. Of course, fashion photographers are generally working with very slender subjects. We wedding photographers deal with a much wider range of body sizes and shapes. That's why I don't think that butterfly lighting is the best lighting for most brides, grooms, wedding parties, and families. The unfortunate truth these days is that photographers who choose to bounce a flash directly off the ceiling above the subject, or use the various fill cards available, are

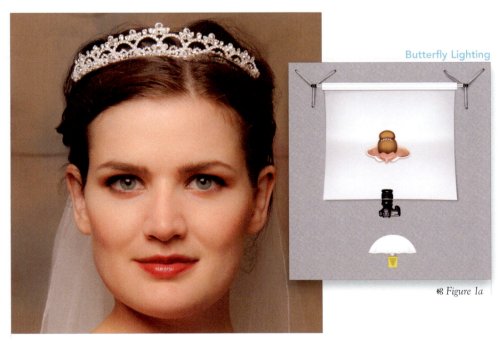

Butterfly Lighting

❦ *Figure 1b*

❦ *Figure 1a*

basically creating this butterfly lighting pattern on their subjects, and many times, not very well.

Loop Lighting

My favorite lighting pattern has always been the loop lighting pattern. So, in this scenario, let's move the light around the subject just a bit (see ❦ *Figure 2a*). As I move the light around the subject's face, the nose shadow will traverse the upper lip in the opposite direction of the light. That's going to create a little loop shadow just off to the side of the subject's nose. The cheek shadow also gets progressively larger. As the cheek shadow gets bigger, the highlight area is reduced. With more of the subject's face shadowed, it creates the illusion of thinning them. The more I rotate the light around the subject, the more the shadow increases and the highlight area is reduced (see ❦ *Figure 2b*).

Rembrandt Lighting

Let's say you have a person with an even rounder face, is there any way we can do a better job of flattering them with the lighting? Sure. Let's just go ahead and rotate the light around the subject even further (see ❦ *Figure 3a*). As we do so, we will have the nose shadow connect with the cheek shadow (❦ *Figure 3b*). This is what is referred to as the Rembrandt lighting pattern.

Notice that as the nose shadow connects with the cheek shadow, we are left with a little triangular patch of light right under the bride's eye. You can see this same lighting characteristic in many of Rembrandt's paintings, hence the name. Also, notice how we have minimized the area of illumination on our subject's face, seeing much more shadow. This is how we minimize or reduce the weight of the person visually—simply by using light.

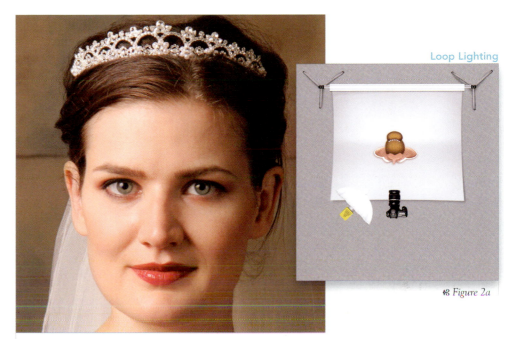

Loop Lighting

❦ *Figure 2a*

❦ *Figure 2b*

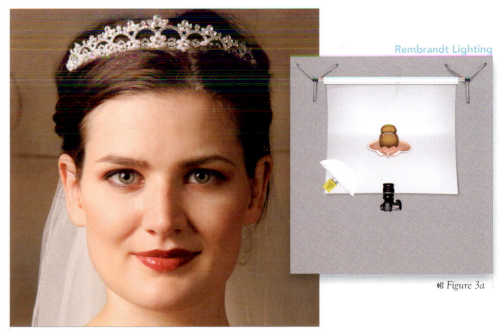

Rembrandt Lighting

❦ *Figure 3a*

❦ *Figure 3b*

(Continued)

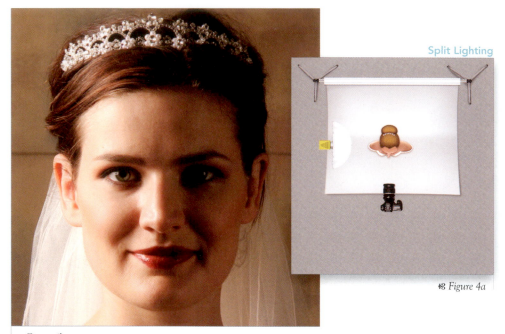

Split Lighting

❧ Figure 4a

❧ Figure 4b

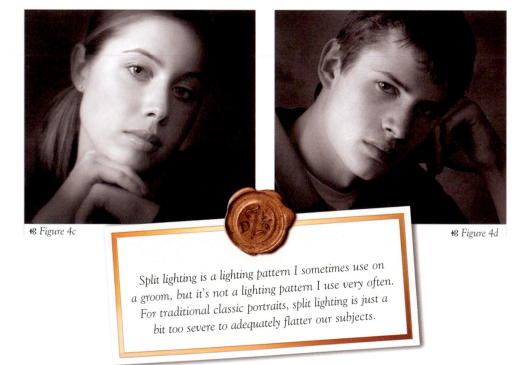

❧ Figure 4c

❧ Figure 4d

Split lighting is a lighting pattern I sometimes use on a groom, but it's not a lighting pattern I use very often. For traditional classic portraits, split lighting is just a bit too severe to adequately flatter our subjects.

Split Lighting

If I continue rotating the light around the subject even more, to where it's perpendicular to the subject's face, then I have a split lighting pattern (see ❧ *Figures 4a* and *4b*).

I mention the split lighting pattern because it needs to be included in our five classical lighting patterns. It does work well for the more dramatic portrait, a trendy senior portrait, or fashion-focused shoot, but typically it's not what we'd use on a wedding day. I suggest you experiment with split lighting for your own projects, and you'll see how it can add drama to the shot (see ❧ *Figures 4c* and *4d*).

Rim/Accent Lighting

The first four lighting patterns—butterfly, loop, Rembrandt, and split—are the four main lighting patterns used in portraiture, but watch what happens if we continue rotating the light around the subject even further (❧ *Figure 5a*). Notice how the light completely leaves the face and just rims out the subject's head ever so slightly (❧ *Figure 5b*). This crescent of light on the back of the subject is called rim or accent lighting.

Since there is no light on the front of the subject's face, the rim lighting pattern is not a predominant lighting pattern we use. The rim lighting pattern is an accent light, and is used when we want to separate the subject from a dark background. My good friend, Don Blair, God rest his soul, used to call it his "garlic light." Don used to say, "Aah, add a little garlic on the back, just to separate them from the background. It will allow the subject to pop out from the background just a little bit more." Once you've established your rim lighting on the subject, use the loop or Rembrandt lighting pattern to illuminate them properly.

So, folks, that's pretty much the five lighting patterns of the face. Take a look

at ❧ *Figure 6* to see the relative position of the light source with respect to the axis of the subject's face in each of the lighting patterns just described. Let me do a quick walk-through one more time:

1 Notice that my camera is at the 4 o'clock position in relation to the subject's face, and the subject is in the two-thirds view. You will also notice that the direction of the light is in line with the axis of the subject's face for the butterfly lighting pattern.

2 For a loop lighting pattern, I just need to bring the light around through the arc a little bit more, so it throws a nose shadow on the camera side of the person's face.

3 The Rembrandt lighting pattern then becomes apparent, as I continue to rotate the light around the subject.

4 You can see that the direction of the split lighting pattern is perpendicular to the axis of the subject's face, illuminating just one-half of the face.

5 In the rim lighting pattern, the light source needs to continue all the way around our subject to the 10 o'clock position in relation to the axis of the subject's face. Be careful not to photograph the light source in this instance.

Remember, use the rim lighting in conjunction with a loop or Rembrandt lighting pattern for your portraits. It adds a nice final polish to your images.

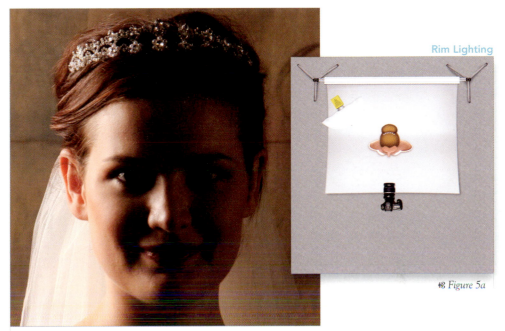

Rim Lighting

❧ *Figure 5a*

❧ *Figure 5b*

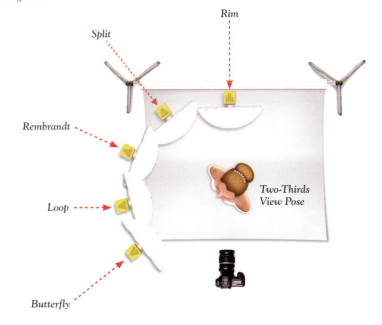

❧ *Figure 6*

(Continued)

Back in the old days, I used to carry a portrait background and a strobe, halo, and reflector with me to weddings. It was fast and easy to use, and gave me such a great result. I've changed with the times, since my clients, these days, don't want this kind of a look in their wedding photography. But, all things considered, a studio strobe fitted to the Westcott Halo, when used with the reflector fill, is still the most consistent and easiest way to take a portrait in your studio. What I love about the Halo is that it is a convex light source. The beauty of a convex light source is that it throws light everywhere—toward the subject, the reflector, and the background. Positioning the Halo for my loop lighting pattern gives me a soft light on my bride, while spilling some light onto my reflector, giving me the perfect amount of fill. I even get some of the light to hit the background, too. So there you have it—a single light source and reflector fill creating everything we need.

It is interesting to see how lighting equipment has evolved over the last couple of years. My good friends at Westcott introduced the Spiderlite a few years ago. It's a very high-intensity, daylight-balanced, cool-burning fluorescent bulb. They were originally invented for videography, but have found their way into working photography studios because of their ease of operation, and because they let you see exactly what type of lighting pattern you are creating all the time. And, they don't melt the subject. I think Spiderlites are a great continuous light solution for any studio photographer looking to obtain gorgeous lighting on their subjects, while also having the ca-pability to see the desired lighting pattern in real time. With the high-ISO cameras on the market these days, these new continuous light sources might be just what the doctor ordered for your studio.

Spiderlite TD5
with Box

COURTESY OF WESTCOTT

Lighting Gear

When working in the studio, it's easy to get the lighting pattern exactly where you want it—you just rotate the studio light around the subject's face until you get the desired lighting pattern. But, there are all kinds of light sources we can use to illuminate our subject. Back in my early high school days, when I was just starting to learn about portraiture, I used the old Smith-Victor reflectors fitted with photofloods. Granted, I nearly melted my subjects in front of those 500-watt, super-bright, hot lights, but I could always see from which direction the light was coming.

My lighting setup today is utter simplicity. It consists of a studio strobe within a Westcott Halo, positioned on one side of the subject, with a 36-inch silver reflector placed on the other side and held in place by a light stand (see ☙ *Figure 7*).

I've never been a big fan of the studio umbrella as a light modifier, but I am a huge fan of the Westcott Halo Light Modifier, and have been since it was introduced in 1986. The Halo (which works with any studio light) has been my choice for modifying my studio light for over 23 years. With my one light source and my reflector fill, I have just about all the control I need to create a studio portrait. The setup is fast, easy, and gives a beautiful result.

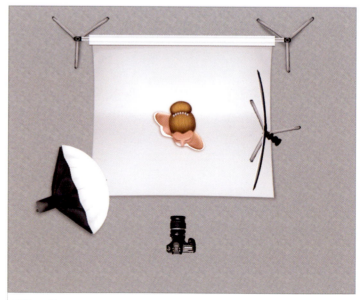

☙ *Figure 7*

Okay, Now It's Time for the Really Big Lighting Rule!

If you have been paying attention, you may have deduced this rule already. If you haven't, then read these last few paragraphs. If you can get this rule etched into your brain, you can improve your portrait photography substantially. Here is the rule:

Regardless of the view of the face you are photographing (full-face, two-thirds, or profile) and the lighting pattern you are using (butterfly, loop, Rembrandt, split, or rim), you must remember that the axis of your studio light relative to the axis of the subject's face creates an angle for that lighting pattern, and that angle is the same for that lighting pattern whether it is a full-face, two-thirds, or profile view. Check out *Figure 8* to see exactly what I mean here.

Also, if the subject looks down, then the light moves down. If you ask the subject to raise their chin and look up, then the light needs to follow and move up.

Understanding the three simple views of the face (four, including my modified two-thirds view) and the five easy lighting patterns with which you can illuminate the subject's face will improve your photography dramatically. They will give you the basic tools to go out and produce flattering photographs of your clients easily and consistently. If you can get them down, your photography will start zooming past your competition to the top of the heap. Why? Because there aren't many wedding photographers out there paying attention to quality lighting, so learn from the masters and it will make a big difference in your photography.

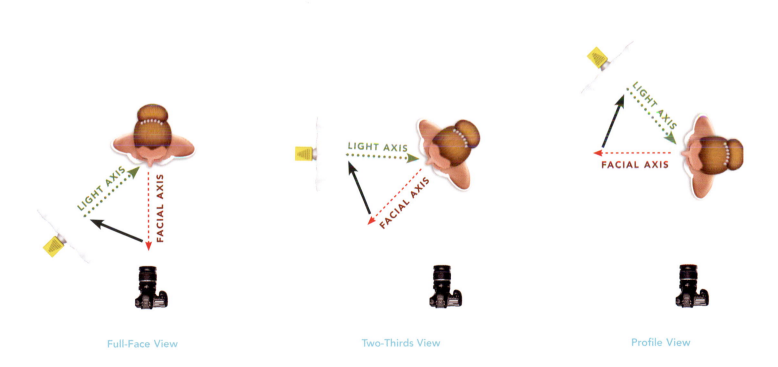

Full-Face View Two-Thirds View Profile View

Figure 8

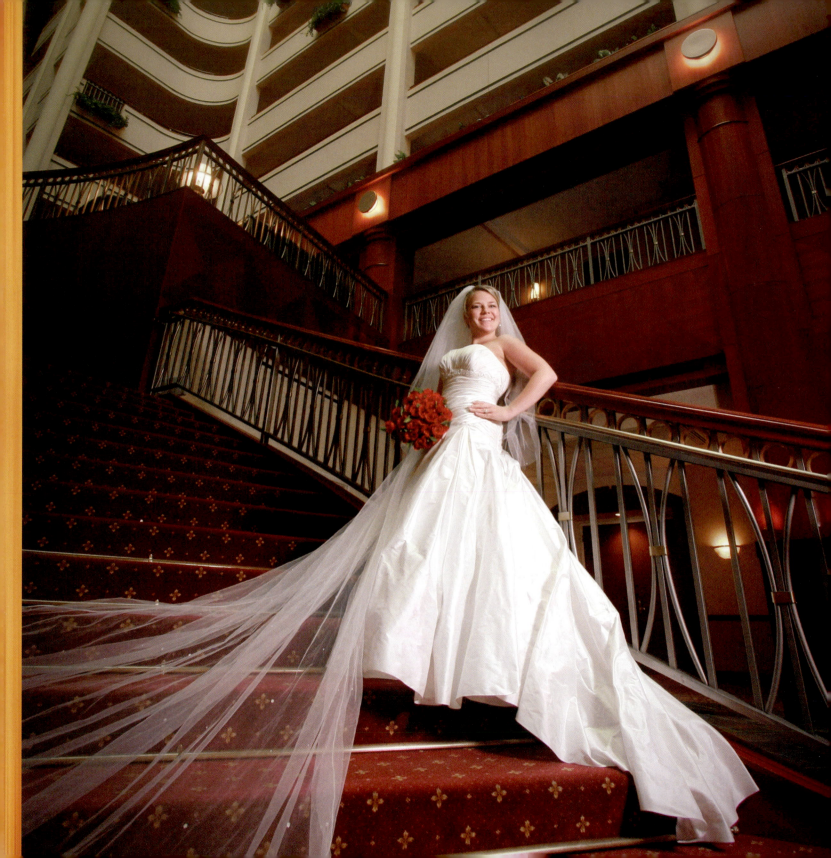

Just Set the Camera to "P" for Professional (Not!!!)

First Things First, Let's Nail The Exposure

In this chapter, I'm going to discuss how I get my best exposure. Back in the old film days, I always carried an exposure meter with me, but since switching to digital, I really haven't found the need for one. I know a number of people may cringe at that remark, but by using the techniques in this chapter, I think you'll find that you can nail your exposure every time. Yes, I still use a light meter, but now it is the camera. Instead of reading the numbers off a light meter, I use the camera's visual assets, like the histogram.

First, let me warn you about one thing that you should not rely primarily on when determining the proper exposure of the scene: the LCD screen on the back of your camera. In my experience, the brightness of the LCD varies from camera to camera. Even when the shot looks good on the screen, it still may be a stop underexposed when you view it on your calibrated computer monitor.

Now, having said that, in the past I've had some luck using my camera's LCD in evaluating my exposure. Currently both my Canon EOS 7D and 5D Mark II do a great job matching what I see on my computer monitor (see ✌ **Figure 1**).

I'm not trying to say that you should use your LCD as an exposure meter, nor am I trying to infer that the camera's LCD screen is as good as your calibrated computer monitor. But, for me, if in the heat of the shoot, it's giving me decent visual feedback about my exposure, indicating that I'm at least in the exposure ballpark, then I'm a happy camper.

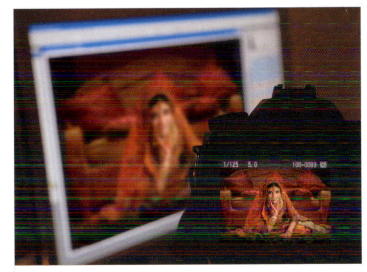

✌ *Figure 1*

Let me just add that I'm talking mostly about using your LCD with images taken indoors, like at a church. We introduce a new set of problems when we go outside in much brighter light. Things get a bit dicier because of the bright light, especially with newer cameras' auto viewfinder brightness feature. So, I would stick to my more tried-and-true methods, which you'll learn in this chapter.

Getting the Perfect Exposure: "Blinky" Method

Okay, we all know that the best starting point for a good photograph is getting the correct exposure. But, how do we do that? Since I don't carry an exposure meter with me, I've developed a simple method to nail the exposure every time: the "blinky" method. Now, some of my DigitalProTalk .com readers have said (emphatically) that this is a very unprofessional way to judge exposure. Frankly, I think it's a perfect way to judge the exposure, because the scene's brightest light value is a large area of diffuse white (a wedding gown, a white tuxedo shirt, etc.). Here is my method:

Step One:
Be sure that your camera is set to show what I call the "blinkies" on your LCD screen, as you see in ✺ *Figure 1*. I know your camera menu may use a term like "Highlight Alert," but they're still "blinkies" to me. Blinkies are an indication that you have blown out the exposure in a highlight area of the scene.

Step Two:
Once you and the bride are in position, and your assistant has the light in the proper position, zoom in tightly on the bride's veil or gown and take a shot.

Step Three:
Examine the LCD screen and see if you have to deal with any blinkies on any diffuse whites, like the bridal veil or gown (see ✺ *Figure 2*). If I'm photographing the groom, I use his white tuxedo shirt.

Step Four:
If the veil or gown is "blinking" back at you,

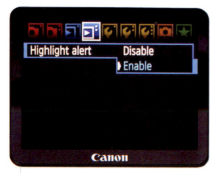

✺ *Figure 1*

then it will be overexposed and you'll need to make an adjustment to your exposure. Do one of these three things: have your assistant, holding the flash, back away slightly; increase your aperture; or reduce your ISO slightly. Take a second test shot and see if the blinkies have disappeared (✺ *Figure 3*).

Step Five:
Repeat this process until you have no blinkies in the diffuse highlights of the scene. It's okay to have church lights and candles showing the blinkies. We just want to assure that the bridal veil (gown, tuxedo shirt, etc.), is not overexposed. We will talk about how to control the church overhead lights, candles, and other areas of reflections, later in the book.

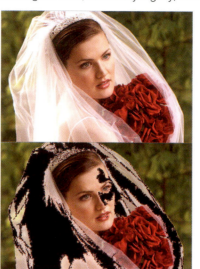

✺ *Figure 2*

✺ *Figure 3*

Pretty darn easy, wasn't it? This is about the easiest way to get near-perfect exposure on the scene. The secret lies in having a diffuse white in the scene when making your shot. Don't have a bridal gown or veil? Any other diffuse white surface will do. I carry a small pop-up reflector with me in my gear bag, which I use in just those circumstances.

While Nikon had a full-screen Highlight Alert (blinkies) feature as far back as the Nikon D1x, prior to the 40D, Canon cameras never did. It really made the technique I just mentioned unusable. The highlight alert showing on such a small image on the LCD made it nearly impossible to see and, consequently, literally unusable.

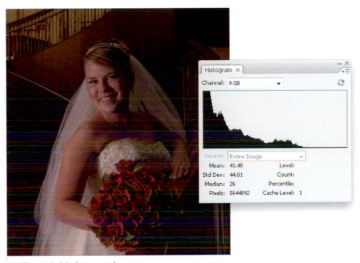

Getting the Perfect Exposure: Using the Histogram

If you take exception to my "blinky" method, then let me give you a second method for determining good exposure. This one uses the histogram on your camera.

The histogram is defined simply as a chart showing the light values between 0–255 within the exposed scene. If your image is underexposed, the curve of the histogram shifts to the left. It will go to zero (hit the x-axis) before it hits the right-hand y-axis, as you can see in the Photoshop Histogram panel in ✸ *Figure 1*.

If your image is overexposed, it will shift to the right and bang up against the right-hand y-axis, indicating that you have light values above 255 (the pixels could not record the higher light values; see ✸ *Figure 2*). Your blinkies should be going crazy too, if you turned them on. Rather than giving you a detailed description of histograms, I just want to show you how to use one to determine an accurate exposure of the scene (as shown in ✸ *Figure 3*).

✸ *Figure 1: Underexposed*

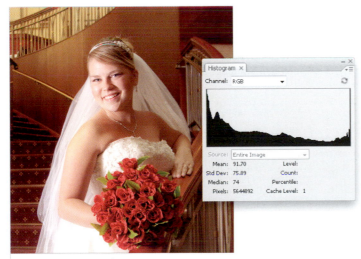

✸ *Figure 2: Overexposed*

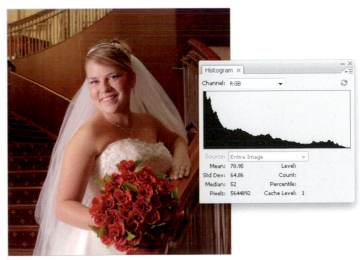

✸ *Figure 3: Correct Exposure*

(Continued)

Run this test on your own gear to see what the optimum location is on your histogram, photographing a diffused white for the best exposure. Also, to make a distinction between a diffused light and a specular highlight, a specular highlight is a blown-out highlight, but may be a candle, a light bulb in a chandelier, the bright sun coming in a church window, etc. When you analyze the histogram for good exposure, you need to take those factors into account. I base my histogram evaluation on an image containing a diffuse white as the brightest part of the scene. If I get some of those blinkies on candles, no problem.

Step One:

Make an exposure, and be sure it includes a diffuse white as the brightest part of the image. Try to avoid photographing many specular highlights, which may throw you off—a few lights or candles are okay.

Step Two:

Check the histogram and determine where the curve falls as it moves to the right on the graph. This is where the curve must hit in order to get the most consistently correct exposure without blowing out the highlights. I have found that on my Canon 5D Mark II, the curve must hit the baseline (x-axis) about one-third into the fifth segment of the histogram, as shown in ❧ *Figure 4*.

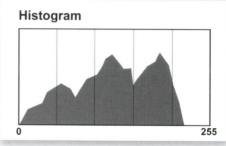

❧ *Figure 4*

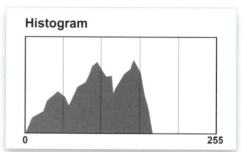

❧ *Figure 5*

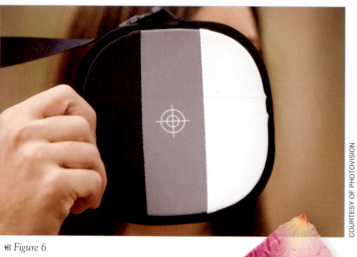

❧ *Figure 6*

Step Three:

Many photographers make the mistake of thinking that the histogram must always land at, or just slightly before, the right-hand y-axis. But, if we photographed a Caucasian couple dressed in blue shirts and khaki pants against a dark background, and made the exposure so that the curve of the histogram landed at the right-hand y-axis, we would severely overexpose our image. Why? Because there's no diffuse white in the scene. The lightest tonalities in the scene would be their faces, and those faces are not as bright as a bride's gown. So, we need to understand how to read a histogram when there is no diffuse white as a reference. I have found that when photographing a couple dressed as I just suggested, I get my best exposure when the curve of the histogram lands, not one-third of the way into the fifth segment

of the histogram, but rather one-third of the way into the fourth segment (see ❧ *Figure 5*). Keep in mind, different ethnic backgrounds will change how you read your histogram.

Step Four:

To make things easier, I always include a reference diffuse white somewhere in the early part of the shooting. I use my buddy Ed Pierce's Photovision 14" Digital Pocket Target in these kinds of situations (see ❧ *Figure 6*). I just look for the blinkies on the white section. This lets me easily establish the correct exposure, and then I'm good to go until I change locations or the light changes.

❧ *Figure 7*

It really is important to understand what the histogram is telling us. I was in Hawaii, photographing dark foliage, and made the mistake of thinking that my histogram needed to shift to the right to get a correct exposure. How wrong I was. Dark foliage is dark and, if the lightest part of the image is supposed to be dark, then I want the histogram to accurately reflect the dark-only values of the scene. It should not push toward the right side at all. As a matter of fact, I actually want the curve of my histogram to land no further than midway across the x-axis (❧ Figure 7). So, always consider the subject matter when analyzing your histogram. It can really help you nail your exposure if you read it correctly.

JPEG Salvation: Highlight Tone Priority

Highlight Tone Priority is the "whipped cream and cherry on top" for digital cameras—(called Active D-Lighting on Nikons). It's one of those features that's listed in the camera's specs, but receives little real-world discussion for the wedding shooter. It started showing up on new cameras a few years ago. For the JPEG shooter, Highlight Tone Priority is the hottest digital camera feature, and it makes JPEG shooting almost foolproof. Even if you're a RAW shooter, the benefits are unbelievable.

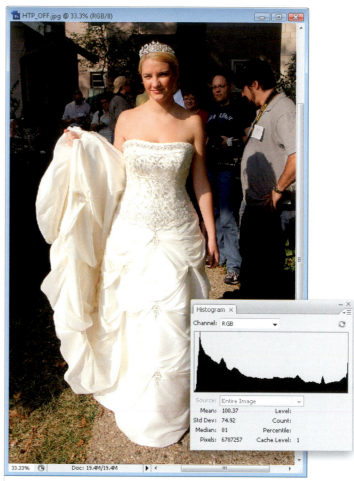

❀ Figure 2: Program Mode

As an example, I shot a wedding with Canon's 1D Mark III with Highlight Tone Priority enabled (see ❀ *Figure 1*), and the bride came out of the house on this super-bright (not to mention hot), cloudless day. I had the camera in P (Program) mode and shot away. I "chimped" the shot (checked it out on the LCD) and could see no blinkies. (Again, I know they call it Highlight Alert, but it's still blinkies to me.)

Now, any good wedding photographer knows that when shooting the bride leaving the house or getting out of the limo—or any inside location—and moving into full sun, there can be a big problem when it comes to the exposure. In the old days, you were just about guaranteed to blow out the bridal gown in this situation—shooting JPEGs in any auto mode would result in the dress highlights being blown out. As a JPEG shooter, I always make a slight adjustment to my exposure before the bride steps into the bright sun. This is fine if you have the time, but it can be a hassle when things are really moving. Now, I know the RAW guys are going to say they don't have this problem. Granted, but it's still about nailing the exposure—RAW or JPEG.

Let's take a look at some of my hands-on shooting during one of my Digital

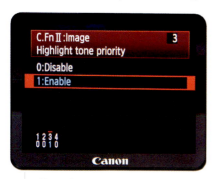

❀ Figure 1

Master Class shoots: I asked our bride to step out of the shadows and into the sunlight (again, my camera was in Program mode). Look at the first image (❀ *Figure 2*). The image's histogram shows it is clearly blown out.

So, I enabled the Highlight Tone Priority feature on my camera, and had the bride step out of the shadows into the sunlight again, as I continued to shoot away. Check out the second image (❀ *Figure 3*). The exposure is just about nailed, and look at the histogram—it's right where it needs to be.

Now look at the close-ups of these images (❀ *Figure 4*). Look how the gown detail is preserved beautifully with the Highlight Tone Priority feature enabled. Amazing!

Figure 3: With Highlight Tone Priority

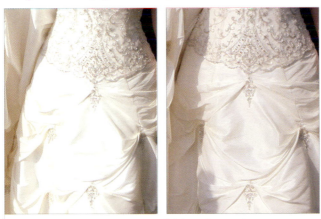

Figure 4: Highlight Tone Priority Off (left) and On (right)

So, just how far can you go before you go beyond the range of this safety net feature? I'd say about one stop. Take a look at the last image (❦ *Figure 5*). The difference between exposures is one stop. The over-exposed photograph is saved by the Highlight Tone Priority feature.

Don't overlook these additional benefits: When doing the "cocktail candid" shots, we are sometimes in fairly tight quarters. We may be shooting a group only a few feet in front of us with a 17–85mm lens at 17mm range. The on-camera flash may overexpose about ½ stop. We know this and (most of the time) make the necessary adjustment, but now the Highlight Tone Priority feature saves the day and takes the worry and "exposure fiddle" out of the picture—no pun intended. It also reduces facial shine, saving work in post-production, as you can see in ❦ *Figure 5*, as well.

Figure 5: Highlight Tone Priority Off (top) and On (bottom)

Wrap-Up: Nailing the Exposure in RAW or JPEG

Some photographers may say, "Oh, I shoot RAW, so I really don't have to worry about overexposure." Well, I would agree with that—in part. Shooting RAW does give us about two stops of overexposure latitude. But, if we're sloppy, we can still overexpose a RAW file and blow out the diffuse whites.

I've been a JPEG shooter for eight of the last nine years, since I've been shooting digitally. I know that will make the purists cringe, but I always get great exposures from JPEGs. Why? Because I took the time to learn how to use my histogram, and I'm careful about watching for blinkies in the scene. I'm so careful and attentive to the image exposure that overexposure is rarely a problem. Actually, shooting JPEGs has trained me to get the best exposure to minimize post-production issues. With that experience, it is easy for me to make a transition from JPEG to RAW files and still nail the exposure.

So, don't let shooting RAW be a crutch for not learning good exposure. Follow the steps I've outlined in this chapter, and you can be assured of great exposures all the time. I'll wrap up this chapter by walking you through, one more time, exactly how I determine the exposure when shooting the really important formal and group photographs at the wedding.

Step One:
I ask my assistant to get in the proper position and have the proper power setting set on his/her flash.

Step Two:
I take up my position in the optimum location for photographing the group, and fire off a test exposure as they are coming together.

Figure 1

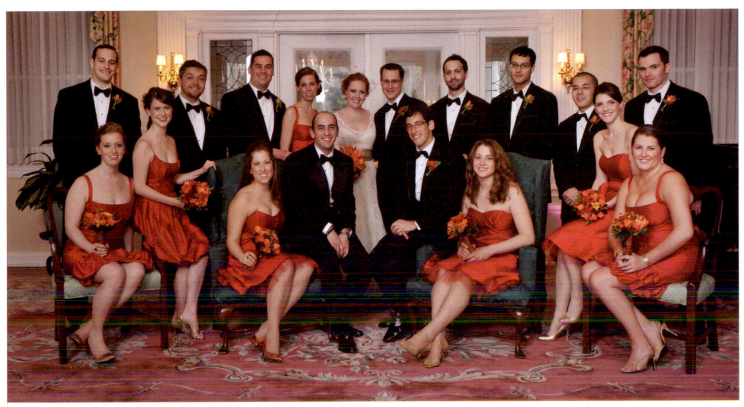

Figure 2

This way, I don't waste any time trying to establish the correct exposure with them already in place. I think having a group wait for us is not putting our best professional foot forward.

Step Three:

After making my test exposure, I look for blinkies in any diffuse whites in the image. I also check the histogram to be sure the curve is landing one-third of the way into that fifth segment. If I have no blinkies in the diffuse whites and the histogram is looking good, then I know I've got a correct exposure, as shown here in *Figure 1*.

Step Four:

If I see that I'm a little under- or a little overexposed, I'll make the necessary adjustments.

Step Five:

Once I'm confident of the correct exposure, the rest is history. My assistant stays in the same location at the same power setting. I also maintain my same location, using the camera's zoom lens to change perspective, as needed. The group hasn't had to wait on me, and we get some great shots (see *Figure 2*).

By sticking to this routine, I guarantee myself that I have a properly exposed, consistent set of images.

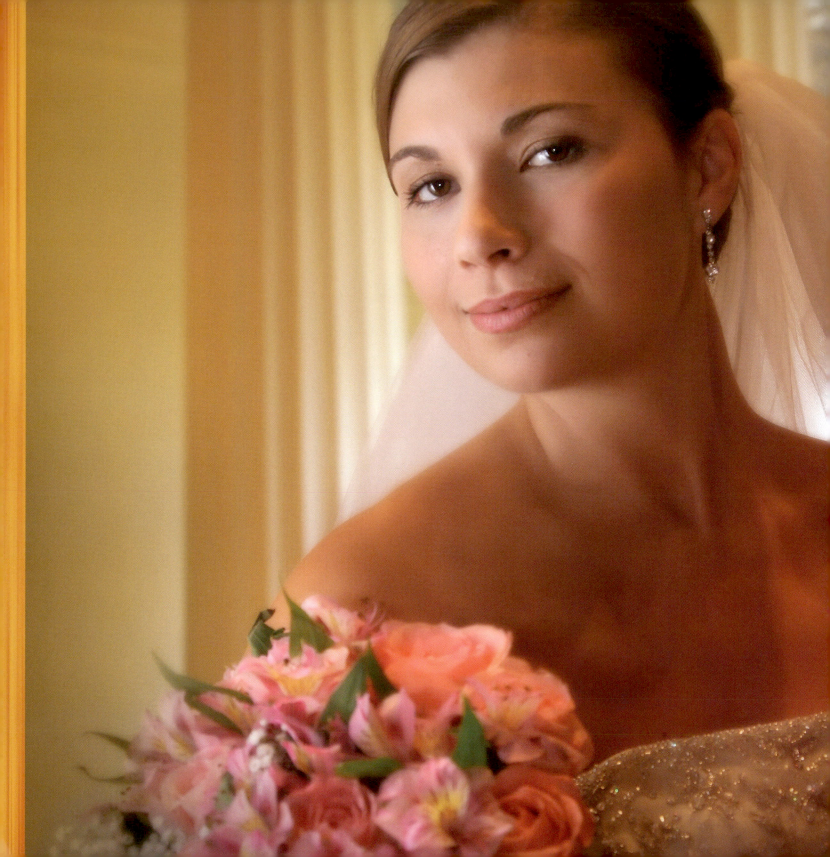

You Already Own It, Now Make It Dance for You

On-Camera Flash Lighting Techniques

Okay gang, let's talk about some equipment. The most important piece of equipment, after your camera, is your on-camera flash. If you're in the wedding biz, you need more than that little pop-up flash that's built into many DSLRs. If you are a Canon or Nikon shooter, you probably own 580EX IIs, or SB 800 or 900 units. But, the fact of the matter is most people just point these flash units directly at their subjects and shoot away. Frankly, folks, if that is the case, our wedding photography won't look much different from Uncle Harry's or Cousin Mary's snapshots.

For years, I've said, "It's always about the difference that makes the difference," and great lighting in wedding photography makes a big difference in the look of your work. It's this kind of quality lighting difference that will make potential clients seek you out. If your work looks the same as everyone else's—or Uncle Harry's or Cousin Mary's snapshots—then why should they bother to hire you to shoot their wedding? So, we can choose to do the same things as everybody else in the wedding market, or we can differentiate ourselves with style and technique, and offer our clients differences instead of sameness. And, guess what? You can charge a whole lot more for differences!

Good Lighting: The Biggest Difference

One of the biggest differences we can bring to our wedding photography is good lighting. Let's just take a second to review the options:

The first image here (❦ *Figure 1*) was taken with the flash pointed directly at the subject, which caused the heavy specularity (or shininess) on the skin tones. The on-camera flash is really quite a small light source—only about 2x3". When it sends its photons directly onto the bride's face, if her face is the least bit shiny, it will act like a mirror and bounce the photons right back into the camera.

Some photographers point their on-camera flash to the ceiling, thinking this will soften the light. Bouncing the light off the ceiling still gives us a lousy result, what I call office lighting: light coming straight down and pocketing the subject's eyes. In ❦ *Figure 2*, you can see that the eye sockets are really dark (we call those "raccoon" eyes). If you think about it, it's quite obvious why this happens: we're illuminating everything above the subject, creating a downward direction of light, and causing the brows over the eyes to shadow them. Not good.

The third option is to bounce the light off the ceiling, while using the flash unit's built-in fill flap, which pops a bit more light into those dark eye sockets. But, we still haven't produced a very flattering light on our subject (see ❦ *Figure 3*). Notice that the lighting does look a bit less harsh, and that the eye sockets are not in deep shadows, but we have our specularity problem back again on the forehead and cheek.

So, where is the specularity coming from this time? From all those photons bouncing off the fill flap. Think about it: we created another small light source when we pulled out the fill flap. Granted, it's not nearly as strong as what we had in our first instance, when we pointed the flash directly at our subject, but because of the fill flap's small size, the light coming from it still creates a specular return (shiny face).

Sure, there are all kinds contraptions we can add to our flashes to soften the light, spread it out, and make it appear more pleasing. But, folks, the bottom line is: this is not about destroying the shadows; it's about saving them. It's only when we put a shadow next to a highlight that we create detail, depth, dimension, color saturation, and a three-dimensional look that really flatters the subject.

So how do we accomplish that with our on-camera flash? How do we get the light coming from any direction other than from the ceiling or from the flash on the camera? Well, dear readers, starting on the next page, I'll show you how.

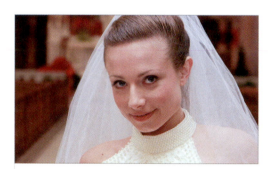

❦ *Figure 1*

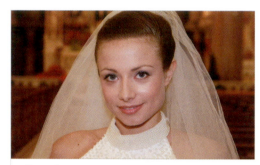

❦ *Figure 2*

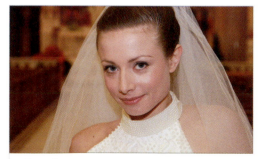

❦ *Figure 3*

I know what you're thinking here: f/4 is way too wide an aperture, and the subject will be out of focus. I come from the medium-format days, where f/4 was a wide aperture. But the f/4 on a DSLR, with the lens at 85mm, gives you the equivalent depth of field of f/5.6 at 150mm on the old medium-format cameras—f/4 is just fine to keep your subject in focus. If you're a little nervous about it, then crank up the ISO and use f/5.6. That's more than enough safety margin for your shots.

Throw Some Photons Against the Wall: Wall Bounce #1

Here I'll show you the quickest, easiest, coolest way to get really pretty light on your bride. Let's say you are meeting with the bride at her parents' house and taking some great photographs of the bride alone, with her parents, and with her girls. Let me walk you through exactly how to do it quickly and easily:

Step One:

Survey the home and see if you can find something or someplace that would make a really pleasing background for your photographs of the bride—a wall with some interesting decor, a beautiful set of drapes, a fireplace, etc. The photo on the left here was actually taken in the ladies' room at a country club.

Step Two:

Okay, you've found your location. Show the bride where you would like her to be within the room that makes the best composition for the photograph.

Step Three:

Now, set your camera to ISO 800 (or higher, if you're using one of the latest high-ISO Nikon or Canon cameras) and determine the correct exposure of the room at f/4. I usually set my camera to aperture priority mode and see what shutter speed is indicated. Let's say it's 1/30 of a second. Do *not*, I repeat, do *not* keep your camera in aperture priority mode to take the shot, though (more on that in Step Five).

Step Four:

Okay, you've got the exposure determined, but now we want to modify that a bit. If you're exposure is, say, f/4 at 1/30 of a second, then I want you to increase your shutter speed to 1/60 of a second. You always want to underexpose the room by at least 1 stop. It's the ambient light that will be supplying your fill illumination for the shot, and the fill light is always 1 stop or 1½ stops less than the main light.

(Continued)

CAPTURED BY THE LIGHT

I have one basic rule whenever I have a flash attached to my camera: my camera is always in manual mode and my flash is set to ETTL (Canon) or ITTL (Nikon). This gives me complete control over the ambient light of the scene, via my shutter speed, helping me create the proper ratio of highlight-to-shadow illumination on my bride. Remember, it's a highlight next to a shadow that creates detail, depth, and dimension in the finished image.

Step Five:

Next (this is a really important part), set your camera to manual mode. A lot of photographers want to set their cameras to P, for program mode, and some shooters may want to set their cameras to aperture priority mode. But, read my lips, don't do it.

Step Six:

We are now ready to take a photograph. The next step is to turn your flash head 90°–120° to the right or to the left of its straight-on position, pointing the flash towards the nearest wall (see ❦ *Figures 1a and 1b*). If it's not turned at least 90°, some of the photons coming out of the flash head will make a direct beeline to your bride's face, washing out the beautiful result you'll get with your flash bouncing off of a side wall.

❦ *Figure 1a*

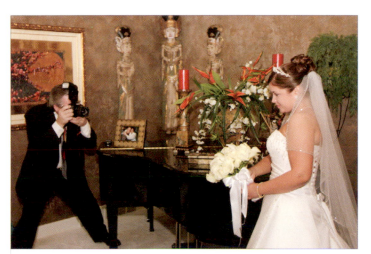

Figure 1b

Step Seven:

Encourage the bride to give you a great expression, and press the shutter button. Take a look at the resulting images (*Figures 2a* and *2b*). They're beautiful. The flash does all the work because of its ETTL/ITTL setting. We put a nice directional light on our subject, and that makes her look great. No more flat lighting—hooray, we have saved the shadows.

Folks, it's that simple. Now, I'm not suggesting you shoot the whole wedding with your flash pointed 90° from your subject, but in this instance, you can really improve your results and get some great images. And, believe it or not, this technique works really well whenever you're working in smaller, more confined spaces. Give it a try, and see if you don't like the results, too.

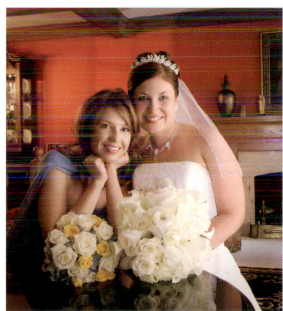

Figure 2b

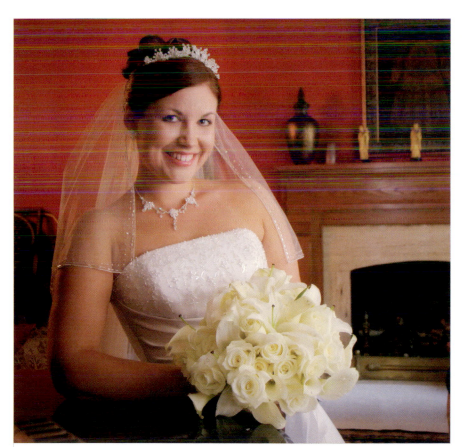

Figure 2a

Throw More Photons Against the Wall: Wall Bounce #2

Another good place to use this wall bounce technique is in candid shots of the girls getting ready. The space is usually a bit confined, and the wall bounce technique works great. Here we'll add a little twist to the last technique.

In Chapter 1, I showed the direction of light we need in the studio to create a flattering loop lighting pattern on our subjects. Well, we can do the same thing elsewhere with our on-camera flash, as long as the walls are of a fairly light color and the ceiling is not too high.

When taking wall bounce candids, I just rotate the flash head a bit more than 90° and elevate it a few degrees to bounce the light off the wall, ceiling, or both. Look at the diagram in *Figure 1* and you can see the basic orientation of the flash relative to the subject.

What happens here is the light emitted from the flash head actually travels behind me and upward slightly, illuminating part of the wall/ceiling. Okay, this is important: notice that the direction of the returned light has the same direction as the light that I got with a studio light positioned for the loop lighting pattern—ah ha, pretty light again. Let me walk you through the steps:

Step One:
Check the scene to see if a little wall bounce will help the shot. In the case of the girls getting ready, I think it will.

Step Two:
Turn your flash head about 110° away from the subjects, to the right and slightly toward the ceiling.

Step Three:
Set your ISO to 800 (or higher, if you are using one of the new high-ISO cameras), your camera to manual mode, and your aperture to f/4 or f/5.6, and shoot away. The secret here is to not point the flash too high toward the ceiling. If you do, you'll create some of those raccoon eye sockets that we discussed earlier. If you do it properly, you'll get a nice directional light on your subjects and really good-looking wall bounce candids (see *Figure 2*).

Typically, our camera set to f/4 or f/5.6 and 1/50 of a second at ISO 800 will pick up some of the ambient light of the room. More importantly, though, is that with the flash bouncing off the ceiling and wall, we get the additional benefit of those stray photons flying around the room and illuminating the space quite effectively, creating fill light. Check out *Figure 3*.

Granted, shooting at f/5.6 at ISO 800 gives us a pretty good flash dump with each firing of the strobe. But with all the new high-ISO cameras out there, this problem really does go away. Shooting my Canon 5D Mark II at ISO 1600 or 3200 at f/5.6 with this technique lets me get some great results I wasn't able to get before, and doesn't use much of the battery reserves.

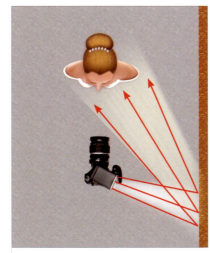

Figure 1

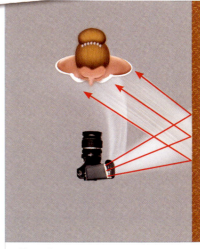

Figure 3

At this higher ISO, I'm only dumping ½ to ¼ of the amount of light that I would've with my camera set to ISO 800. Open the aperture to f/4 and you get down to ⅛ the amount of light. That means a lot more flashes per charge. We seldom go through a set of AA batteries in the course of a long wedding day, because of the high ISOs. With these brand new, stratospherically high ISO settings, I might even be able to shoot two or three weddings in a row without changing batteries. Isn't technology wonderful?

I know, I know.
Not all walls are white.
What do we do in
those kinds of situations?
Check out the next
technique, and you'll
see how I handle
walls with colors
other than white.

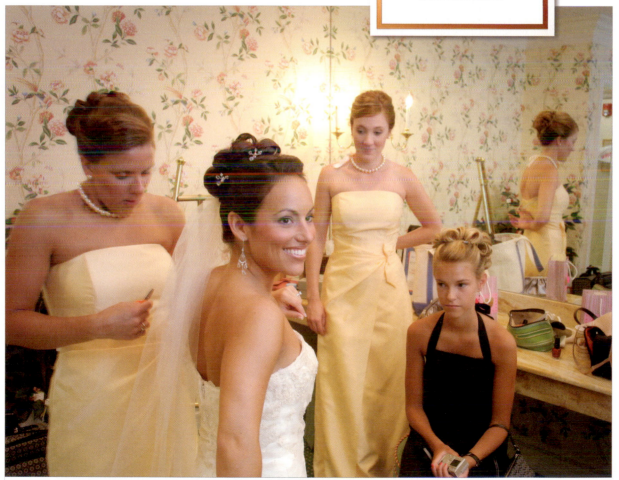

❦ *Figure 2*

Walls of a Different Color

Since I bounce my strobe lights off the walls all the time, photographers often come up to me and ask, "What happens if your walls aren't white?" Back in the film days, this was a much bigger problem than it is today. Frankly, it's even less of a problem if you shoot in RAW format. But, whether you're a RAW or JPEG shooter, let's walk through the steps to get the best results:

❦ *Figure 2*

If you shoot in RAW format, this is an easy fix in Adobe Photoshop Lightroom or Adobe Photoshop. But, if you shoot in JPEG format, it might be a little tougher to get (and keep) the best quality image.

Step Two:
So, let's set up a custom white balance for the scene. Without changing a thing, zoom in to the bride's gown, and repeat the exposure as before. Let your camera know that this is the image you want to use for your custom white balance, and set your camera's white balance to custom.

Step Three:
Now, make another exposure. Notice, this time it's much cooler than our first exposure (❦ *Figure 3*). As a wedding shooter, I'm not really happy with the camera's custom white balance setting—I think the super-neutral look is just a little too cool for wedding photography. I prefer a slightly warmer image.

Step One:
Position your subject as we've done in our earlier techniques, and adjust your camera to the best exposure for your subject and background. With your flash pointing toward a close wall, which isn't necessarily white—in this case, quite warm—make your exposure (see ❦ *Figure 1*). You'll notice that, because of the color of the wall, I got a result that is really quite warm (see ❦ *Figure 2*).

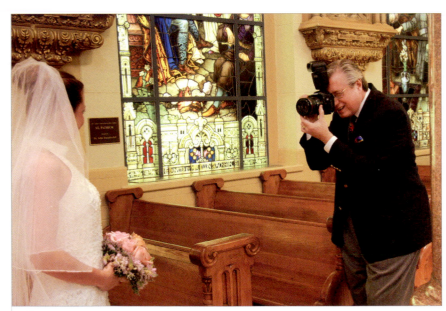

❦ *Figure 1*

❦ *Figure 3*

Figure 4

Okay, it's confession time: I tend to be a speed freak at weddings—I shoot very quickly and I'm apt to take shortcuts. So, I might find myself on auto white balance, or P for program, and I'm less apt to fine-tune the color in the heat of the moment. I just hate taking a few minutes to nail the color, since I can do it so easily in Lightroom and sync the rest of the images to the corrected image. I know that sounds like the easy way out, but for me, it's always about getting the shot first.

Step Four:

We can do that easily within our camera's menus. Dig down into your white balance menu settings to find where you can shift the color (see *Figure 4*). Notice how I've shifted the color to a slightly warmer part of the color spectrum. Once set, take your photograph again. This time, with the slight warming added, it becomes a much more pleasing image (see *Figure 5*).

Just remember, if you color shift your settings, you need to reset the camera to neutral before you continue with the rest of the day's shooting. If you don't, everything is going to be shifted to the warmer color balance and you'll have a lot of post-processing work to do.

I included this technique just to show what you can do to enhance the image. Granted, it takes a little bit more time than you might have on the wedding day, but it's still good to know. You can also pick up one of ExpoImaging's ExpoDiscs and set your custom color balance with it. If you choose to use the ExpoDisc, I recommend their Portrait warm filter. It adds just a slight bit of warmth and is perfect for the wedding photographer.

Although I'm a speed freak, I do resort to this color shift technique in locations where time is not so tight and my shooting routine isn't cramped—maybe if I'm using my wall bounce technique for several images in a room with non-white walls. In this case, it works perfectly and reduces the Lightroom/Photoshop work considerably. Anyway, it's good to know, and I suggest you practice it just a bit in case you need it in a future shoot.

Figure 5

Throw Some Photons at the Best Man: Shirt Bounce

I know what you're thinking: "But David, suppose I don't have a wall close by. Suppose I'm working in a huge church and a wall seems to be about three or four miles away. What do I do then?" Let me tell you:

The solution is simpler than you think. In the Wall Bounce #2 technique, all we did was turn our flash slightly more than 90° and bounce it off a light-colored wall. So, if you think this new dilemma through, the easy way to solve it is to find something else light-colored off which to bounce the on-camera flash.

The most likely candidate on the wedding day may just be the best man's white shirt. I know it sounds crazy, but bear with me. This technique works, it's easy to set up, and you still get a nice result. Let me show you how easy it is:

Step One:
Once again, position your subject against a pleasing background—in this case, the interior of the church.

Step Two:
Set your camera to ISO 800 or higher.

Step Three:
Be sure your camera is set to manual mode, for the reasons stated previously in this chapter. Set your aperture to f/4. Now, simply look through the viewfinder and adjust your shutter speed to a point where it underexposes the scene by one stop, using the exposure indicator in the viewfinder.

Step Four:
Have the best man take up a position to your right about six feet away and open his coat or take it off, turn your flash head 90° in his direction, and shoot away (see ✿ *Figure 1a*). Look at ✿ *Figure 1b* to see the result. Looks pretty cool, doesn't it? Notice how the bride seems to pop off the page with the ambient light underexposed by one stop.

Anyway, you can see that we get a much more pleasing light on our subjects (✿ *Figure 1c*) than we would have had we just shot the image with our on-camera flash, snapshot style. Check out the next technique for an even better way to bounce your light.

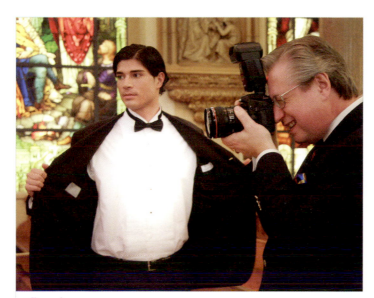

❀ Figure 1a

❀ Figure 1c

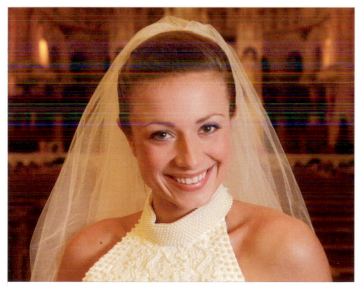

❀ Figure 1b

Hey, This Is Even Better Than a Shirt: Panel Bounce

I use the best man as my human bounce card only in rare instances—you can actually bounce a light off of anything white or light-colored (bed sheets, tablecloths, etc.)—it's just not the classy way to do it at a wedding. Instead, I prefer to carry a white collapsible panel with me. These reflectors don't break the bank and are really handy. I prefer a 42" Westcott reflector that's white on one side and silver on the other. Here are my quick, easy steps using this method:

Step One:
Determine the best location for your subject. I usually choose a location about one-third to halfway down the center aisle of the church. That gives me a beautiful view of the front of the church, and a nice composition for my photo.

Step Two:
Next, have your assistant, who should be about six feet away to your side, pop open the reflector. For some reason, I don't know why, I usually bring the light in from the right side of the subject. I've done it forever, but there is no hard or fast rule for this, so choose your own best side.

Step Three:
With your subject in position (in this case, the bride), point your on-camera flash toward the white reflector your assistant is holding. Ask your assistant to turn the reflector slightly toward your subject, so you get maximum light returned from the panel (you can see this setup in ❦ *Figure 1*).

Step Four:
Verify that your camera is in manual mode. Adjust the ambient light exposure to be underexposed one or two stops (your preference), encourage a great expression from your subject, and shoot away. Now you have a great image of the bride taken without a whole bunch of studio lighting equipment, and executed very quickly (see ❦ *Figure 2a*). It works for the groom, too (❦ *Figure 2b*).

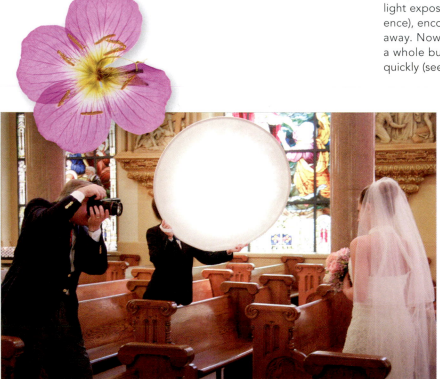

❦ *Figure 1*

❦ *Figure 2a*

⚜ Figure 2b

⚜ Figure 3a

⚜ Figure 3b

As long as it's white, it doesn't matter what you bounce your flash off. Sometimes, I even use my shoot-through umbrella (⚜ *Figure 3a*), which is often more easily accessible than my white panel, and gives me a similar result (see ⚜ *Figure 3b*). Anything you can come up with that is light-colored, preferably white, will give you an easy way to create some really beautiful portraits.

Here are a few things to remember about using panel bounce:

1 *The panel you bounce off of doesn't need to be flat. Since the surface is diffused, the photons bounce everywhere—you only need the light rays that come back and illuminate your subject.*

2 *When bouncing from panels, walls, etc., always be sure that no light coming from the flash head falls directly on your bride, or you'll lose the beautiful dimensional lighting you created (see ⚜ Figure 4).*

3 *If the image seems a bit underexposed, which doesn't happen very often with today's super-automatic cameras and flashes, increase your ISO, open your aperture, or increase the flash output from your flash until you get the desired result.*

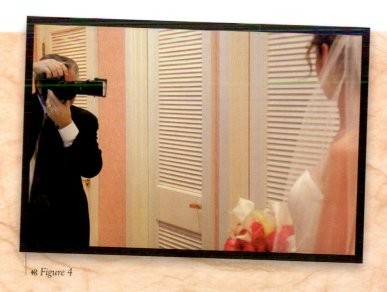
⚜ Figure 4

Balancing the Flash with Ambient Light

So far, we haven't really talked about how to balance the exposure of the flash relative to the ambient light within the wedding venue, hotel, or home. Since it's important how the exposure of the subject relates to the exposure of the ambient light, this is an important concept to understand.

If we have the subject properly exposed, but the background (the church, in this case) is very underexposed, then the church looks too dark relative to our subject and we lose the beauty of it within our composition. If the ambient light of the church is adjusted, and it's too bright relative to the proper exposure of the subject, then the subject tends to blend into the background and isn't the focal point. We have to create the proper balance to make the image sing, rather than fall flat visually.

First, we need to determine what key the church is in or, said differently, what the inherent tonalities of the church are. I've photographed in churches many times where the wood paneling is quite dark, so getting the proper exposure on the scene depends on how light or dark I want the background to be relative to the subject in my final composition. There are also times, say in a more contemporary or modern location, where the tonalities are fairly bright. In this case, I may want to tune those tonalities down so that my subject pops from the scene more effectively. Let's walk through how to balance the flash with the ambient light of the location:

Step One:

Set your aperture to f/5.6. This is what I call my "aperture of convenience." I use f/5.6 because it's easy for me to memorize the working distances I use for my off-camera flash at various power settings to get the proper exposure. (More on that in the next chapter.)

Step Two:

When shooting with flash, always have your camera set to manual mode. It's only in manual mode that you have total control over the tonalities of the scene via your shutter speed.

What happens when your camera is in program mode? The camera adjusts for the ambient light first, and then adjusts the flash output to complement the ambient light. The flash only fills as needed. This, many times, results in very flat, ugly lighting.

Step Three:

Now, with the camera in manual mode and your lens set to f/5.6, look through the viewfinder and adjust your shutter speed to a setting that shows an accurate exposure of the scene. Yes, I'm using my camera as a light meter. Take a test image. I'm assuming the exposure on the subject is correct. If not, you need to make the correction to your flash output. Is the subject blending into the background? Probably. This is because both the subject and the background are properly exposed (see ❦ *Figure 1*). But we want our subject to pop out of the scene.

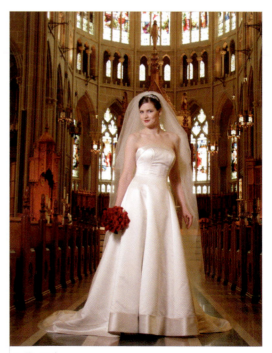

❦ *Figure 1*

Step Four:

So, increase your shutter speed one stop. Let's say our original exposure was f/5.6 at ¹/₂₀ of a second. For this next photograph, let's adjust the shutter speed to ¹/₄₀ of a second, and make another exposure (see ✳ *Figure 2*). How does it look this time? Probably a lot better, because we underexposed the ambient light by one stop and now our subject pops out from the background.

Your shutter speed will depend a lot on the key (lightness or darkness) of the background. That's why we keep the camera set to manual. Only in manual mode do we have that shutter-speed control. If you're working in a very dark location—and I don't mean one with the lights turned out, but a location with very dark wood—then you might want a shutter speed that brightens up the tonalities of the location. When in a more contemporary location (where the tonalities are more in the whites and light beiges, for example), you may want to increase the shutter speed by not just one stop, but maybe even two stops.

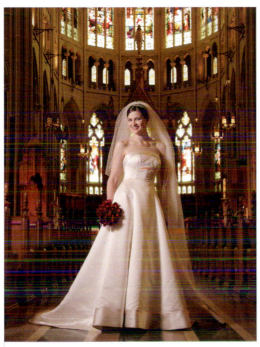

✳ *Figure 2*

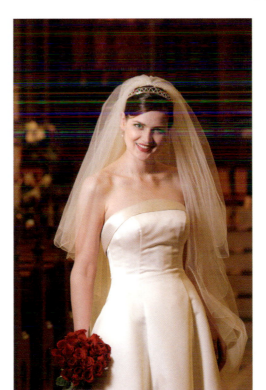

✳ *Figure 3*

Step Five:

In our third image (✳ *Figure 3*), I reduced the exposure of the ambient light by increasing my shutter speed by two stops. Notice how the subject is really popping out of the scene now, but the shadows on the shadow side of her face are going very deep and dark. In this case, we may need to fill the shadows slightly. When using an on-camera flash, you can try the judicious use of its fill flap. If using off-camera flash, you can use your on-camera flash.

(Continued)

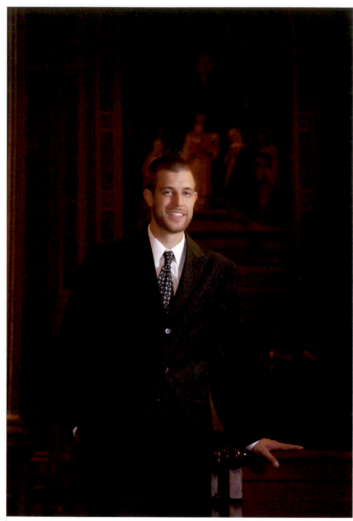

Figure 4

Step Six:

Take a look at the photograph of the groom (❧ *Figure 4*). Here, I underexposed the background by three stops. Notice how dark the background is relative to the subject—there's not much detail in it at all. I think it goes beyond what really works for this.

Also notice how deep the shadows are on the shadow side of the groom's face. Now we've really got problems—an extremely contrasty subject that no amount of Lightroom or Photoshop is going to fix. Raising the density of those dark areas will introduce way too much noise for a finished image.

This process is simpler now than in the film days, when we had to make our best guess, based on experience, to get the photograph we wanted. It's so simple these days to set the camera, take a test shot, check the LCD, and then determine which way to make the next adjustment. Making that adjustment and checking the viewfinder usually puts us in the ballpark. I have found that using my viewfinder works just fine in visualizing my finished result.

Let me raise another point here: Sometimes, even though the background is underexposed by one stop and our shot may look good, we occasionally run into contrast problems on the subject if the area of the church in which we are working (usually near the rear of the church) has most of the ceiling lights turned off. This reduces the level of ambient illumination around our subject, thus creating really dark shadows.

Some dos and don'ts for balancing the flash with the ambient light:

- *Do* make an initial exposure to see how the lighting on the subject balances with the ambient lighting of the location.

- *Do* make a few test exposures, increasing the shutter speed one f-stop at a time, and evaluate how the ambient light balances with the illumination of the subject.

- *Do* shoot around the subject, changing composition with your zoom lens, working quickly to create a whole series of images of your subject against your beautiful background, as in my series of the groom (**Figures 5a**, **5b**, **5c**, and **5d**).

- *Don't* forget to take into account the background tonalities when adjusting your shutter speed. Darker woods, when underexposed one stop, may become too dark, making the venue look cave-like. You may also find that the correct exposure was the test exposure, as determined with your camera.

So, there you have it: by varying our shutter speed, we can control the ambient light in the church—or any location—to get our best result. It's always what *you* think looks best, not necessarily what *I* think looks best. It's a matter of choice, and now you have the tools to help you make the best choice for you and your client.

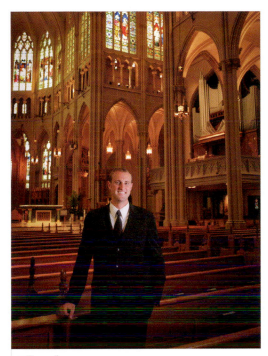

Figure 5a

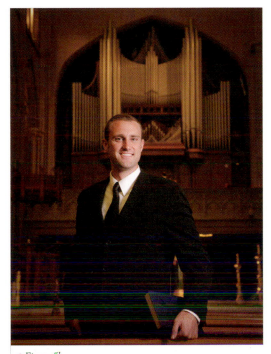

Figure 5b

Figure 5c

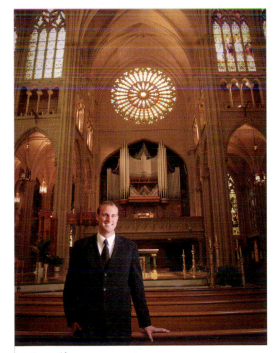

Figure 5d

Speed Racer Lighting: Zoom Flash

This is a really cool technique I stumbled upon about a year ago. I was photographing a large event in Key Largo, Florida, and wanted to get a shot of the entire room setup where the ceremony was to take place. It was outside, in a tented area, overlooking the beautiful Florida coast. I ran into a problem, and here's how I solved it:

❀ *Figure 1*

The challenge in getting a shot in this situation is that if you expose for the interior of the tent, everything outside the tent gets overexposed. Exposing for the area outside the tent obviously underexposes the area under the tent. I solved this problem by using my on-camera flash to illuminate the interior and balance the exposure for the exterior. Let me show you how:

Step One:

First, I mounted a really wide-angle lens on my camera (a 10–22mm), and then I made an exposure. Take a look at the first image here (❀ *Figure 1*), and you'll see that the interior is quite muddy.

Step Two:

Now look at ❀ *Figure 2a*. I took this photograph with the flash firing, but the flash head automatically zoomed to its widest-angle setting (❀ *Figure 2b*), because I was using my wide-angle lens. Notice how the flash really overexposed the seats and floral decor in the foreground.

Step Three:

It struck me that I could manually zoom my flash to whatever setting I wanted. So, I hit the zoom button on the back of my flash head and manually zoomed up to 80mm. By zooming the flash and creating a smaller cone of light, I could avoid the overexposure of the outside edges of the scene. I took the next photograph (❀ *Figure 3*), where you can see that the overexposure in the foreground disappeared, but now I had a hot spot in the center of the image. I zoomed too much.

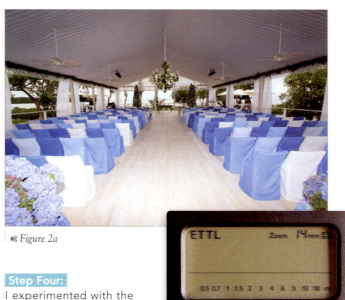

❀ *Figure 2a*

❀ *Figure 2b*

Step Four:

I experimented with the zoom amount—or, rather, the size of the "cone of light" I was creating—a bit more. I found that the 24mm setting worked just fine. My wide-angle lens was set to 10mm (a very wide field of view), but with the flash zoomed to 24mm, the cone of light I created was the perfectly balanced illumination for this shot (see ❀ *Figure 4*).

Figure 3

Figure 4

Perfect Vignettes: Using Zoom Flash for Wedding Candids

I've used this zoom flash technique at many events. I remember one wedding where the father of the bride was making a toast. I was jockeying for position in the crowded room, and somehow got stranded with my 10–22mm lens on my camera and no way to switch to a larger-zoom telephoto. Once again, the flash head automatically zoomed to the focal length of the lens, sending out a really wide cone of light, severely overexposing almost everything in the foreground, and underexposing my primary subject, the father. Here are three images where zoom flash came to my lighting rescue and I got the shot:

Image 1:

Here's the image with the father making a toast (see ✈ *Figure 1*). Notice the heads of the two people at the bottom of the frame. Had the flash zoomed to the same focal length as my wide-angle lens, these two people would be severely overexposed. I created a smaller cone of light by zooming the flash to its 80mm setting. See how the photons flew right by the two guests, without giving them much illumination at all, and illuminated the father of the bride perfectly?

Image 2:

Take a look at this image of the bride and groom responding to the maid of honor's toast (see ✈ *Figure 2*). It's the same situation as before: the centerpiece on the left would be blown out because of the large cone of light that would've been set automatically by the flash. Zooming the flash to 80mm again solved my potential lighting problem and created a great candid image.

Image 3:

Let's take it a step further. I had an idea in mind for one of my signature images. When the time was appropriate, I asked the bride and groom if they would be agreeable to getting a really cool shot in front of the country club. It was near the holiday season and the exterior was nicely decorated. They agreed, and outside we went.

Once again, I set the 10–22mm lens on my camera at or near 10mm, and framed the couple against the beautiful background. Knowing that I didn't want my flash to throw the large cone of light, because it would wash out the foreground, I zoomed it manually to the 80mm setting. Notice how in this photograph (✈ *Figure 3*) the cone of light illuminates most of the couple with no stray light falling on the foreground. This technique literally puts them in a spotlight in the scene. (Yes, my assistant holding my off-camera flash behind the subjects created the backlighting. But we'll cover that in a later chapter.) In any event, this zoom flash technique can be used to solve potential lighting problems, or even enhance the finished image for your client.

✈ *Figure 1*

Figure 2

Wrap-Up

Look at how many different ways we used our on-camera flash in the techniques in this chapter. Just by trying any of them, you can really enhance the lighting in your wedding images, and the cool thing about them is that the flash does all the work. The flash is set to ETTL (ITTL for Nikon), making it a completely automatic operation. Sure, we may make a few adjustments along the way, but they are quick and easy to do, and don't slow down the shooting process.

I suggest that you practice these techniques, because once you nail them, you won't want to settle for anything less. You will be rewarded with great-looking wedding images, and I guarantee you, your clients will appreciate the results.

Figure 3

Kicking Your Lighting Into High Gear

Off-Camera Flash Lighting Techniques

One thing I learned a long time ago is that, in the profession of wedding photography, I need to differentiate myself from the competition. One of the easiest ways to accomplish this is by doing what Uncle Harry and Cousin Mary do not do: Use a second flash. With the proliferation of wedding shooters these days, a lot of wedding photography is looking pretty much the same. The reason is that most people just use their on-camera flash as their primary light source and shoot away. Within the last year, every photographer I saw working a wedding was using just his or her on-camera flash for their primary illumination.

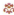

Why do we want to differentiate ourselves from the competition? The main reason is this: if I am just one of many photographers out there shooting weddings, then the primary reason my clients select me as their wedding photographer is price. But, if I differentiate myself from the competition in both style and technique, my clients will seek me out for those differences—price is no longer the primary consideration in that decision-making process. The bottom line is that you can charge a whole lot more for "differences" than you can for "samenesses." So, in this chapter, I will walk you through flash techniques that can really make your lighting look exciting and different from the competition.

You Don't Have to Break the Bank

First of all, the equipment I use is important. My most important piece of gear is my off-camera flash: a Quantum T5d-R flash head powered by a Quantum Turbo 2x2 power pack. It's fired with Quantum's FreeXwire radio control system. This is my basic setup—we'll get into my additional equipment later in this chapter.

For now, let's discuss how I add zing and sizzle to my photographs with an off-camera flash (❧ *Figure 1*). To fire it, I attach my radio transmitter to the top of my on-camera flash with Velcro. The transmitter is wired directly to the camera sync. You can see the setup in ❧ *Figure 2*.

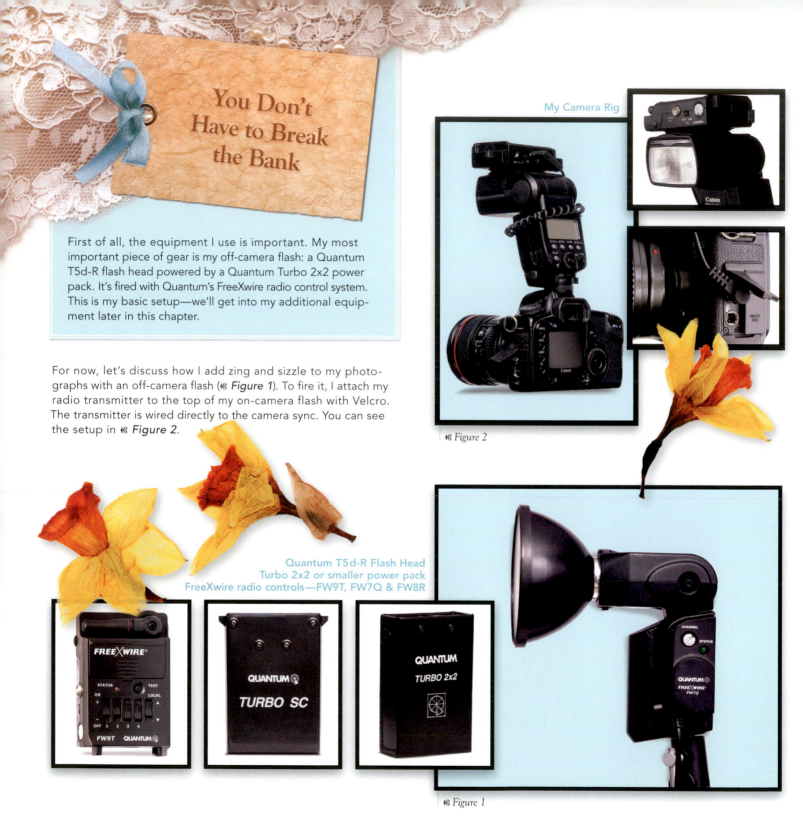

My Camera Rig

❧ *Figure 2*

Quantum T5d-R Flash Head
Turbo 2x2 or smaller power pack
FreeXwire radio controls—FW9T, FW7Q & FW8R

❧ *Figure 1*

Whenever I'm producing portraits of the bride and groom, I fire my off-camera flash through a 42" translucent or shoot-through umbrella (see ✥ *Figure 1*). The term "translucent" is important to understand. There are many white umbrellas on the market, but many of them are not truly translucent. They use a denser fabric and don't have the ability to pass the light through them as efficiently as the more translucent white umbrella I use. I always used the most inexpensive shoot-through umbrellas I could find (typically in the $15–$16 range).

Then, I asked my buddy, Tom Waltz, the owner of Westcott, if he would make me a collapsible umbrella with the very translucent Westcott Halo fabric. He finally obliged, and the Zumbrella was born. We started shooting with it in April 2009.

Since it's collapsible, we hardly ever need to take it off the monopod while shooting any of the bridal portraits. If I need my assistant's help to "floof" and straighten the gown, he just collapses the umbrella, lays it on the ground, adjusts the gown, grabs the flash again, pops open the Zumbrella, and we are off and running. Before the Zumbrella, we often damaged the umbrella because it wasn't collapsible. Not anymore—it works like a charm.

Umbrella Lighting

I use my off-camera flash in many different configurations, but this is one of the most important. We have to be sure to get very beautiful and flattering photographs of the principal players on the wedding day: the bride and groom, their parents, grandparents, additional family members, the wedding party, and friends.

The Zumbrella is available through my *Digital Resource Center*, which you can access through my blog at *www.digitalprotalk.com*.

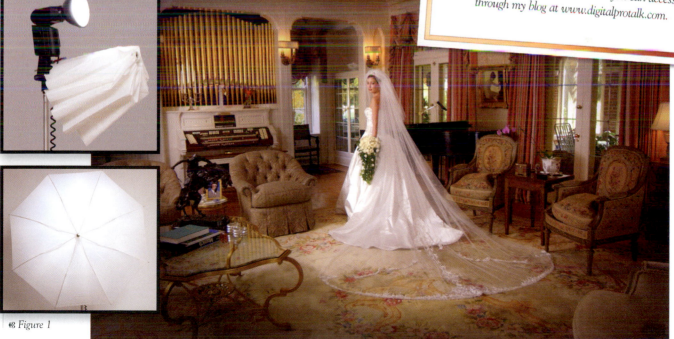

✥ *Figure 1*

(Continued)

Figure 2

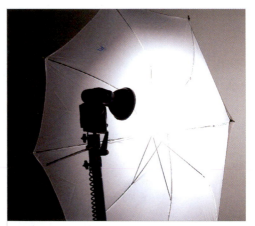

Figure 3: The flash is too close to the umbrella

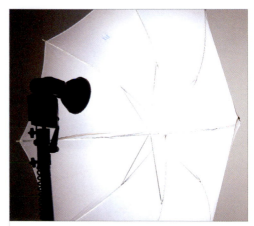

Figure 4: The flash is at the right distance

Step One:

Attach the flash head to a monopod with an umbrella adapter. I use the Bogen Manfrotto 2905 Swivel Umbrella Adapter. *Figure 2* shows a close-up of my setup.

Step Two:

Open the umbrella and insert it into the adapter. The secret is to not push the umbrella too far down the shaft. If you do, the light from the flash head won't spread out enough and will give you a very small light source (see *Figure 3*), which creates a harsh pattern on the subject. The idea is to keep the light source broad, creating a softer shadow outline. Push the shaft forward so you are at the very end of it. This lets the flash spread out across the full umbrella head area (*Figure 4*), and gives you a very soft light source on your subjects.

Step Three:

I use my Quantum in manual mode—no TTL here. The main reason is so I can more accurately control the light that's falling on my subject.

Step Four:

Each power setting represents a different radius I work from the subject. With my camera set to ISO 800, I typically set my flash to one-eighth power. My working distance with these settings is about six feet away. This means that as my assistant is illuminating the subject, he or she can be no more than a six-foot radius away from the subject.

If I want to move further from my subject to photograph them in a full-length view or capture a wide-angle shot, my assistant needs to back up so they are not in the photo. This means they must increase the power output of the flash as they move away from the subject. If the power output is increased to one-quarter power, then the new radius is about 10 feet (see the main image at the beginning of this technique).

I always shoot at f/5.6 (Figure 5), which I call my "aperture of convenience." By using a fixed aperture all the time, I can easily calculate the power settings and distances when working quickly at a wedding. Remember, the further the working distance from the subject, the greater the power output from the flash needs to be. Keeping your aperture at f/5.6 helps you pick up this technique quite quickly.

Figure 5

Keep Your Assistant in the Perfect Position

Here is another very important part of the last technique: It is my assistant's job to put a loop lighting pattern (we covered that in Chapter 2) on the subject. For me, it's always about the loop lighting pattern, regardless of the view of the subject's face—full-face, two-thirds, profile, etc. Too often, my assistant is worried about where I, as the photographer, am positioned, instead of where his or her light needs to be correctly positioned. But if your assistant can remember the following instructions, his light will be perfect every time:

Step One:

Have your assistant rotate around the subject's face, away from the camera, until they can no longer see the "camera side" of the subject's nose. I say the camera side, because that's the side that the camera sees when taking the photograph, not your assistant. If your assistant is illuminating the same side of the nose as the camera sees, then he/she will not be putting a loop lighting pattern on the subject's face, but instead, a broad lighting pattern illuminating too much of the face. Check out *Figure 1* to see what your assistant needs to see from their position.

Step Two:

This second part is just as important as the first: as your assistant rotates around the subject's face and just loses sight of the camera side of the nose, he is pretty well in the correct position. Many times, they travel further around the subject's face, creating first a Rembrandt lighting pattern and, if they continue around the subject, a split lighting pattern with very harsh shadows on the camera side of the face. They need to rotate around the axis of the subject's face until just the camera side of the nose disappears *and* they still see as much of the far side of the subject's cheek as possible.

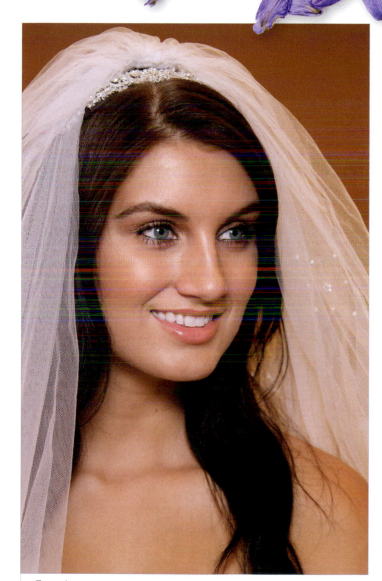

Figure 1

(Continued)

When I'm working in a particularly spectacular location and want to create a very dramatic photograph with a wide-angle lens taken from a very low vantage point relative to the subject, I sometimes have the subject lean toward me from the waist, so I don't distort them with the wide-angle lens. What's important is that because of my low vantage point, my assistant needs to lower the light—that's the only way to get the light in the eyes of the subject.

Step Three:

See what happens as my assistant rotates around the axis of the subject's face? It creates shadows on the camera side of her face (see ✿ *Figure 2*). My goal is a loop lighting pattern, but if my assistant goes too far, then the nose shadow will connect with the cheek shadow—that's a Rembrandt lighting pattern, and is often too harsh for wedding photography. When the assistant moves too far around the subject and doesn't see much of the camera-side cheek, you can see it's almost in shadow. The light was a bit high, too (notice how the eyes are starting to pocket). If my assistant continued farther, we would have a split lighting pattern on the subject's face (again, see Chapter 2 for more on the different lighting patterns).

The assistant must be aware that he or she also needs to see as much of the camera side of the subject's face as possible, and the problem is solved. We have a nice shadow cast by the nose on the camera side of the face and still have plenty of the face illuminated with our key light (✿ *Figure 3*).

Step Four:

Be sure your assistant is not holding the flash too high over the subject, either. If the light is coming in from too high an angle, it will cast the eye sockets in shadow, creating the "raccoon" look, again spoiling the beautiful portrait. The easiest way to instruct your assistant for the correct positioning of the light is to tell them to keep the light slightly above the level of the subject's eyes. That will guarantee the proper light direction about 99% of the time.

✿ *Figure 2*

✿ *Figure 3*

Loop Lighting Is Your Friend

It's important to keep the lighting consistent from image to image. That's why I resort to a loop lighting pattern about 95% of the time. As I said before, this is about the most flattering light we can place on our subjects, and as long as your assistant follows the instructions I outlined earlier, you should be able to nail the loop lighting pattern every time.

There may be times when you want a more dramatic lighting pattern, and that's just fine, but I'm really stressing the fact that we stick to the loop lighting pattern for most of our images. So, here's a quick list of dos and don'ts when using your off-camera flash with a shoot-through or translucent umbrella to get a loop lighting pattern:

- *Do* push the umbrella shaft as far forward as you can, without it coming out of the adapter, so that you get the greatest spread of light.

- *Don't* push the umbrella too far down the shaft in the umbrella adapter. The resulting light spread will be too small to adequately flatter the subject.

- *Do* memorize the various power settings and respective distances for the correct exposure on your subject.

- *Don't* let your assistant forget that as you reposition your subject, his/her working distance with the flash needs to be consistent with the power setting on the flash. If your assistant changes his/her working radius to the subject and doesn't make the corresponding adjustment to the flash power setting, it changes the exposure on the subject. Always have your assistant work at the same radius to the subject to assure consistent and accurate exposures.

(Continued)

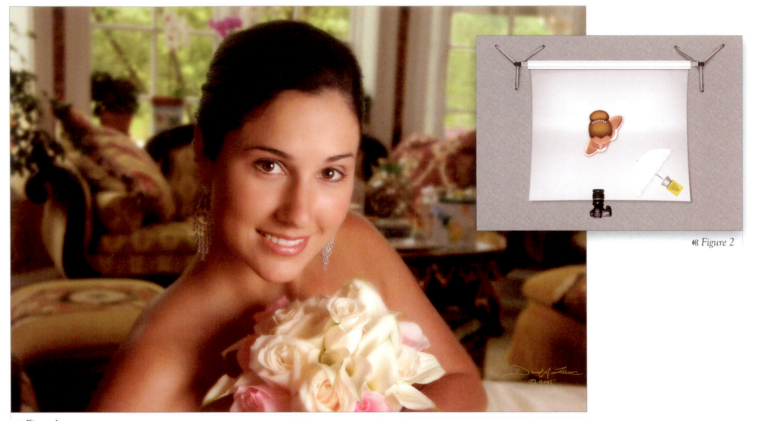

Figure 1

Figure 2

> *Do* make your assistant practice the proper lighting position and emphasize where he or she needs to be to see the camera side of the face, but none of the camera side of the nose.

> *Don't* have your assistant rotate around the subject too far. If he/she doesn't see the camera side of the nose, but can't see much of the camera side of the subject's face, then he or she has gone too far.

> *Do* stick with the loop lighting pattern when illuminating your subject.

Take a look at this first image (*Figure 1*). It's a simple, but still beautiful bridal portrait taken just moments before she was to leave home for the ceremony. I basically had five things to consider in making this photograph: the setting of the scene, the lighting on the subject, the ambient light, the exterior light, and any expression of the subject.

Step One:
First, I quickly surveyed the scene to see how my bride might work in the composition.

Step Two:
Then, I evaluated how much daylight was coming in the windows in the background.

Step Three:
I determined my aperture should be f/5.6 (my aperture of convenience), and selected a shutter speed that would be fast enough to maintain the detail of the foliage outside the picture window in the background.

Step Four:
Then I positioned the bride on the sofa and placed her in what I'll call the bottom-left quadrant of the scene.

Step Five:

I asked my assistant to bring the light in from the right-hand side to illuminate her face (see ✻ *Figure 2*).

Step Six:

The positioning of the lighting was important in order to get the most flattering light on her face. My assistant, using my off-camera flash shot through an umbrella, was positioned to the bride's right, and could no longer see the camera side of her nose, but could still see plenty of the far side of the her cheek.

Step Seven:

Since the flash exposure is independent of the shutter speed, I was able to use the shutter speed to balance the ambient light in the room and the illuminated foliage outside the picture window in the background with the flash exposure on my subject.

Step Eight:

Once things were set, I took several images, ranging her expression from a soft, subtle smile to a big grin, giving me plenty of variety for when I presented them for her final selection (see ✻ *Figures 3a*, *3b*, and *3c*).

✻ *Figure 3a*

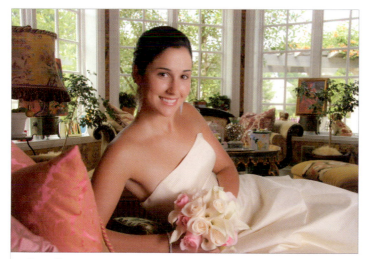

✻ *Figure 3b*

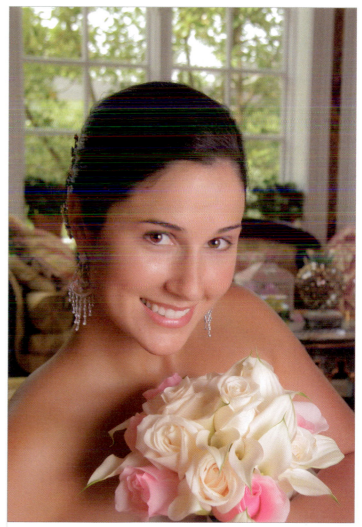

✻ *Figure 3c*

Shooting Without the Umbrella

Shooting without the umbrella in place is pretty much like shooting with it in place, as far as determining your exposure and the proper location of your off-camera flash. When do I not to use the umbrella with my off-camera flash? Sometimes, when working with very large groups, my assistant is at a distance that is far from the subjects, and the light output from the umbrella/flash combo is not strong enough to carry the distance.

The umbrella soaks up two stops of light intensity when the strobe fires through it. That means when we shoot through an umbrella, we only deliver one-quarter of the amount of light to the subject vs. using the strobe without the umbrella. So, there are many times when I decide to not use the umbrella with my off-camera flash unit. Here's my quick list:

❀ When I'm photographing a large group where the flash simply needs to be at a greater distance from the subjects (❀ *Figure 1*).

❀ When I'm shooting outdoors where the flash needs to be a good distance from the subject(s), say 25 feet (❀ *Figure 2*).

❀ When I need maximum light output because of a bright, sunny day. Removing the umbrella delivers two more stops of light, giving me maximum light output from my flash (❀ *Figure 3*).

Any time I'm shooting regular wedding candids, I shoot the off-camera strobe without an umbrella attached. This is particularly true in the case of wedding receptions, where using the umbrella would be way too conspicuous.

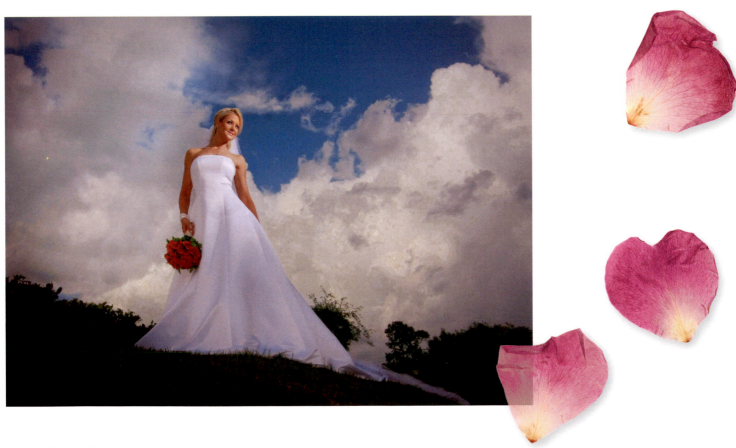

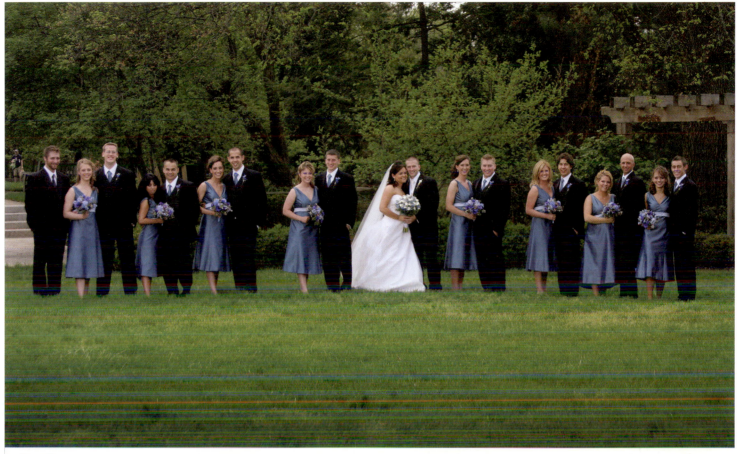

Figure 1

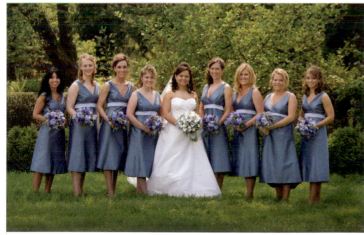

Figure 2

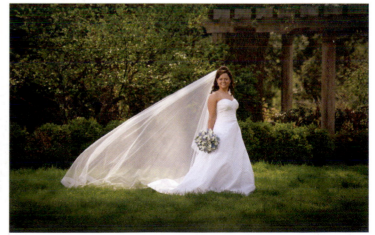

Figure 3

Shooting Large Groups

When shooting groups with an off-camera flash, particularly large groups at a wedding, you need to pay attention to how the shadows are falling from one group member to the next. You don't want anyone to wind up in the shadows.

When working with large groups, my assistant is typically to my right at an angle of about 25° around the group from me. Let me rephrase that: if we consider the center member of the group at the middle of the face of a clock, and we consider me, the photographer, at the six o'clock position on the clock, my assistant is positioned at four o'clock or eight o'clock (see ✦ *Figure 1*).

Here's the slightly tricky part: if I have a large wedding party or family group, I try to pose them in what I call a "shallow" group—one where the people are posed no more than two or two-and-a-half people deep (see ✦ *Figure 2*).

The problem arises when we pose a larger group, say four people deep. When we bring the light in from the side, we may produce serious shadows from the group members in the foreground that fall onto the group members standing behind them.

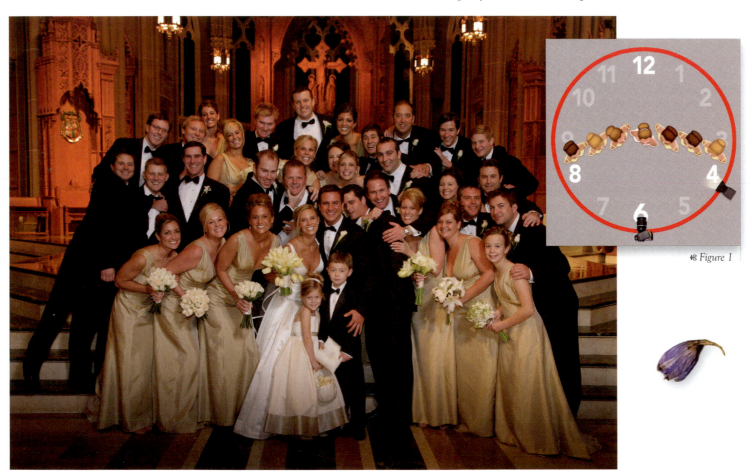

✦ *Figure 1*

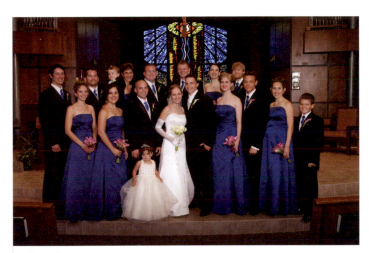

Figure 2

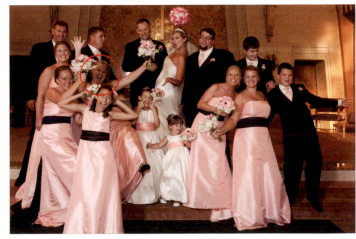

Figure 3

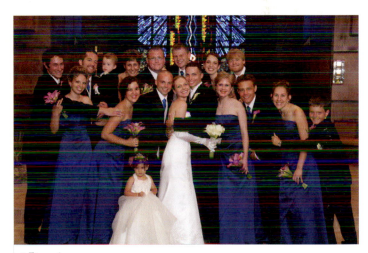

Figure 4

It is important that my assistant, from his/her lighting position, can see every single face in the group in its entirety. My assistant must constantly be aware that if he or she can't see one of the faces in the group (or can only see part of a face), then he or she will be throwing a shadow on that person. Check out the wedding party acting a little wild in ᨠ *Figure 3*. See how the one bridesmaid (circled in red) was caught in the shadow? This shot is more the exception than the norm, but be sure your assistant can see all the faces. It'll save you tons of time in Photoshop trying to save the shot.

Protect yourself against those instances when you might have a shadow problem. I set my on-camera flash to 1²/₃ stops less light than the off-camera flash, so that the on-camera flash supplies reduced illumination to the shadows. This creates a nice ratio with the off-camera flash, giving me a roundness and depth to the scene (see ᨠ *Figure 4*).

To ensure that we don't have any major problems when shooting large groups, I use my on-camera flash as a fill flash in E-TTL mode (on my Canon, i-TTL for Nikon). I could just use the ambient light to create a fill, but the ambient light in a church is generally much warmer than my off-camera flash, therefore the shadows will be warmer looking when compared to the highlights.

Posing Groups

This is one of the most critical parts of the wedding shoot. You have to get everybody together quickly, be able to pull the different groups together efficiently, get perfect exposures and great expressions, and do it all while everybody is ready to party.

Here's how I pose the wedding groups quickly and efficiently:

Step One:
Pose a shallow group (❧ *Figure 1*). You can actually get people at three levels when posing a group. If steps are unavailable, then these levels are standing, seated in available chairs, and kneeling on the ground.

Step Two:
Have your assistant positioned at the four o'clock or eight o'clock position on the clock (the group will be at the center of the clock face).

Step Three:
Be sure your assistant understands—this is really important—that he or she needs to see every single face in the group. If your assistant can't see all the faces, be sure that you are notified immediately,

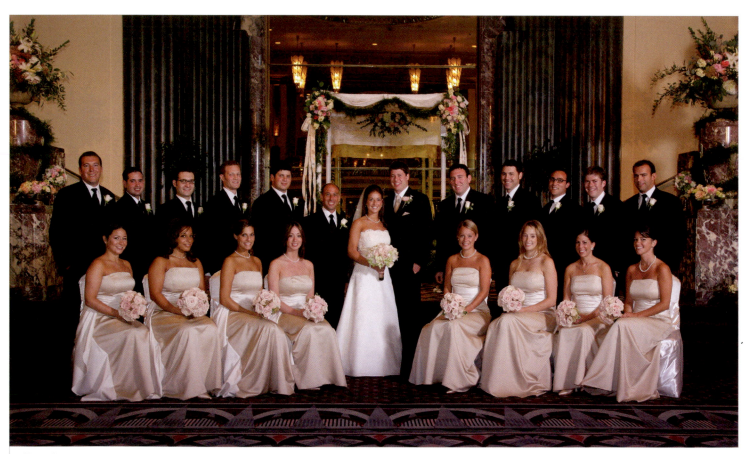

❧ *Figure 1*

so you can reposition people in the group who may be shadowed. Remember, we need to have everyone in the group fully illuminated.

Step Four:

Have your assistant point the off-camera flash *not* toward the center of the group, but slightly left of center if he/she is standing in the four o'clock lighting position (☞ *Figure 2*). If they are positioned at eight o'clock, then the light is feathered slightly to the right of center.

We do this because the illumination falling on the right side of the group will be brighter than the illumination falling on the left side of the group. Why? Because your assistant is closer to the right side of the group than the left side. So, we "feather," or direct, the light a bit more to the left of center, which causes the light to fall off in intensity ever so slightly on the right side of the group and still carry effectively to the left side of the group. This evens out the illumination across the entire group, as seen in Figure 1.

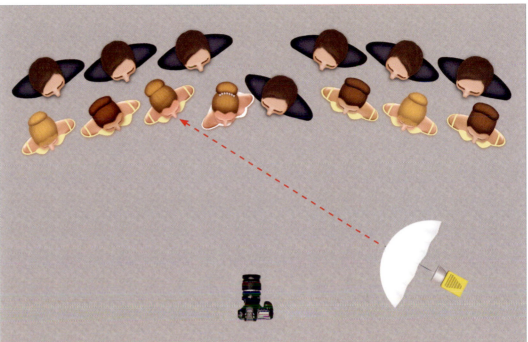

☞ *Figure 2*

Step Five:

After setting up the lighting, I want my assistant to remain in the same location while I finish all the group photographs. Things happen too quickly on a wedding day, so just nail the flash position down, and the exposure will stay the same. Then, move the groups in and out of position.

Step Six:

To save time in establishing the proper exposure for my group photographs, I make several test exposures as a group is coming together. That way, when everybody is ready, my lighting and exposure are perfect, and I can shoot quickly through the series. Never have the group wait for you to fuss with getting the exposure right. Be prepared, be professional, and work efficiently and correctly.

Controlling
the Contrast

There are times when I'm trying to create beautiful images of the bride and her gown, and the lighting doesn't fully co-operate. This often happens while photographing near the back of the church. Here's how I handle it:

If the lights at the back of the church aren't turned on, I don't get much fill from the ambient light (see ✿ *Figure 1*), so I have to add some supplemental fill with my on-camera flash. But, I don't want the on-camera flash to overpower the beautiful direction of light from my off-camera flash, so I dial down the power output for my on-camera flash. I determine the amount of fill light by how the test photos look on my camera's LCD after the flash adjustment. A good starting point with my Canon 580EX II is typically about $1^{2}/_{3}$ stops less light than the default setting. Look at ✿ *Figure 2* to see what my flash settings look like.

Over-filling the shadows will give you the not-so-great-looking result you see in ✿ *Figure 3*. Take a look at the next photograph (✿ *Figure 4*). You can see here that the finished result is much better with the proper fill light illuminating the scene.

When adding an on-camera fill light and rotating the camera to a vertical position, be sure you don't cast any "ugly" shadows on the background (rotating the camera places the flash to the left or right of the lens). If you do need to rotate your camera, make a test exposure and check for shadows on the background.

Generally I'm working in a large church and the background is pretty far away. The ugly side shadows, many times, will blend in with the church background and are not a big problem. Still, be aware of them. If I'm working in tighter locations, closer to a wall, the side shadows will definitely rear their ugly head, which means I've got big Photoshop problems on my hands. Instead, I look for open areas where the shadows will tend to fall off unnoticed. As you can see, the addition of the fill flash improves the image substantially, as shown in ✿ *Figure 5*.

My best advice is to always know how the shadows are going to fall on the background, should you decide to turn your camera sideways with an on-camera flash. (I've got a whole section on this topic later in the book.)

✿ *Figure 2*

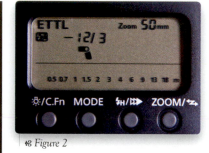

✿ *Figure 1*

✿ *Figure 3*

I've never been a fan of flash brackets, especially flash brackets with all the rotating contraptions. With all those robotics in front of my face, I think I look more like robo-photographer than a wedding photographer. I prefer to have as much eye contact with my subjects as I can, without the distractions of camera equipment.

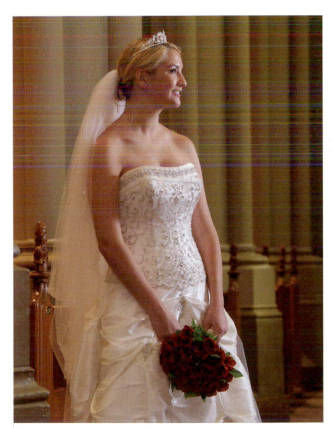

Figure 4

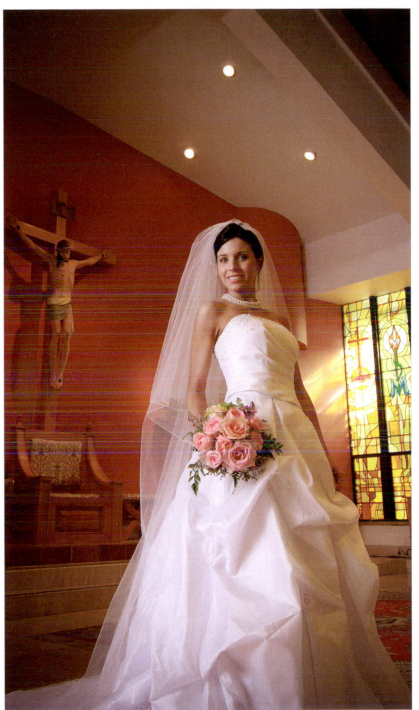

Figure 5

Major Wall Bounce

In Chapter 3, I discussed how I use my on-camera flash, rotating the flash 90°–120° to bounce/ricochet the photons off the wall. There are times, though, when the on-camera flash doesn't have enough "oomph" to get me all the light I need to illuminate the scene. So, why don't I just shoot through my umbrella? Sometimes, in very close quarters, the umbrella can actually be a hindrance, because my assistant can't get far enough out of the scene and the lighting gear may show up at the edge of the image.

That was the case in ✥ *Figure 1*. As I was trying to bring my off-camera flash in from my left to give me that beautiful direction of light on my subject, my assistant wasn't able to back up far enough and the umbrella was still within my wide-angle view.

The simple and quick remedy was to have my assistant remove the umbrella and rotate the flash 180°, pointing it directly into the corner at the white wall (see ✥ *Figure 2*). Hitting the white wall gave me a nice, widely spread source of illumination, bouncing back toward my subject, and giving me a very large, soft, white light.

It emulates the direction of light I would have with my umbrella in place to create my beloved loop lighting—the light falling on the subject was the same quality and direction, giving me the beautiful result you see in ✥ *Figure 3*.

Let's take a look at another example: One of my favorite places to photograph is at The Phoenix, a popular reception venue in Cincinnati, Ohio. Built in 1893 by renowned architect Samuel

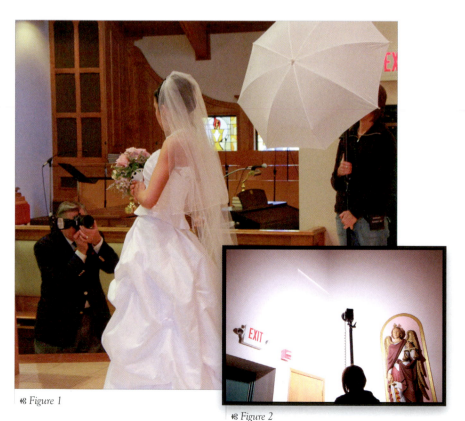

✥ *Figure 1*

✥ *Figure 2*

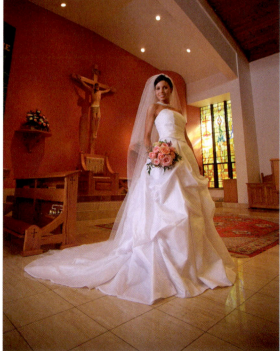

✥ *Figure 3*

Hannaford, it's a fine example of Italian Renaissance architecture, and provides an elegant turn-of-the-century ambiance with its magnificent staircase (✿ *Figure 4*). Brides and grooms love this location because of its incredible architecture, and the staircase gives us the opportunity to create beautiful compositions.

When working at this location, I know I'm always going to be bouncing my off-camera flash off the wall to my right for several photos, because of the size of the space that I need to capture. It's also important that I have a very soft light illuminating the bride when I position her on the staircase. Sure, I could use an umbrella, but when using it at this larger distance, the lighting isn't going to be as soft on the subject. Here are the steps I follow when photographing my subject in this type of location:

Step One:
Position the subject—in this case, the bride—within the scene in a way that allows for the best composition (✿ *Figure 5*). By the way, there is an entire chapter on composition coming up (Chapter 7).

Step Two:
Now, I have my assistant position the flash so that he/she can't see the far side of the nose, but can still see plenty of the far side of the cheek (we've discussed this many times already).

Step Three:
We have three choices for illuminating our subject: The first choice is with the flash pointing directly at the bride. This would be my least favorite choice, because of the harsh lighting and the distracting shadows that would be cast throughout the scene. The second choice is to shoot through the umbrella. But, in this case, with the umbrella about 15 to 20 feet away from the subject, the softening effect is not so evident.

✿ *Figure 4*

✿ *Figure 5*

(Continued)

Bouncing the light like this creates a very beautiful quality of light on your subject. The large light source also illuminates the rest of the scene. You only need to balance the ambient light appropriately with the light bouncing off the wall to produce some stunning images.

Step Four:

Our third choice is best. My intent is to create a "wall of light" to illuminate my subject. With my assistant in the optimum position, I have him/her remove the umbrella and turn the flash 180°, pointing toward the light-colored wall and maintaining a 5- to 8-foot distance from the wall. Now when I fire the flash, it emulates the same direction of light I had with my umbrella, and creates a very broad, directional light ricocheting from the wall and illuminating my bride. You can see how big the reflected light source is in ✿ *Figure 6*. This is a great way to get beautiful directional light on your subject.

Step Five:

It's at this point that we can explore many compositional possibilities within the setting. Try some close-up telephoto images (see ✿ *Figure 7*), and even back up and try to do some wide-angle images, as well (see ✿ *Figure 8*).

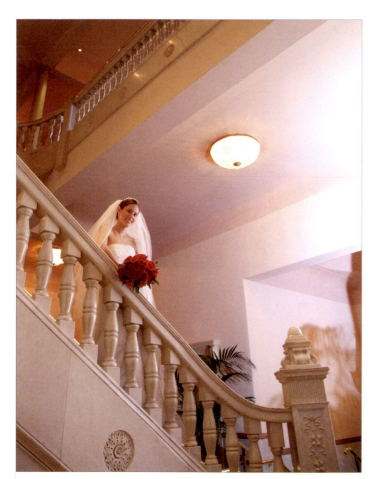

✿ *Figure 6*

✿ *Figure 7*

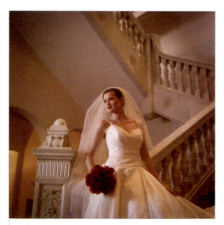

✿ *Figure 8*

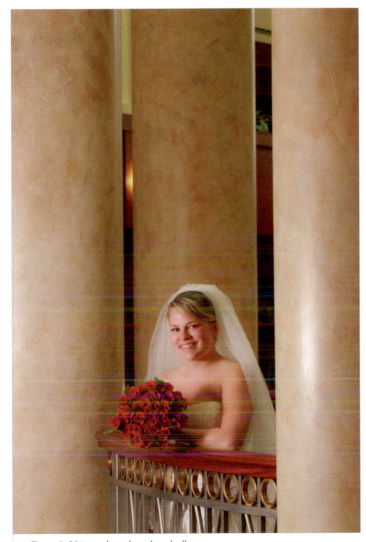

⚙ Figure 1: Using a shoot-through umbrella

⚙ Figure 2

Hollywood Lighting

I love this lighting technique. I call it Hollywood lighting, because it mimics the lighting that famous photographer George Hurrell used when photographing Hollywood stars in the '30s and '40s. Simply stated, he created a small cone of light to illuminate his subject's face, thereby isolating the individual from the darker surrounds—like putting a spotlight on the subject, but the spotlight never fell off onto the surrounding scene. Consequently, the result gives us a clearly defined illuminated area of the subject, drawing the viewer's eye directly toward the essence of the portrait—the face.

While Mr. Hurrell worked in a large photographic studio with assistants to carry all the lighting gear on location for shoots, we, as wedding photographers, can create the same type of lighting. How can we do it quickly and easily on the wedding day and still get the same great result? Let me show you:

Step One:
Find a nice setting for your subject, in this case the bride. The setting should complement the final image, and could be the bride's home, a hotel suite, or even the church.

Step Two:
Now, just for fun, let's illuminate the bride with our shoot-through umbrella flash technique (⚙ *Figure 1*). Notice how the flash has illuminated the entire surroundings, as well. It's a nice image, but let's see how the "feel" of the image changes with Hollywood lighting.

Step Three:
For our Hollywood lighting, first we need to create a very small cone of light to illuminate the subject. We're going to do this by simply rolling up a magazine, pulling off the reflector for the off-camera flash, and wrapping the magazine around the flash tube (see ⚙ *Figure 2*).

(Continued)

Step Four:

Set your camera's aperture to f/5.6, and the shutter speed at a value that will underexpose the ambient light at least one stop. You may have to fiddle with the power settings on the strobe to get the exposure correct on the subject. As I mentioned in Chapter 3, I use my Quantum flash on manual for just this reason—the ability to dial in the light to its proper exposure.

Step Five:

Now have your assistant point the flash/magazine combo at the subject very precisely, so that that small cone of light falls only on the subject's face. This is a great lighting technique for spotlighting the illumination (see ₫ *Figure 3*).

Step Six:

Because we're working with such a small cone of light, your assistant's aim is critical. Remember the big rule, too: you want a loop lighting pattern on the bride's face, so your assistant needs to rotate around the subject, so that the camera side of the nose cannot be seen, but most of the far side of the cheek is still visible.

Step Seven:

The assistant also must be aware that he/she is not throwing the subject's shadow on any of the surrounds that may be included in the image area. Actually, the moment I take a photograph, I can tell if my assistant was in the right location or not.

Figure 4a

Figure 4c

Figure 4b

Step Eight:
Now, adjust your shutter speed to control the exposure of the ambient light of the scene. I happen to be a big fan of underexposing the rest of the scene by about 1 to 1½ stops. Again, you may have to fiddle with it a bit to get the result you are looking for (see *Figures 4a*, *4b*, and *4c*).

By the way, I haven't discussed much about power settings, because so much depends on the distance of the assistant to the subject, the ambient light, how tight the magazine is rolled, and so many other factors. As we're setting up a shot, I'll simply give my assistant a couple of educated guesses for the power setting on the flash, and quickly make my adjustments along the way to nail the exposure.

Done right, this technique can give us some really cool results that are completely different from what we normally see in wedding photography.

Cheating the Sync

Here, we're going to talk a little bit about native sync speed and how to use it to our advantage.

All cameras that we use come with a set native sync speed. Native sync speed is the fastest speed at which the camera can sync with the flash. The native sync speed, for example, of a Canon 40D/7D would be $1/250$ of a second. The maximum sync speed of the Canon 5D and 5D Mark II is $1/200$ of a second. Nikon is running at $1/250$ of a second, as well.

What this means is that when the shutter is set to $1/250$ of a second, the CMOS sensor is fully exposed to the flash. The shutter curtains are fully opened, revealing the entire CMOS sensor at the moment of exposure (see ❀ *Figure 1*).

Let's say I increase that shutter speed to $1/320$ of a second. Now the CMOS sensor isn't fully exposed, as the shutter curtains cover part of the sensor during the exposure (see ❀ *Figure 2*). So, what happens here is that the bottom half of the CMOS sensor is all in darkness. That's not the reality, actually, because when I'm making my exposures, I have another light source illuminating the scene.

The other light source would be the ambient light. With it still hitting the CMOS sensor during exposure, the bottom portion of the CMOS would not be completely unexposed, but would still receive some illumination from the ambient light, thereby not fully darkening the sensor but making it look more like it does in ❀ *Figure 3*.

Since we know that only the top two-thirds of the image is going to receive flash exposure and the bottom one-third receives only the ambient light, we should really be able to have this work to our benefit. We can use this to our advantage outdoors when we need to be working with faster shutter speeds, so we can put a directional light on our subject.

I'm going to be using my Quantum flash. The Quantum flash doesn't talk Canon talk or Nikon talk in this situation. I'm using the Quantum radio transmitters, Quantum receiver, and the flash itself. So, let me walk you though my process of "cheating the sync."

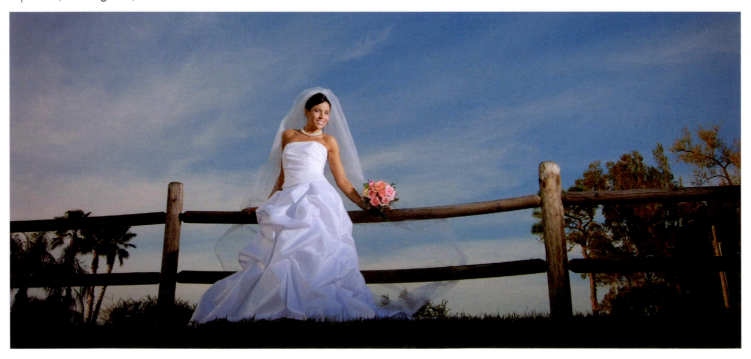

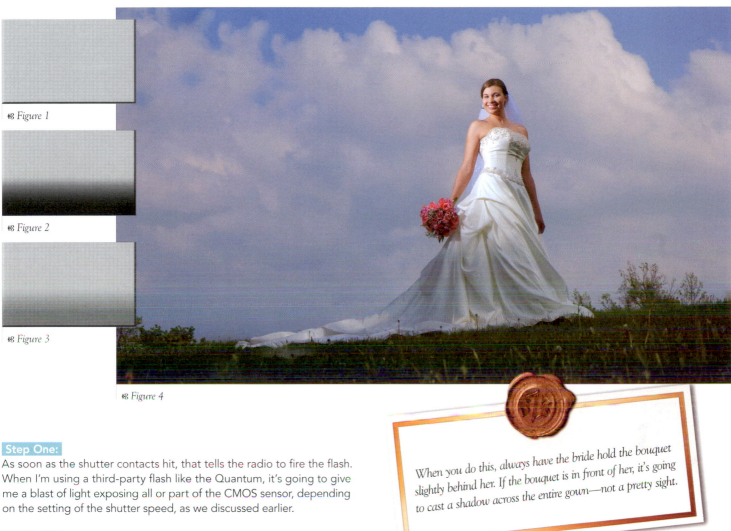

8 Figure 1

8 Figure 2

8 Figure 3

8 Figure 4

Step One:

As soon as the shutter contacts hit, that tells the radio to fire the flash. When I'm using a third-party flash like the Quantum, it's going to give me a blast of light exposing all or part of the CMOS sensor, depending on the setting of the shutter speed, as we discussed earlier.

Step Two:

To reap the benefit of this technique, select ¹/₃₂₀ of a second. This means that on my Canon 40D/7D, the top two-thirds of the CMOS sensor will be exposed to the flash, as shown in Figure 2.

Step Three:

Knowing which part of the sensor is exposed is important. The easiest way to determine that for your particular camera is to point your camera at a white wall with a shutter speed faster than the native sync speed and see which part of your LCD screen goes dark. Now just be sure to keep the subject out of that part of the image area.

When you do this, always have the bride hold the bouquet slightly behind her. If the bouquet is in front of her, it's going to cast a shadow across the entire gown—not a pretty sight.

Step Four:

I'm going to have my bride in the top two-thirds of my image area. The flash is going to illuminate her from my left side, lighting her face and approximately two-thirds of her body. The bottom one-third of the image (the bottom of the gown here) will have a slight vignette, or be slightly darkened, because we aren't going to have any flash exposing it (*8 Figure 4*).

(Continued)

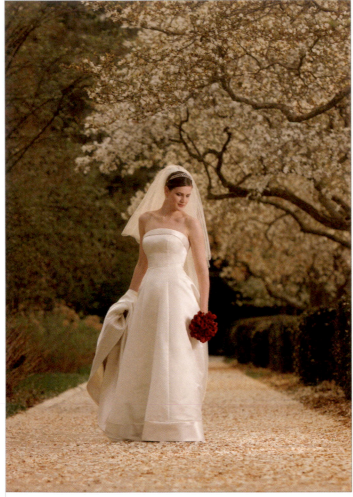

Figure 5

Figure 6

Figure 7a

Step Five:

You'll notice that, from about the knees up, the bride is receiving the exposure from the off-camera flash at this $\frac{1}{320}$ of a second exposure. But from the knees down, and into the grass, there's no flash illumination. This gives us a nice vignette on our bride with a beautiful direction of light.

Step Six:

You can use a higher shutter speed to darken the sky on a bright sunny day, but remember, less of the CMOS sensor will be revealed during the flash part of the exposure. That means you really have to be careful as to where you position your subjects in the viewfinder.

Step Seven:

Let's take a look at a couple more images. Here is another example (*Figure 5*), where I've shot at $\frac{1}{400}$ of a second. You don't see the light fall off as much in this example. Why? Because the camera was oriented vertically and the bride was in the "flash sync" part of the viewfinder.

Step Eight:

Look at *Figure 6*. It's a great shot, with the light falling off nicely, giving me exactly what I want. But you might say, "David, I want the bride and groom to be fully illuminated. I don't want that fall-off. I think it looks cool and everything, but I want full illumination

over the whole scene. How do I do that?" Good question. How do we pull it off?

Step Nine:

The easiest way to do that is to—pay attention now—turn your camera upside down. That way, when you take the photo, your subjects will be in the "flash sync" area of the viewfinder, which happens to be the top section of the CMOS sensor (see ❧ *Figure 7a*). Pretty cool, eh? Then rotate the image 180° in Photoshop to get the shot you envisioned.

Notice how when we flip the image back upright (❧ *Figure 7b*), we can see that the subjects were completely in the "flash sync" area of the viewfinder. You can't even see the light fall off because the flash is completely exposing the subject area of the image. Figure 6 is probably my preferred image— the light gradually and ever so slightly falls off the couple, creating a slight vignette, and bringing the viewers' attention directly to them. But, if you do want the entire subject illuminated, rotate the camera, and shoot away.

❧ *Figure 7b*

What if…? Sometimes we need to ask ourselves the question, "What if I try this, or what happens if I try something different?" This was my first attempt and I was really happy with the result. An amazing benefit we have with digital is the ability to experiment without out-of-pocket costs to ourselves. It allows us to challenge ourselves, to play, to explore, to test ideas. So, ask yourself, "What if…?"

Let's take a look at the first time I tried this technique (❧ *Figure 8*). I remember wondering, "What if I just increase the shutter speed? Is my camera going to blow up if I use a flash sync higher than what the manual stated?" My camera didn't blow up, and I was really happy with the result. This Cheating the Sync technique takes a little practice, so how about starting today?

❧ *Figure 8*

Adding Color Gels to the Flash

Here is another technique that gets very little discussion in any of the photography books, especially wedding photography books: adding color gels to your on- or off-camera flash. I'll walk you through four scenarios and the methods of determining why and when you may want to add color gels to your strobes while photographing an event.

❧ *Figure 1a*

First Scenario

I first experimented with the gelled-flash technique several years ago while photographing party interiors for an event planner friend of mine. My friend asked me to photograph the room setups he designed at a large hotel for a major corporate client. I thought it would be an easy assignment, so I just grabbed my camera and headed for the hotel. I thought I would mount my camera on a tripod, set it to tungsten color balance, and shoot away.

Well, the hotel banquet room had been transformed into an amazing vision. It was magnificent. Sea grass replaced carpeting. Soft sofas and settees replaced many of the tables and chairs. White sand, shells, and a color palette of pale blue, camel, beige, and off-white invited the corporate attendees to a tropical oasis in the middle of downtown Cincinnati.

My lighting challenge was that the illumination throughout the room was not totally balanced. Nevertheless, I set my camera on tungsten mode and started making some exposures (see ❧ *Figure 1a*). Because of the lack of uniform illumination, the foreground of many of my photographs was dark and underexposed. Here's how I handled the situation:

Step One:

The foreground needed added illumination, and I did have my camera fitted with my on-camera flash, but the on-camera flash would add a blue cast to the scene, since the camera was set to tungsten mode.

Step Two:

What if I somehow turned my on-camera flash into a tungsten-flavored light source? I looked throughout the hotel for a colored piece of plastic that I could use to cover the flash head and give me light that more closely resembled the color balance of the room—no luck.

Step Three:

I happened to have a gold pocket square in my jacket pocket, so I covered my on-camera flash with it (⚜ *Figure 1b*). See? It does pay to dress up for a job.

Step Four:

Next, I rotated the gold-pocket-square-covered on-camera flash 90° toward the ceiling and ran a test. It worked perfectly.

⚜ *Figure 1b*

Step Five:

Take a look at ⚜ *Figure 1c* and you will see the improved photograph. This image is the result of two separate light sources on the scene, the first being the lighting set up by the lighting technician to illuminate most of the room, as seen in the background. The illumination on the foreground was created by my on-camera flash covered with my gold pocket square. Since the filter, in this case, was gold, it gave me a reasonably close color balance to the tungsten setting on my camera, thus balancing the lighting throughout the photograph.

I occasionally have to use a variation of this technique when shooting reception venues. I always want to get some shots of the main

room before all the guests enter. Many times, the tables are lit with pin spots—very bright lights that highlight the centerpieces (⚜ *Figure 1d*). In order to get a good shot of the room, I bring up the room lights a bit to minimize the contrasty lighting effect of the pin spots.

In some cases, because of time or technical constraints, I don't have the option of bringing up those lights, so I go to Plan B: gel my Quantum flash

⚜ *Figure 1e*

(⚜ *Figure 1e*) with a tungsten-flavored gel and bounce my own light off the ceiling. The result is a great shot of the room (⚜ *Figure 1f*).

⚜ *Figure 1d*

⚜ *Figure 1c*

⚜ *Figure 1f*

(Continued)

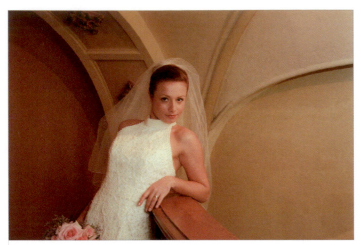

 Figure 2a

 Figure 2d

Second Scenario

After that, I started thinking about other possibilities for gelling my on-camera flash. I had a situation in which the primary illumination on the bride was a small tungsten bulb that was overhead and on her left, and provided a very contrasty light source. What if I wanted to use this as my primary light source? The problem wasn't getting my nice loop lighting on the bride, and I loved the location. The challenge was to control the contrast lighting. Here's how I did it:

Step One:

The first thing I needed to do was orient the bride's face to the direction of light. I certainly couldn't move the light, so I needed to orient the bride for the best illumination on her face (see *Figure 2a*).

Step Two:

Okay, I've got a nice lighting pattern on her face, but the contrast of the scene is quite high. I determined that I could easily rectify the situation with my on-camera flash. But, just as in the last scenario, since my camera was going to be in tungsten mode when I made the photograph, I needed to create a tungsten-flavored fill flash on the scene.

 Figure 2b

Step Three:

This turned out to be pretty easy to fix. You can pick up a sampler pack of Roscoe gels inexpensively from B&H (www.bhphotovideo.com). From the sampler pack (see *Figure 2b*), I've selected several colors that allow me a range of options when photographing a wedding. In this case, I used the tungsten orange gels.

 Figure 2c

Step Four:

The nice thing about the Roscoe gels from the sampler pack is that they are just the right size to cover up the flash head of our portable strobes, like the Canon 580EX II or the Nikon SB-800 (see *Figure 2c*).

Step Five:

Next, I pointed my tungsten-gelled on-camera flash toward the ceiling (*Figure 2d*), dialed down the power of the flash 1²/₃ stops, and ran the test exposure. Things looked good—the contrast

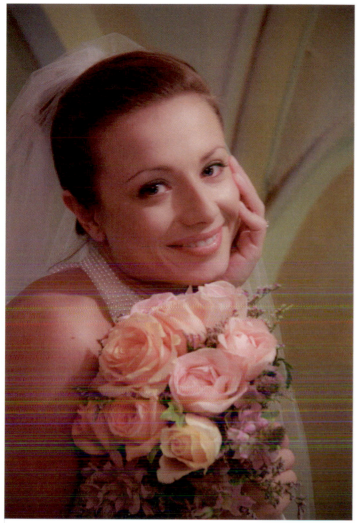

Figure 2e

Figure 3a

of the scene was right where I wanted it to be—and I was pretty happy about the shots I got (see *Figure 2e*).

Third Scenario

What happens if you're working outside on a cloudy day? Here is the original scene (*Figure 3a*). What if I change my off-camera flash into a tungsten-flavored off-camera flash by adding a gel to it, then photograph my subject (in this case the groom) with the camera set to tungsten color balance? Once again, let me walk you through what I was thinking and show you the end result:

Figure 3b

Step One:

In my mind's eye, I envisioned the color balance on the groom's face to be normal. He would be illuminated with a tungsten-flavored light source—my gelled flash (see *Figure 3b*)—and the camera would be set to tungsten to give me the correct color balance.

(Continued)

Figure 3c

Figure 3d

Step Two:

But what happens to the surrounds, especially that cloudy sky? The color temperature of a cloudy day is pretty darn blue—a much higher Kelvin setting than the tungsten color balance that my digital camera was set to capture. In my mind's eye, I thought all the surrounds would go very blue because of the extreme difference in color balance between my gelled flash and the cloudy day.

Step Three:

I took the photograph and got the great result you see in *Figure 3c*. I love how the subject is surrounded by all those blue tones. It's just another way to separate your subject from the scene, to draw the viewer's attention even more closely to the subject. What would have happened if I tried the same thing on a bright, sunny day? I don't know—never tried it. I'll save that one for my next book.

Step Four:

Here is one more image from the shoot (*Figure 3d*). This was the groom's idea. He thought it would be cool to catch him midair, jumping from the railing. Hey, what was I to do? I took the shot and loved it.

Fourth scenario:

After playing around with these gelled flashes for a while, I asked myself, "What happens if you use different color gels on the off-camera flash—say a red gel—and start aiming it at the background during a wedding reception?" Well, I gave it a try and, again, was really pleased with the results. Let's walk through my steps for this:

Step One:

I asked my assistant, with my red-gelled off-camera flash, to see if he could direct the light toward the dance floor behind a couple that was really groovin'. After a couple of tries, we nailed it. I love the final result (see *Figure 4*).

Step Two:

Now, you might be asking, "How did you keep the on-camera flash from overexposing the vibrant red color of the off-camera flash?" The answer is simple: I was using a very wide-angle lens (my 10–20mm) when I created this photograph. It was racked out pretty wide—to the 10mm setting—and was pretty close to the couple—only a few feet away—as I made the exposure.

Step Three:

The light from my off-camera gelled flash behind the subjects was much further away. Therefore, the ratio of the distance of

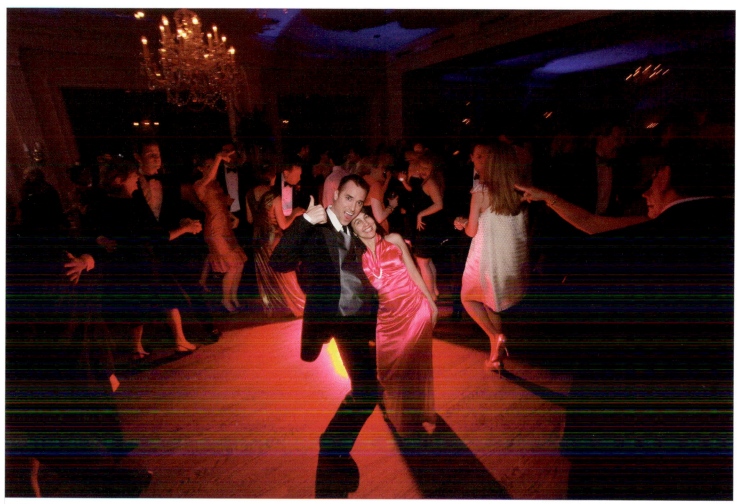

Figure 4

my on-camera flash to my subjects was much shorter than the distance from my off-camera flash to the floor behind the subjects. Consequently, the light from my on-camera flash fell off substantially before it even reached the floor, and didn't wash out the light from my red-gelled flash hitting the floor behind them.

This is a great technique for bringing a wonderful party feeling to your wedding candids/dance candids. Yes, I have many other colored gels in my bag and I am constantly trying different flavors of light.

Using colored gels is just another way to keep things interesting, fun, and exciting when photographing wedding after wedding, weekend after weekend. We owe it to ourselves to constantly strive to keep our images fresh, new, and innovative—not only for our clients, but especially for ourselves.

Bouncing Light Off the Floor

When using an off-camera flash, you can point it anywhere and get a pretty creative result. I was taking some wedding images at a local church, and as I was setting up for the shot, I triggered the camera inadvertently with my assistant out of position. The flash was resting down the side of my assistant, pointed at the floor, but when I looked at the resulting image, I really liked the light coming up from that lower direction and illuminating the bride's face. I thought, "What if I could work the accidental lighting into a pretty cool photo?" Here's how I did it:

Step One:
I composed my bride against the beautiful stained-glass window of the church, and dramatized the pose by asking her to turn toward her left, leaning on the communion rail, which was close by and a comfortable resting place.

Step Two:
Once I had the composition just the way I wanted it, I showed my assistant which part of the floor to illuminate. The reflected light needed to be consistent with the lighting pattern I wanted to place on my bride (& *Figure 1*).

Step Three:
Once we were set, I started making images, varying the composition and zooming in and out on the subject. We got some great shots (see & *Figure 2*).

Too many photographers don't follow any rules at all when making photographs, which leads to some pretty ordinary looking imagery. On the other hand, we sometimes get so wrapped up in following every single rule that we forget to play, experiment, or try something new. We need to take a chance and break those rules every now and then to see what new result can be obtained. It's really cool when it produces a result that's exciting, fresh, and sets us apart from photographers who simply follow the rules.

That's part of the fun of having an off-camera flash: we can place the light anywhere we want to create a trajectory of light coming from any direction to illuminate our subject. The results are vastly superior to what many photographers capture with their on-camera blast flash.

I know I step on a few toes when I say that too many photographers do too much of the same thing at every single wedding. If we don't shake it up a bit, then we relegate ourselves to the same low-paying wedding jobs that so many other photographers find themselves shooting week after week. So try something different, experiment, gel, get your flash off your camera, and really make the lighting sing.

& *Figure 1*

& *Figure 2*

Step One:

Have your assistant adjust the power on your off-camera flash (in my case, my Quantum T5d) to half-power.

Step Two:

Next, have your assistant move to the opposite side of the dance floor, positioned either to the right or left center of the shot, as viewed in your viewfinder—I use hand signals to direct my assistant to the correct position. This light position works best when it coincides with nodal point #2 or #3, as we'll discuss in Chapter 7.

Step Three:

Then grab a really wide-angle lens, like a 10–22mm lens, and rack that puppy out to its widest setting (10mm here). You want the widest field of view you can possibly get for this shot.

Step Four:

Frame up the scene with the revelers at the top of the image area and a lot of the dance floor at the bottom part of the image area. When your backlight fires, you'll create these wonderfully long shadows in the foreground (see ✤ *Figure 2*, where I used a Rayburst filter on my lens).

Long Dance Shadows

This is a great technique for getting a series of images that really capture the party flavor of the wedding reception. It is also one of the easiest techniques to execute. Take a look at ✤ *Figure 1*. See how the backlighting created very long shadows coming back toward the camera? The image just says "party time" and adds to the celebratory feeling of the wedding reception. Let's walk through the simple steps for this technique:

I think this shot works best when there aren't too many people on the dance floor. This typically means later in the evening, almost near the end of the wedding reception. Too many people on the dance floor means that some will be blocking the shadows of others. Separate shadows look better than a big clump of shadows—they are much more distinct and dramatic.

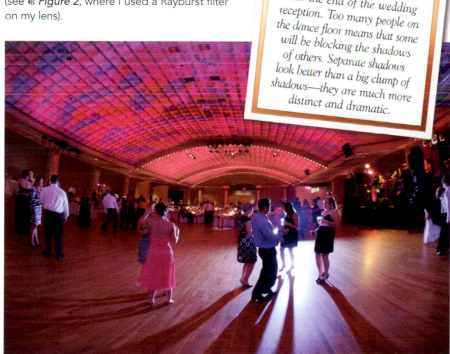

✤ *Figure 1*

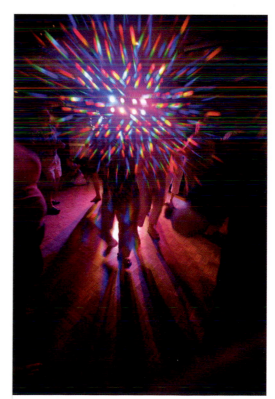

✤ *Figure 2*

Adding a Third Light at the Reception

Okay gang, this is where we separate the men from the boys in wedding photography. We talked about how most shooters just use on-camera flash as their main light source at weddings, often creating flat, unflattering images. We talked about how using a second flash can really create some dramatic lighting. So, let's pull out all the stops and really get those photos singing, let's add a third light to our setup. Its primary purpose will be to add more of an ambient light feel to our reception coverage.

In many wedding reception photos, the people in the foreground are properly exposed, but the light falls off quickly, so the guests look like they are standing in the black hole of Calcutta. Off-camera flash does a good job of creating nice dimensional lighting on the scene. But, even with two lights firing, that light still falls off over the longer distances in a large reception venue.

That's where the third light comes in. We find a suitable space for the light—in a corner, or behind the band or DJ—place it on a tall light stand, attach a FreeWire radio unit to it, set the power, and we are good to go. What kind of light are we talking about? Generally, a fairly strong studio light—about 600 watt seconds, with a fast recycle rate that lets us shoot quickly to capture all the action at the reception. There are several good ones on the market. Just be sure that they can take the rapid firing of your motor-driven DSLR without blowing the fuses on the strobe.

If you don't want to spend the bucks on a big flash unit, you can use a smaller wattage portable unit. The only reason I suggest this is because of the high-ISO DSLRs coming onto the market. We don't need nearly as much power now to light up the rest of the room. Frankly, with the new high-ISO cameras, I'm thinking I can get by with a second Quantum strobe working as my room light.

Here's a cool thing: if we shoot reception candids routinely at 1600 or 3200 ISO, that means we only need a "wink" of light from all three flashes to get a correctly exposed image. That also means our charged flash units seem to work forever on the built-in battery power, because each flash is such a minimal dump of energy.

Let's walk through the steps I take when setting up a room light at a wedding reception:

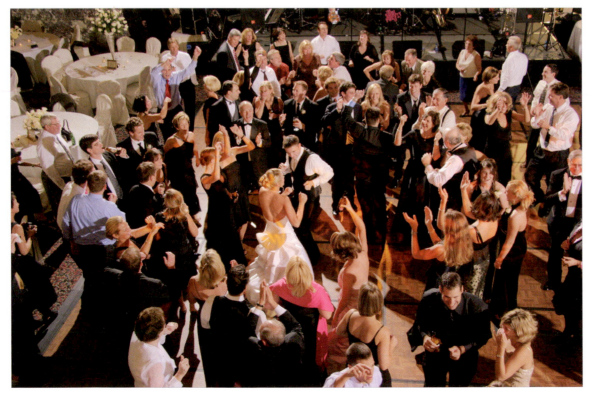

 Figure 1

Figure 2

Step One:

Take your room light—your third light source—and place it in a corner or next to one of the band's or DJ's speaker stands. With your light stand almost fully extended, point the strobe back at the center of the dance floor.

Step Two:

There are two other configurations you can use: If the room space is quite a bit smaller, you can pull the reflector off of the room light and use it in a bare-bulb configuration. The second configuration, if your room light is powerful enough, is to point it at the ceiling, spreading the cone of light out even more, and creating a nice, soft, ambient splash of light over the entire room (⚉ *Figure 1*). You need at least 600 watt seconds of power to pull this off.

Step Three:

As a safeguard, I try to keep my light stand as close to the speaker stands of the band or the DJ as I can, so that people don't bump into my equipment. A balcony is also a great spot to place the light, if that's an option for you.

Step Four:

The next step is to set the correct exposure of the room light. I do this by having my assistant stand in the middle of the dance floor, facing the room light. Then, I have him pull back or remove

his jacket, exposing his white shirt to the light as I make some test exposures (⚉ *Figure 2*). I adjust the power on the room light till I just see "blinkies" on his shirt—shown in black in Figure 2—then decrease the power till the blinkies disappear, and decrease the power setting slightly more. I want the room underexposed about a stop.

Step Five:

By the way, my preferred aperture when shooting reception candids is f/5.6. This gives me plenty of depth of field and assures a quick recycle time on all strobes—remember those high ISOs I'm using—so I never miss a shot because of a miss-fire from the strobes.

I prefer using a tall light stand (12 feet) with a broad footprint (at least 36 inches). This ensures the stability of the setup. My choice for many years has been a 12-foot stand made by Manfrotto.

(Continued)

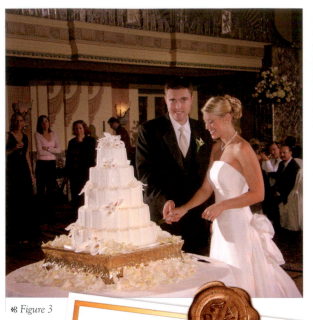

Figure 3

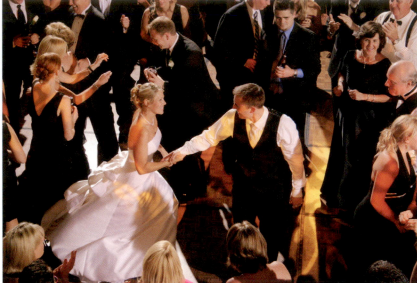

Figure 4

Why do I set the ambient light for the room at one f-stop less than the normal exposure? Because I want the room light to supply an overall feel of the lighting in the room—opening up the shadows, showing the expressions of the friends and family in the background. But, I also want the main subjects I'm photographing (the bride and groom here) to pop out of that ambient light setting (Figures 3 and 4).*

Figure 5

If the overall ambient light is just as bright as the subjects, they will simply blend into the background. But with the background slightly darker, one stop underexposed, the bride and groom (or any other subjects I photograph) will pop out of the scene because of their added brightness. Remember how we balanced the lighting at the church earlier in this chapter?

Also, look at the depth the third light brings to the scene. The way the third light accents the bouquet toss shot just adds that much sizzle and pizzazz to it (* *Figure 5*).

Step Six:

Now, let me introduce you to my "three-point lighting" concept. Imagine the face of a clock. All the action (dancing, bouquet/garter toss, cake cutting, etc.) takes place at the center of the clock face. I always define my position as being at the six o'clock position. The room light is positioned at either the ten o'clock or two o'clock position. It is my assistant's job to be in the remaining triangular position (in this case, two o'clock). So, we have created a triangular area of light illuminating the scene, and all the action takes place within that triangle (* *Figure 6*).

Since the room light is stationary, it is my job, and that of my assistant, to always create the triangular three-point lighting system. Obviously, due to the action of the wedding events and activities, I can't always be at the six o'clock posi-

tion. So, if I move to the two o'clock position, and the room light is in the ten o'clock position, then my assistant needs to move to the six o'clock position.

When considering the distances between all three light sources, we obtain wonderful light patterns and accent lights, filling the "action" space, creating exciting candids, photojournalistic images with pizzazz, images that just have a lot more punch, as well as dramatics, than the basic on-camera blast flash.

Anyway, you can see that it takes a little more effort to set up a room light at the wedding reception, but it makes a big difference in your reception candids. I've been doing it for most of my photographic career and my clients can recognize the difference.

The main rule we follow when using our three-light setup at a wedding reception is this: both my assistant and I have to be constantly aware that we never line up under the stationary room light. The room light never moves, and if we line up in the same direction as the stationary room light, we double the light coming from that particular direction, negating the nice lighting we are trying to get. This can cause some really big exposure problems.

Just as important is the fact that your assistant needs to be aware of where you are, know what lens you have on your camera, and not be in the shot, as my assistant was in ❦ Figure 7.

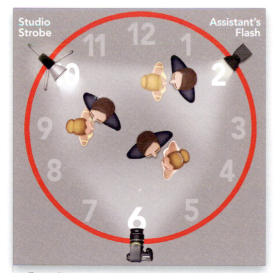

❦ *Figure 6*

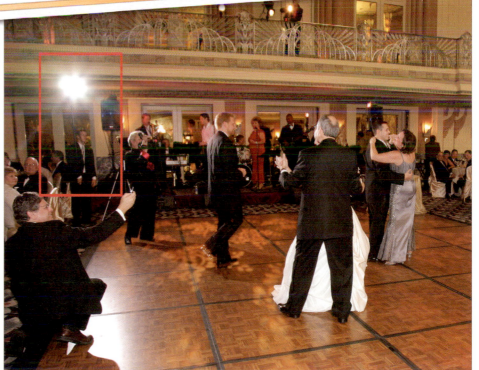

❦ *Figure 7: Notice how my assistant and his flash made it into this particular shot*

Shadow Problems with On- and Off-Camera Flash

I can sit here all day long and say how great it is to use your on-camera and off-camera flashes in all the different, creative ways that we discussed. But, I'd be doing you a disservice if I didn't point out some of the problems you can encounter along the way. There are really two main problem areas when using your on-camera or off-camera flash: shadows and reflections.

Avoiding Side Shadows #1: On-Camera Flash

Generally, side shadows can be a big problem if you use your flash on-camera, especially when you turn your camera sideways. Now your on-camera flash is either to the right or left side of the lens—bad news. If you take a photograph with your flash to the side of your lens, it will throw a big ugly shadow onto the background of the scene, particularly if that background is fairly close to the subject (see *Figure 1a*). Pretty nasty shadow, isn't it? I know all this sounds obvious, but I see it happen all the time.

My regular shooting routine means never tilting the camera unless, of course, turning the camera to a vertical position guarantees that I will produce no ugly shadows on the background. Those instances include when I'm working with the bride, say, about two-thirds down the center aisle of the church, where any shadows cast to the left or the right of her will fall off and be camouflaged and disguised by the background (see *Figure 1b*). The other instance is when we are work-

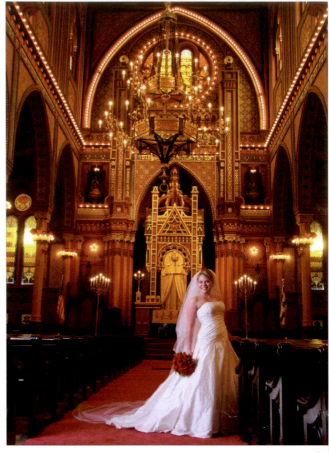

Figure 1b

Figure 1a

Another thing that I do to avoid being a robo-photographer at a wedding is to put the camera to my eye, frame up the subject(s), get a good focus, then drop the camera down so that they can see my face. They see me smiling back at them and respond accordingly with great smiles and expressions—works every time.

ing outdoors and there really isn't any obstacle for the shadow to land upon (*Figure 1c*).

As I said, I prefer to keep my camera in the horizontal position for most of my photography. Today's DSLRs have plenty of pixels, so even if I do need to crop a horizontal shot into a vertical image, I still have plenty of pixels remaining to create a good vertical image. Follow my logic: I'm shooting with my Canon 5D Mark II. Its full-frame 36x24mm sensor gives me 21+ megapixels. If I shoot horizontal and discover later that it needs to be vertical

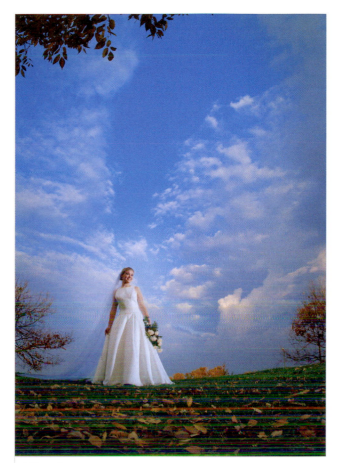

❧ Figure 2

❧ Figure 3

for the wedding album, I can just crop it vertical and still end up with a 24x16mm slice of the sensor. That's half of what I started with. Yep, 10.5+ megapixels still left over.

Avoiding Side Shadows #2: Off-Camera Flash

This is something you really have to watch out for. You need to train your assistant to watch for these ugly side shadows, because he/she is the one creating them. The biggest problem comes when photographing large groups. Read my lips: If your assistant can't see *all* of the faces of *all* the people in the group, then he/she will cast shadows on the individuals they can't see.

Remember our group shot from earlier in the chapter (see ❧ *Figure 2*)? I remember years ago when I had another photographer shoot a job for me. His assistant was so far to the right of the group that

the shadow completely covered up one of the wedding party members—you could hardly spot them because of how deep and dark the shadow presented itself. That was a big custom job back in the film days.

Halloween Shadows: Off-Camera Flash

This is kind of a weird one. Here is how it happens: You've got the wedding party posed on the church steps, taking the big group shot. Your assistant holds the off-camera flash in just the perfect position—well, almost. It seems the group on the steps is much higher than the height to which the assistant is extending the off-camera flash. What happens? Halloween shadows (shadows that are larger and higher than the group). It's time to call your favorite Photoshop guru in for the fix. I added the shadows in this shot to give you an idea how bad the problem can be if you aren't careful (❧ *Figure 3*).

(Continued)

 Figure 4a

Five More Times Shadows Won't Be Your Friend

1 Watch for shadows whenever shooting people standing under canopies, flower arches, etc., inside a church. They will show up every time if you are not at least shooting through an umbrella. You can still see the shadows here, although they are quite soft and not too distracting, thanks to my assistant shooting through an umbrella (※ *Figure 4a*).

2 Watch for shadows when working in smaller churches where there isn't much distance from the altar area to the back wall. This is especially a problem if the back wall is white, and often happens if the area has rows of white pews for the choir. This example shows our shadow problem cropping up because my staff photographer had the bride and her grandmother too close to the white altar in the background (※ *Figure 4b*).

3 Watch for shadows when shooting in front of a fireplace, often at a country club, hotel lobby, or family home. I generally shoot at an oblique angle to the fireplace to avoid the shadows (※ *Figure 4c*).

※ *Figure 4c*

※ *Figure 4b*

❧ *Figure 4d*

❧ *Figure 4e*

❧ *Figure 4f*

4 Watch for shadows cast on the bride during the cake cutting, because the assistant is out of place. In the rush of the cake cutting activities, your assistant can easily find himself to be out of place, as in ❧ *Figure 4d*, where he is casting the groom's shadow on the bride. As you can see in ❧ *Figure 4e*, he quickly got into the proper position.

5 If the wedding cake is placed close to a wall, watch for shadows when shooting the cake cutting activities. This can become a very difficult situation to control (❧ *Figure 4f*).

The bottom line is this: you and your assistant have to be "shadow aware" when shooting a wedding. Know where the light is coming from, and where the shadows are falling, before you take the shot—'nough said.

Reflection Problems with On- and Off-Camera Flash

The other flash problems we need to avoid are reflection problems. There are three kinds of reflection problems: (1) specular reflections, (2) diffuse reflections, and (3) a combination of both.

Specular Reflections

Specular reflections are direct mirror-image reflections of the light source reflected back into the camera. All really shiny surfaces will create a specular reflection. Common sources in wedding photography include mirrors, windows, shiny marble, or highly polished wood paneling. All of these can cause problems with reflections, as you can see in this shot of the head table in ❧ *Figure 1a*. The same problem popped up again when the bride and groom were cutting the cake in ❧ *Figure 1b*.

❧ *Figure 1b*

The easiest way to solve a problem with specular reflections is to be aware of the surface characteristics behind your subjects. Once we know we might have problems with reflections, we can determine how to reposition ourselves and our subjects for the shot, or find a better location for the picture.

Check out ❧ *Figure 1c*. See the reflection of the umbrella in the group shot? We had to fix it in Photoshop because we missed it during the shoot.

❧ *Figure 1c*

Diffuse Reflections

A bigger problem with reflections happens with diffuse reflections. This worst-case reflection scenario happens when you photograph into polished wood paneling or large polished wood pieces of furniture, or even fireplaces. The situation is worsened when using an off-camera flash.

Here's why: when the light from the flash(es) hits that kind of surface, it just spreads out like crazy. Check out ❧ *Figure 2a*. See how the reflection is spreading out in the background behind

❧ *Figure 1a*

Figure 2a

Figure 2b

Figure 2c

the groom's left shoulder? The quick fix in this case was to change position and shoot into the paneling at an oblique angle, and we ended up with a pretty cool shot (✷ *Figure 2b*).

I remember photographing a dinner celebration at Morton's The Steakhouse for a client. The entire banquet room was paneled in this beautiful, polished, cherry wood paneling. It was a reflection nightmare. Wherever I positioned my off-camera flash or my on-camera flash, the reflections just spread out everywhere (✷ *Figure 2c*).

I had to be very judicious with the use of my off-camera flash. I also had to try to orient the shot at an oblique angle to the paneling to reduce the specular return as best I could. Part of the solution was to also slightly lower the camera position, so that the subjects would block the large reflections that tended to appear behind them. A few of the images still required a little Photoshop magic to eliminate the reflections.

(Continued)

Specular and Diffuse Reflections Together

I was photographing a bride and groom with grandma in front of a large marble altar and, at first, didn't notice the specular and diffuse reflection bouncing off the marble right behind them. This time it was my on-camera flash causing the problem (❧ *Figure 3a*). Fortunately, I noticed it in time and was able to correct the problem for the rest of the shots by lowering the camera position ever so slightly, so the subjects blocked the light from hitting the background (❧ *Figure 3b*).

Five Steps for Avoiding Reflections in Your Wedding Photography

1 Before you set up your subjects for the shot, run a few test flashes and watch the background for reflections.

2 If you do see some reflections, analyze the surface characteristics where the reflections are appearing and determine what kind of reflections—specular or diffuse—you're dealing with.

3 If it's a specular or smaller diffuse reflection, you know that you can alleviate the problem by lowering your camera position slightly. This keeps the light from hitting the surface and allows your subjects to block the reflection, thus resolving the problem.

4 If you're dealing with a larger diffuse reflection, as when working in a church with highly polished wood paneling, try to reposi-

tion your light so that the reflection does not appear within the frame of your image.

5 If it appears that the diffuse reflection is going to be a problem, try to minimize it as best you can. Try repositioning yourself and/or your subjects at an angle to the surface. Then, ask yourself if it's a relatively easy fix in Photoshop. If it is, shoot away and handle it in postproduction.

Let me just give you one last piece of advice: When shooting in a situation that could create some of these problems with reflections, if you're aware of the problem, you'll be able to solve it much more easily without creating a monster to be fixed in Photoshop later.

A client once commented, "Your [photography] studio is the master of light." The client could see the difference in our lighting and recognized just how beautiful our lighting looked in all of the weddings and Bar/Bat Mitzvahs that we had photographed for his family over the years. It points out that people can indeed tell the difference between Uncle Harry's on-camera blast flash and the professional use of lighting, which really makes a difference in one's photography.

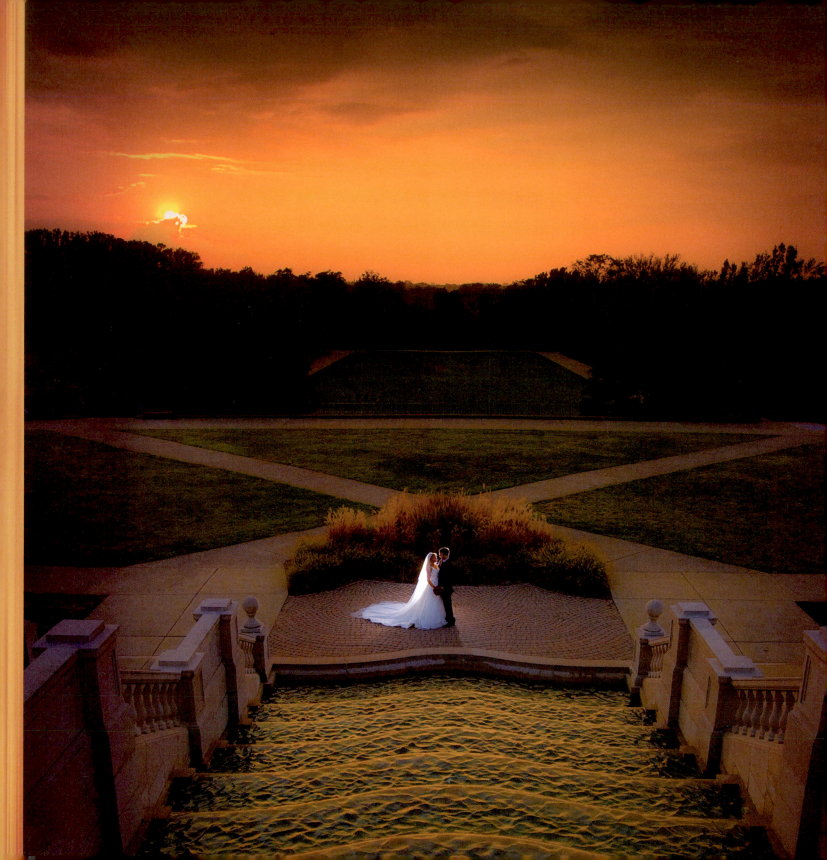

Kickin' It Up a Notch

Make Your Wedding Shots Sing with Backlighting

Hey gang, you know by now that, for me, it's always about the lighting. If we can get that light really working for us, we can create some imagery that blows the competition away. Wedding photography is more than just running and gunning, and hoping that out of the hundreds (or thousands) of images you take, you capture a couple hundred that look good.

I remember a photographer, years ago, who joked with me as I was telling an audience that I photographed on average about 600 or 700 images per event back in the film days. At that time, that was unheard of—600 or 700 film exposures on the wedding day. That amounted to about $1,000 of film and processing. He thought I was crazy. He said, "So, Ziser, what you're telling me is this: If you can't shoot them good, shoot them fast." You know, it got a chuckle from the audience, but folks, unfortunately this seems to be the mentality for a lot of wedding photographers these days.

In this chapter, we are going to discuss backlighting. Backlighting is one of the fastest, coolest ways to add dramatics to your wedding images. This is a "money shot." Our clients love it.

There are many ways we can add backlighting to our images, too. We can use backlighting to create a simple silhouette, or to create a soft accent light on the bride's veil. We can even use backlighting to illuminate the background for a completely different look in our wedding photography. Let's take a peek at each one of those techniques.

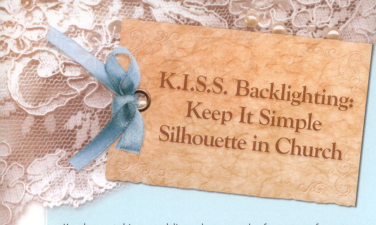

K.I.S.S. Backlighting: Keep It Simple Silhouette in Church

I've been taking wedding photographs for most of my career and backlit photographs have *always* been my best-selling images. Take a look at the first image here. See how the backlighting is just rimming out the subjects and separating them beautifully from the surrounds of the church? Let me walk you through the simple steps to create this beautiful image:

Step One:

Position the bride and groom about two-thirds of the way up the aisle from the front of the church. I choose this position most of the time, because it really frames the bride and groom dramatically against the beautiful architectural elements of the altar area. But, by all means, check out other locations, too.

Step Two:

Look at the diagram (❀ *Figure 1*) and notice that when the light is too close to the subjects, it does not adequately wrap around them—they block most of the light from the lens.

Step Three:

The light needs to be far enough behind the subjects so that it will gently wrap around them. The "magic" distance is from 12–15 feet (3 meters, for my international readers) behind the subjects, about 4 feet off the ground, with the flash head pointing at the subjects'

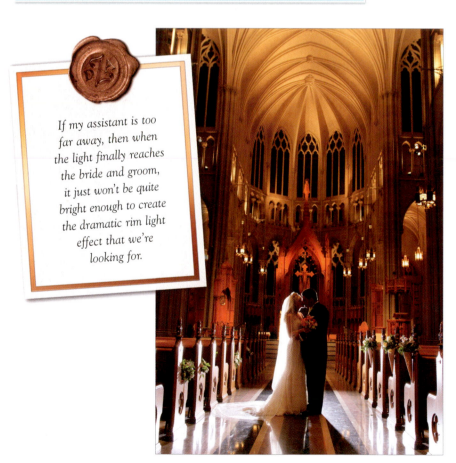

If my assistant is too far away, then when the light finally reaches the bride and groom, it just won't be quite bright enough to create the dramatic rim light effect that we're looking for.

Flash 12' from Subject

Flash Too Close

❀ *Figure 1*

shoulder blades. Check out ✺ *Figure 1* again. It shows how, at this distance, the light wraps around the couple enough to make it to the lens and become a beautiful rim light.

Step Four:

Next, I have my assistant get in position about 12 feet behind the subjects. My assistant needs to get small and compact, and tuck in the elbows and knees as much as possible. If he is closer than 12 feet, the shadows cast by the backlighting will be at a very severe angle and really detract from the composition.

Step Five:

With my assistant 12 feet behind the subject, I have him/her raise the flash head 4 feet off the floor and point it at the subjects' shoulder

blades. I use a Quantum Instruments Qflash T5d at half-power, or about 100 watt seconds, for this shot (see ✺ *Figure 2*).

Step Six:

So, now you ask, "Dave, if my flash is at half-power at 12 feet away and 4 feet off the ground, then what f-stop should I be shooting?" I would say, "Use my f-stop of convenience—f/5.6 at ISO 800—it works every time without fail." See ✺ *Figure 3a*.

Step Seven:

I can see that you have one more burning question on your mind. You want to know what shutter speed I used to make this photograph. Well, take a look at the second image (✺ *Figure 3b*). Doesn't the background of the church look substantially darker in this shot?

To create this effect, I dial my shutter speed up about two stops more than the correct exposure for the ambient light. Another way of saying this is that I am underexposing the ambient light by about two stops. It's this magic number—one to two stops—that seems to give me the most consistent result when creating these backlit church photographs. It's really up to you and the visual effect you want.

> *The bottom line is this: I use a medium amount of light firing behind the subjects. If you own a lesser-powered strobe, just increase the ISO on your camera or open the aperture.*

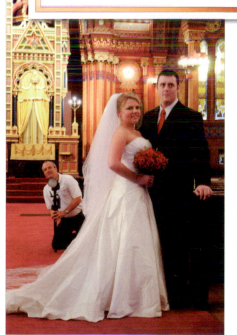

✺ *Figure 2*

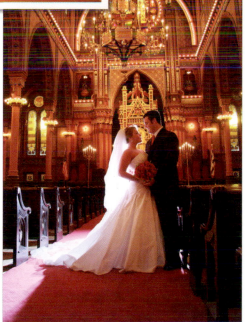

✺ *Figure 3a*

✺ *Figure 3b*

(Continued)

❧ *Figure 4a*

❧ *Figure 4b*

Step Eight:

Be sure you take a couple variations of the backlit church shot. Have the couple look at each other, have them kiss, maybe have the groom carefully dip his bride—just be sure they're having fun. Also include several images at various focal lengths, just to get a different look and feel. Don't forget to take one or two outside on the way to the limo, if possible. It only takes a minute or two to set up the lighting, so really explore the possibilities (see ❧ *Figures 4a, 4b,* and *4c*).

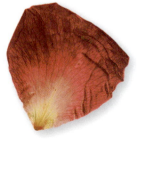

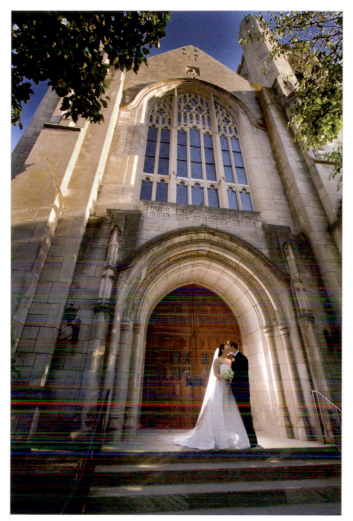

❧ *Figure 4c*

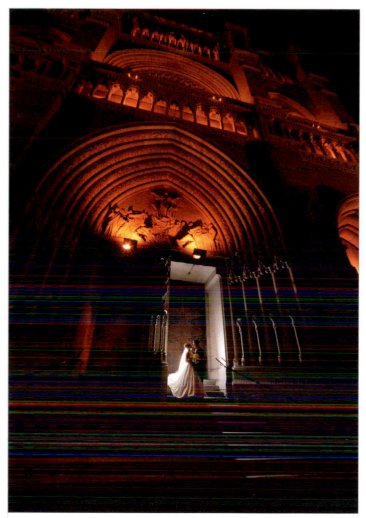

❧ *Figure 5*

Step Nine:

❧ *Figure 5* is another nice result I got when I asked the bride and groom to pause for just an instant as they came out of the church. In this case, my assistant was much closer to the couple and, as a result, the light splashed off of them and added some illumination to the arch of the cathedral doors, highlighting the couple even more.

So, there you have it: all the magic in nine easy steps. Now you, too, can make the wedding image that will sell 100% of the time. Let's say that you photograph just 20 weddings a year for the next 10 years and take this photograph at each wedding. Now let's say you sell a wedding image for just $20. You can do the math: 20x10x20 = $4,000 added to your bottom line! Worth the price of this book alone, wasn't it? ;~)

K.I.S.S. Backlighting: Keep It Simple Silhouette Everywhere Else

But wait, dear readers, there's more! These same techniques that work so well in the church, also work in any number of locations. Let me show you:

Backlighting is great to incorporate at several points in the wedding day, including outdoors (❀ *Figure 1a*), at a cool hotel (❀ *Figure 1b*), and at the wedding reception.

Now take a look at ❀ *Figure 2*. Notice that we have a great photograph of the bride and groom enjoying their dance. If we look closely, we can even see some guests as they watch the happy couple.

How do we pull it off? The band calls for the bride and groom to come onto the dance floor, the music starts, and they are off dancing the wedding dance. Sometimes, we see a couple that has taken dance lessons, and are demonstrating the foxtrot, waltz, or rumba. They are all over the dance floor. So, I know you're wondering how

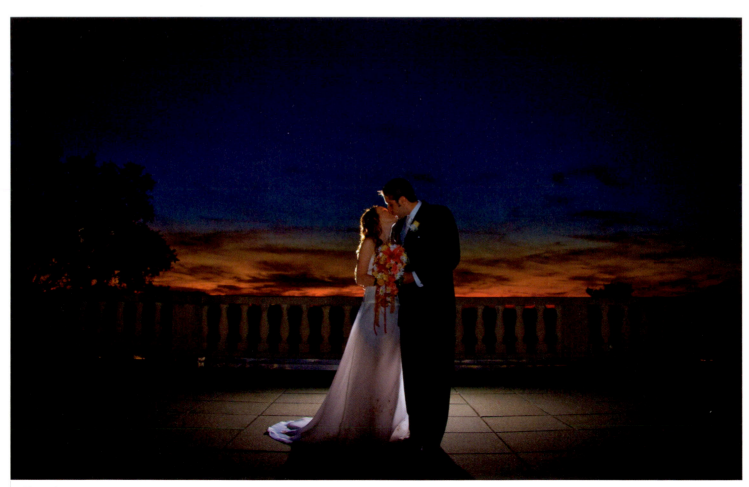

❀ *Figure 1a*

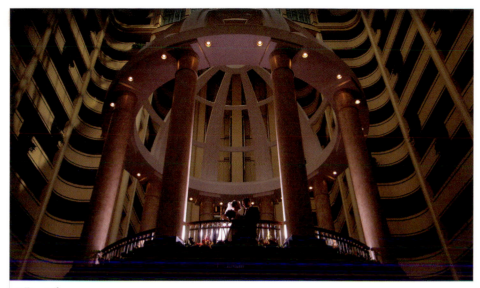

Figure 1b

Figure 2

we're going to get a backlit dance photograph with the bride and groom making giant swaths of motion all over the dance floor. Here are the steps:

Step One:

As we learned from our backlit church photographs, we have to have our assistant about 12 feet behind the couple, with the flash about 4 feet off the ground. So, everything remains the same at the reception.

Step Two:

If you took my advice earlier and have a room light in position for the reception, then remember that you've got to turn it off when doing these backlit dance photographs. I accomplish this easily, because I use Quantum's FreeXwire remote control system. The room light is on another channel, so I simply switch off the room light when making these images to get that dramatic effect (*Figure 3*).

Step Three:

Here's some good news: My f-stop and my assistant's power setting are the same for these shots as they were for the backlit church photographs. That means that my assistant sets the flash at half-power, and I'm at f/5.6. The shutter speed will be substantially faster, though. Typically, it's around ⅟₆₀ of a second.

> *I prefer the higher shutter speed to cut down the ambient light of the scene, while still creating a nice rim light on the couple.*

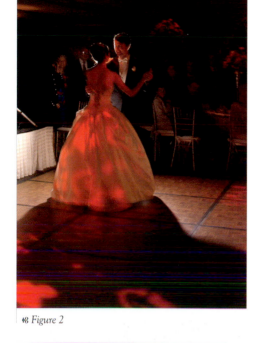

Figure 3

(Continued)

Step Four:

So, how does the assistant stay behind the bride and groom as they are dancing all over the dance floor? Well, that's sort of their problem. If the assistant is out of position, then it ruins the shot (see ❦ *Figure 4*). Sure, they sometimes look like hopping frogs as they try to stay in position behind the bride and groom, but heck, they're young and agile. It's my expectation that they will get themselves into position, whatever it takes, so I can capture the shot(s).

Step Five:

Okay gang, this is where you can really make it interesting. Many times, clients hire a lighting technician to illuminate the dance floor with some very beautiful dappled lighting textures. How do we get some of those dappled lighting textures to show up in the bride's gown? It's simple—slow down the shutter speed to about $1/20$ of a second. At ISO 800, that's usually enough to let the dappled lighting expose sufficiently on the shadowed side of the bride's gown. Check out ❦ *Figure 5* to see the effect.

In the next shot (❦ *Figure 6*), I slowed down the shutter speed to about $1/15$ of a second to pick up some of the ambient light of the reception location. The wide-angle lens adds dramatics to the impact.

Step Six:

In ❦ *Figure 7*, I was pleasantly surprised to see that some of my assistant's backlighting bounced off of the groom's shirt and reflected back into the bride's face, capturing a wonderful expression. I think it really shows the true, raw emotion of the moment.

Step Seven:

Hold on—there is still more to come. Just because you got that beautiful backlit dance photograph doesn't mean you're finished. You've still got a lot of other opportunities to capture some great shots. I want that first photograph to be a really nice wide-angle photograph of the bride and groom, showing the ballroom. But once I know I've got it, I'll switch to my zoom lens and zoom in on the couple to capture some great expressions, then continue with some tight backlit close-ups (see ❦ *Figure 8*).

❦ *Figure 4*

❦ *Figure 5*

❧ Figure 6

❧ Figure 8

❧ Figure 7

(Continued)

Figure 9a

Figure 9b

Figure 9c

Figure 10

Step Eight:

It's at this point that I turn my room light back on, and it's now okay for my assistant to assume his position in our three-point triangular lighting system, which we discussed in Chapter 4.

With the bride and groom in the middle of our lighting triangle, I make several additional images of them enjoying their first dance. My goal is to get some great photographs of the groom looking into the bride's face, hopefully capturing a wonderful expression. I'm also trying to catch the same wonderful expression on the bride's face as she gazes into the groom's face. Sometimes there are some really nice surprises in their expressions: a loving look, a giggle, joy, and endearment as they look into each other's eyes. Check out *Figures 9a*, *9b*, and *9c* to see what I mean.

Step Nine:

And, in our final image, you can see how the light reflected off the bride's wedding gown and the groom's white shirt, and bounced back into the faces of not only the bride's mom and dad, as they proudly watch the couple's first dance as husband and wife, but also a few surrounding guests (see *Figure 10*).

A few things to remember:

- When you think you've got the shot, don't give up, you still have got a lot more to go. Our first goal was to get the backlit silhouette of the bride and groom dancing. I prefer to keep my camera position fairly low to the floor; I'm usually kneeling for these photographs, because the shadows coming back to the camera look better that way.

- After you've captured that great backlit candid, slow down your shutter speed to $1/20$ of a second at f/5.6 and ISO 800 to get that great photograph of the dappled lighting on the bride's gown.

❧ Continue shooting the bride and groom dancing, and zoom in closely on their faces to see if you can catch the light reflecting off the groom's shirt back into the bride's face to create another great image.

❧ And, lastly, finish up coverage of the wedding couple's bridal dance with all strobes firing, keeping the couple within the center of your lighting triangle. Try to capture some great expressions on the bride's and groom's parents, friends, and family as they watch this traditional first dance.

How does it look in the wedding album? You can see I suspect that I'm not going to put just one of these images in the wedding album. I've created a whole series of wonderful images for the couple.

Typically, for us, when we lay out this section of the wedding in the bridal album, the primary image is the backlit image of the bride and groom positioned on one side of the two facing pages. On the other side are the secondary images of them enjoying their dance. Check out ❧ *Figure 11* to see how this page looks. We really want to tell a story, and have them relive the emotions they felt.

For me, it's about catching the whole series of actions and reactions, thereby capturing the moments for our clients—moments which, when put in their wedding album, tell a great story of the treasured memories of their wedding day.

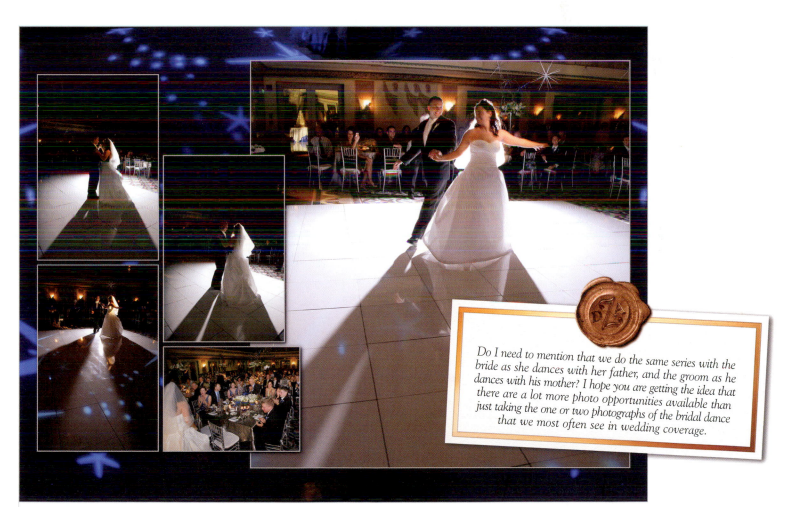

Do I need to mention that we do the same series with the bride as she dances with her father, and the groom as he dances with his mother? I hope you are getting the idea that there are a lot more photo opportunities available than just taking the one or two photographs of the bridal dance that we most often see in wedding coverage.

❧ *Figure 11*

Accent Lighting on the Veil

Okay, everybody, let's talk about a different version of backlighting. When taking the traditional photograph of the bride in church—the classical bridal portrait—we can spice the image up considerably with a little backlighting on the veil, accenting it for a more beautiful effect.

Whenever I'm creating an image of the bride in church, one way to add a little pizzazz to it is to have a little accent light on the back of the veil. That little accent light is created with my mini-slave unit, as shown here in ✸ *Figure 1*. It's a fairly low-power flash unit that is fired optically by my other off-camera strobe.

What I love about this little strobe is that it has a foot on the bottom of the unit, which lets me adjust the flash in an upward direction instead of just laying it flat on the floor. By positioning it on the floor of the church and adjusting it upwards just a bit, I can direct the light into the back of the bride's veil. This is so simple to do. Let me walk you through it:

Step One:
First, pick yourself up a little inexpensive flash from a photography supply store (I prefer B&H). Here are a couple different models I use: (1) the Smith-Victor PG250S Wireless Mini-Slave Flash (my favorite); (2) the Smith-Victor PG160S Wireless Mini-Slave Flash (a little less powerful); and (3) the SP Studio Systems Mini-Slave Strobe (very similar to #1).

Step Two:
I prefer a working distance of around 10 or 12 feet from the subject when using the mini-slave. Check out the before and after images here (✸ *Figures 2*a and *2b*). It just adds a little twinkle, a nice touch, to the photograph.

Step Three:
The thickness of the bride's veil can have an effect on how the backlighting is rendered. If it's a very thin veil, the backlighting may be too strong and actually blow out the highlights in the veil. In this case, I simply cover the flash head with a single layer of a clean handkerchief to reduce the output by two stops, and create a softer accent on the veil.

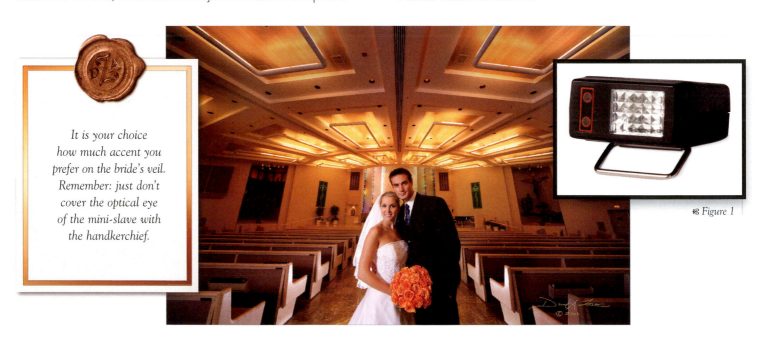

It is your choice how much accent you prefer on the bride's veil. Remember: just don't cover the optical eye of the mini-slave with the handkerchief.

✸ *Figure 1*

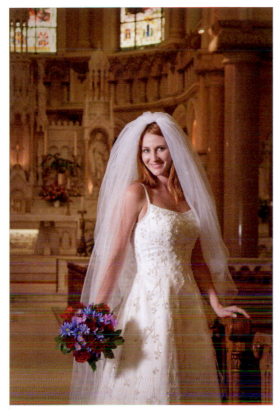

◄ *Figure 2a: Before*

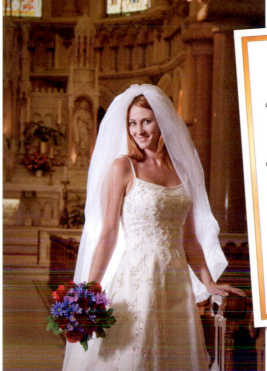

◄ *Figure 2b: After*

If you are using just your on-camera flash, then the mini-slave may not trigger, because your on-camera flash will be blocked by your subject. If your flash is on E-TTL (or i-TTL, for Nikon), the pre-flash may trigger your mini-flash. If you insist on using your on-camera flash—and it may work in some cases—then be sure it is in manual mode, so the pre-flash doesn't trigger the mini-slave before the actual exposure is made. This is why I prefer to use my off-camera flash.

Step Four:

I use an off-camera flash 99.9% of the time. Therefore, with the off-camera strobe coming from the left or right side of my subject, it isn't a problem to have my little mini-flash seeing and syncing with the light coming from my off-camera flash (see ◄ *Figure 3*).

Step Five:

I double-check that my assistant is in the proper position. Remember, during this setup I'm using two light sources: one source is my off-camera flash unit, to apply the proper lighting pattern on the bride's face; the other source is the "twinkle" flash unit I've just placed on the floor behind the bride. The optical slave built into the mini-flash requires a line of sight of light to trigger it, thus my assistant, providing my main light on my subject, is also firing the mini-slave.

This little flash is inexpensive, easy to use, reliable, and just adds that final twinkle touch to the beautiful bridal images.

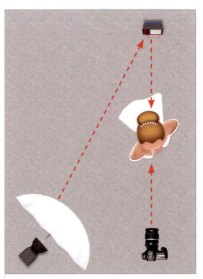

◄ *Figure 3*

(Continued)

Lighting the Background

Here is one more way to backlight creatively. This time we are going to illuminate the background directly. Remember, backlighting is a way to focus the viewer's eye on the subject. Well, studio photographers have been using a "background" light for years. Since the whole world is my studio, my "background" may be the wall, ceiling, or even the exterior door of the church. Here are some cool ways to bring a little more pizzazz to your wedding photography:

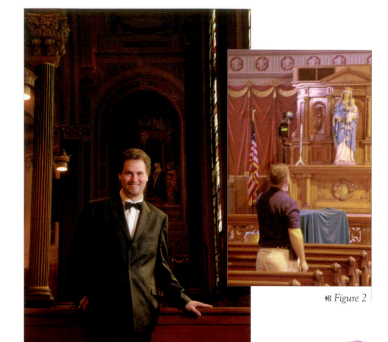

☙ Figure 2

Step One:

Here, I have found a nice place for the portrait of my groom (see ☙ *Figure 1*). The problem is that the wall behind him is too dark. I need to brighten it up. No problem, I have my assistant head to the front of church and point my off-camera flash at the background (see ☙ *Figure 2*).

☙ Figure 1

Step Two:

Run a few tests until you balance the flash illumination on the background with the rest of the scene, then take the shot. See ☙ *Figure 3* for the result.

The distance to the background (which controls the cone of light we discussed earlier) and the vertical distance (how far up the background your assistant is pointing the flash) all contribute to the look of the final result. You may have to experiment a bit, but the result is worth it.

☙ Figure 3

Step Three:
Here I am in the same church on another shoot. This time, I had a problem with the ceiling being too dark behind the bride (see ❦ *Figure 4*). I needed to illuminate it.

Step Four:
My assistant headed to the back of the church, kicked the flash up to full power, and I fired away. You can see the difference in ❦ *Figure 5*.

Step Five:
I didn't like the cool look of the light from the strobe. So, I had my assistant add an orange gel to it and fire again. I finally got it (see ❦ *Figure 6*). How did I light the bride? With the on-camera flash and panel bounce technique I discussed in Chapter 3.

❦ *Figure 4*

❦ *Figure 5*

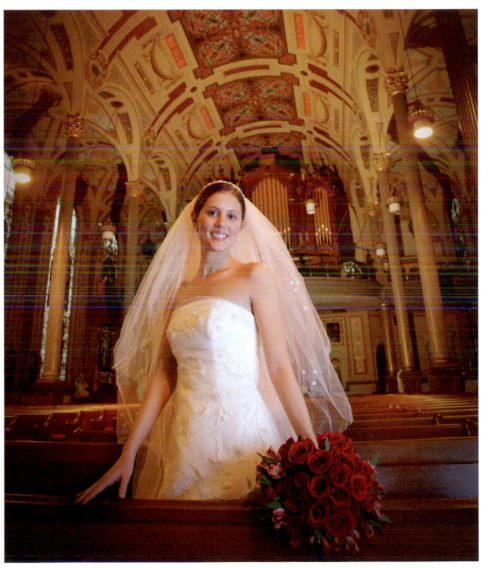

❦ *Figure 6*

(Continued)

Step Six:

Okay, this is one of my favorites. I did everything as outlined above, only this time, after taking the backlit image of the couple (☙ *Figure 7*), I had my assistant light up the side of the church. Since I was outside, I used a much higher shutter speed and smaller f-stop. The use of the fisheye lens added quite a bit of dramatics to the shot (see ☙ *Figure 8*).

I was so close to the tulips in these shots, that when I asked the couple to give each other a hug, they thought I was talking to the flowers.

☙ *Figure 7*

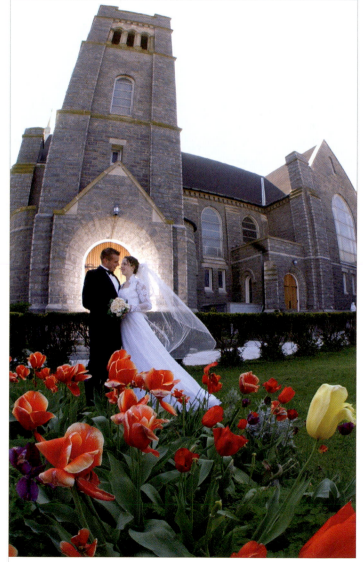

☙ *Figure 8*

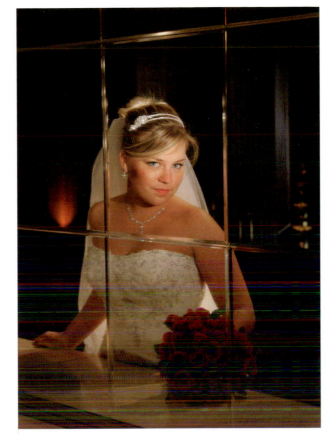

The Z-Ray for Weddings & Portraits

Okay, gang, let me tell you about what I think is one of the most fun ways to create some very cool wedding day images. I call this technique Z-Ray lighting, with my double-barreled, Kryptonite-powered, Z-Ray light. How did the Z-Ray get its name? I'm sworn to secrecy, so I'll let you make your own best guess.

Figure 2

Basically, what I'm using is a high-intensity flashlight (❦ *Figure 1*) to throw a beam of light on my subject to create some very dramatic lighting. Check out ❦ *Figure 2*. It looks like the lighting we see used on the Hollywood stars of the '30s and '40s, and gives a similar result to what we saw earlier in the Hollywood lighting section in Chapter 4.

Figure 1

I love how it lets us isolate the subject from the scene, and really focuses all the viewer's attention right on our bride (see ❦ *Figure 3*).

Shoot Some Z-Rays on Those Tables

The first time I started playing around with my Z-Ray lighting technique, I was shooting scene setters at a wedding reception. The centerpieces were not illuminated quite as well as I thought they should be, so I had my assistant bring in the Z-Ray lighting to better illuminate them (see ❦ *Figure 4*).

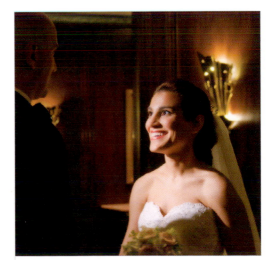

Figure 3

Figure 4

(Continued)

Figure 5

Figure 7

Figure 6

Figure 8

Another time, the client set out menu cards at each place setting, but the cards seemed to fade into the surrounding table décor. I hit the menu card with my Z-Ray light, and popped it out from the background (⊕ *Figure 5*).

You can also use it to spotlight some of the bridal accessories at the bride's home while she is getting ready for her special day. This may include the bridal headpiece, jewelry, shoes, a special detail on her gown, etc. (see ⊕ *Figure 6*).

I've also found that I can get great results with the Z-Ray as the bride is getting dressed, and going through the last-minute preparations—shots like the mother or the bridesmaids buttoning up the back of the gown, adjusting the veil, the bride resting with her hands on her lap, etc. (see ⊕ *Figure 7*).

Z-Rays for Portrait Lighting

It is also very cool to use the Z-Ray as the primary light source for an unusual and beautiful bridal portrait. Take a look at this image (⊕ *Figure 8*) I recently captured as the bride finished her preparations. I had her lean against the counter with the makeup mirror behind her, and had my assistant bring the Z-Ray lighting in from the right to illuminate her face with the standard loop lighting pattern. Notice how the light falls off gently down the full length of her body, leaving the primary illumination on her face. Let me walk you through, step by step, how I use my Z-Ray lighting to photograph the bride:

Step One:
Find a cool background for your shot. Remember, when looking for backgrounds, you're looking for three-dimensional spaces that will look great rendered as a two-dimensional space in your photograph. That means the background can contain many different compositional lines, shapes, and forms.

Step Two:
Position your subject for the best composition. I generally follow the rule-of-thirds composition (see ⊕ *Figure 9*), which we'll discuss in detail in Chapter 7, although sometimes I take a very symmetrical approach.

Figure 9

Step Three:

Once your composition is set, get the light correctly positioned on the subject's face. Always remember that you don't want to point this high-intensity flashlight directly into the subject's eyes, or have them look directly into the light. It is a very bright beam of light and may damage their eyes if they look directly into it. The light should be coming in from an off-axis direction, with your subject looking back into the camera.

It's your assistant's job to create a beautiful lighting pattern, as we discussed in earlier chapters. You can vary the contrast of this lighting pattern by how close to or how far from your subject you have the Z-Ray lighting. Moving it closer creates a more intense

amount of light on your subject's face relative to the ambient light of the scene. Moving it away from your subject creates the opposite effect, reducing the intensity of the light on your subject and balancing it with the intensity of the ambient light.

Step Four:

It's important to have your camera set properly. Since the Z-Ray lighting is fairly intense, and since the area being illuminated by it is substantially brighter than the surrounding area, your camera's light meter may be fooled as to what the exposure should be. So, take a test image, and adjust your exposure accordingly.

(Continued)

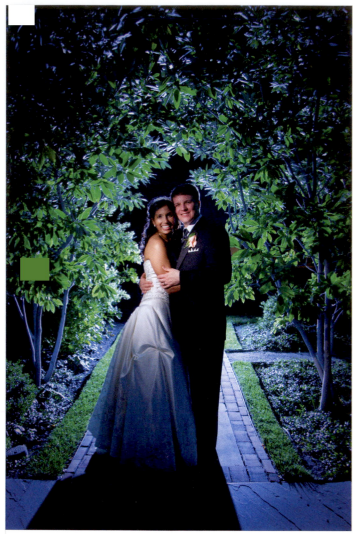

Figure 10

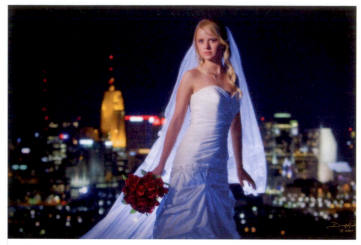

Figure 11

Step Five:

I typically have my camera set to aperture priority mode, tungsten white balance, and ISO 800 or 1600 for this. The new high-ISO cameras give you even more versatility with this technique. Once you've determined your optimum lighting and camera settings, shoot away.

Variations on a Theme

Look what happens when I use the tungsten-balanced Z-Ray as my main light source and then backlight the subject with my daylight-balanced strobe (see *Figure 10*). With the camera set to tungsten white balance, we get the proper color balance on the subject, but the backlighting becomes a very vibrant blue, creating another unique and different look.

Let's look at one more example (*Figure 11*) where I used my Z-Ray as the main light source on my bride. The backlighting was supplied by my daylight-balanced strobe, resulting in the cool rim lighting surrounding her. Notice, too, that since I was shooting outdoors, the overall color temperature of the scene was quite cool. This, once again, created a unique and beautiful bridal portrait.

Wait, there's more. Check out this image created with the Z-Ray (*Figure 12*). I opened the Bible to Corinthians and balanced the groom's wedding ring in the crease of the book. I then had my assistant position the Z-Ray to give me the heart-shaped shadow. Yes, you could do this with a flash, but with the Z-Ray, I know exactly how the shadow is going to fall.

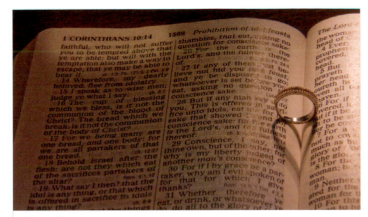

⁍ Figure 12

You can also try a small LED flashlight and a higher ISO to get the same effect (as I did in *⁍ Figure 13*). Here are a few tips to remember about Z-Ray lighting:

- ⁍ A regular high-powered flashlight works best with your camera set to tungsten. You can warm it up a bit by adjusting your camera's Kelvin setting to 2800K.

- ⁍ High-powered flashlights have a very specific hotspot. Be sure that the hotspot is centered on the main part of your subject— the face, for example.

- ⁍ When using an LED flashlight, set your camera to daylight. If you want to warm up the lighting a bit, then use a 6500K setting.

The Z-Ray lighting just brings a very different look to the illumination of our subjects and, when used judiciously, I think it can add some very exciting images to your wedding coverage.

⁍ Figure 13

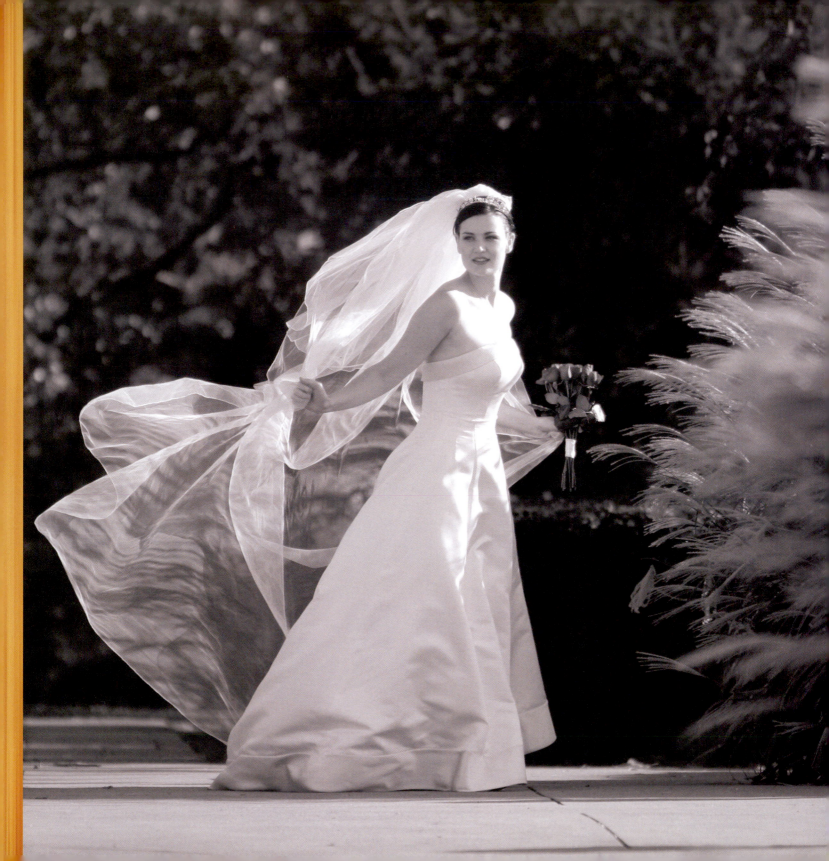

Oh No! I Forgot the Flash

Using Natural Light

We saw earlier in the book how to put a very flattering light on our subjects. We learned about the different lighting patterns on the face. We also talked about how to use both on-camera and off-camera flash to create them. But, in all those instances, we were using an additional piece of equipment—our flash. What happens if we don't have a flash to use in our lighting setup?

In this chapter, I want to talk about how to use nature's own light to create the same beautiful lighting patterns and obtain the same flattering lighting effects on our clients.

Natural light can occur as light coming through an open window at the bride's home, or from an open front door, or even as beautiful natural light outdoors on a terrace, the front porch, or in a park. In this chapter, I want to walk you through all these different lighting situations and show you how to place the best light on your subjects.

Let the Sun Shine In: Window Light

When we're talking about natural light photography, most of the time it has to do with window light. At least, here in the Midwest it does, where much of our shooting season takes place on cold, gray, and rainy days (even snow-covered, in the early months of the year).

The easiest way to understand window light is to understand that it represents nothing more than the direction of a light illuminating our subject. Now, remember, in the studio or anywhere we are using any auxiliary light, we have the luxury of moving that light relative to the subject's position. But, with window light, you can't move the window around the subject. The solution then is to move the subject relative to the fixed window.

❀ *Figure 1a: Full-Face View*

Today, many photographers are complacent and take what they can get when they have window light illuminating their subject. They'll just point the camera toward their subject, set the correct exposure, and shoot away. Sure, this can give you a very nice, quick and easy, unobtrusive candid wedding photograph. I, too, have captured some of my best photographs this way. But, let's take it up a notch by controlling the window light, so it illuminates our subject in the most flattering and best possible way.

Here, we'll revisit the loop lighting pattern we discussed in Chapter 1. As I said, this is the classical lighting pattern I use most often. We'll also revisit the classical views of the face (the full-face view, two-thirds view, and the profile view), which also were discussed in Chapter 1 (see ❀ *Figures 1a*, *1b*, and *1c*). Understanding these classical views of the face and getting a pleasant lighting pattern on the subject will make your wedding photography better.

So, let's walk through the steps to get great window-light wedding photographs:

Window Light Full-Face View

Step One:

If I want to photograph the bride looking directly back at the camera (this would be called a full-face view), I have to be sure the light falls on her entire face properly from the adjacent window. If I position her directly next to the window, the lighting pattern I would create is what is called split lighting (we discussed this in Chapter 1). This is generally not the most flattering light to put on your subject.

❧ *Figure 1b: Two-Thirds View*

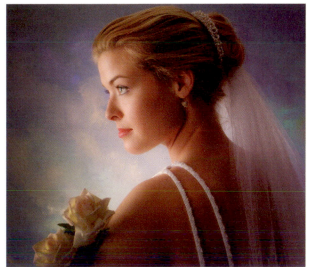

❧ *Figure 1c: Profile View*

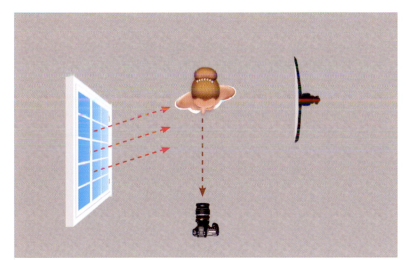

❧ *Figure 2: Full-Face View*

Step Two:

Instead, I just need to back my bride away from me and behind the window a bit more. Check out her placement in ❧ *Figure 2*. Can you see it in ❧ *Figure 3*? Can you see that the light rays illuminating our little flower girl are coming in from a direction that will create that loop lighting pattern on her face?

❧ *Figure 3*

(Continued)

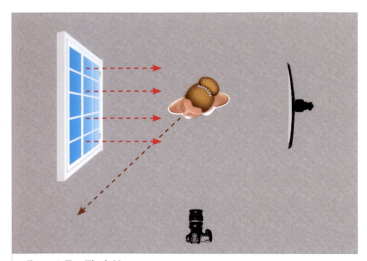

❧ *Figure 4: Two-Thirds View*

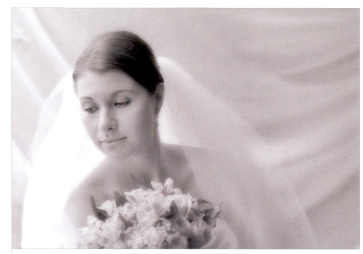

❧ *Figure 5*

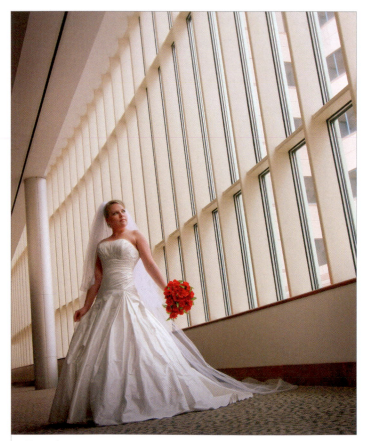

❧ *Figure 6*

Step Three:

With the subject in this position, and assuming our background complements the scene, we can bring the other principal players into the setup, as well. For instance, we can photograph the bride and her father, the bride and her mother, the bride with both parents, and even the bride with her maid of honor or the flower girl. The light is set, so we can just shoot away.

Window Light Two-Thirds View

Step One:

Let's bring the bride next to the window and explore a few more possibilities. Check out the diagram in ❧ *Figure 4* to see how I have the bride positioned next to the window.

Step Two:

I love this next image (❧ *Figure 5*). I asked the bride to just relax, turn slightly away from the camera, and lower her eyes. You can see that, with her in this position, we once again have our beautiful loop lighting pattern.

Step Three:

As you bring your subject closer to the window, the contrast may become greater on the subject. The reason for this is because the bride is much closer to the main light source—the window and the exterior daylight—and the ambient light has remained the same, thus increasing the contrast lighting ratio. (That's a fancy term for how much brighter the bright parts are when compared to the shadow parts of the face.)

There are few ways to work around this: One way is to have your assistant bounce a little reflector "fill" back onto the shadow side of the subject's face. Although this works pretty effectively, it requires you to rely on another pair of hands (or a light stand) and a reflector to soften the contrast lighting ratio.

Step Four:

Another way of softening the contrast is to simply move the subject away from the window. So, if the window is to the left of the bride and only a few feet away, ask her to just move a few feet to the right. Everybody should be familiar with the inverse square law: as you move the light source farther away from the subject, the light falloff (or the light intensity) is inversely proportional to its distance from the subject. The ambient light remains pretty much the same throughout the room, so this is a pretty quick fix for reducing the contrast.

Step Five:

We talked about my favorite way in Chapter 4, but it's worth mentioning again. Simply use your on-camera flash, pointed to the ceiling or back wall, and adjust it down to fill the shadow side of the bride's face. When I use this technique, I dial down the flash output by trial and error until I achieve the result I want (see ❀ *Figure 6*). It's fast, easy, and quick to set up. Reaching for reflectors takes too much time. Moving the subject away from the window may change what's in my background. If the shot looks great, except for the higher contrast, the on-camera flash method is a very efficient way to get it.

When photographing the bride next to a window, it is always best to have her shoulders facing away from the window. Then, just ask her to turn her head back into the light to get that beautiful loop lighting

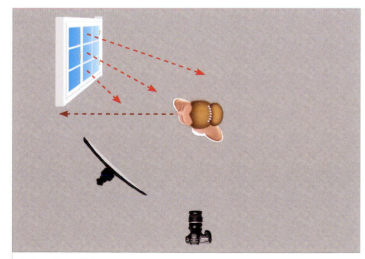

❀ *Figure 7: Profile View*

pattern. Keep in mind that if you have her face and shoulders both facing the window, the illumination on her gown will tend to overexpose the highlights in it when her face is properly exposed. Broad lighting will also appear to add weight to the subject. *No* bride wants to look heavier.

Window Light Profile View:

Step One:

In order to create a window-light portrait of the bride in a profile view and maintain the loop lighting pattern on her face, we need to move her closer to the camera and to the other side of the window (see ❀ *Figure 7*). Notice how we are once again just using the direction of light to create the loop lighting pattern on our subject's face (❀ *Figure 8*), like we did in Chapter 1.

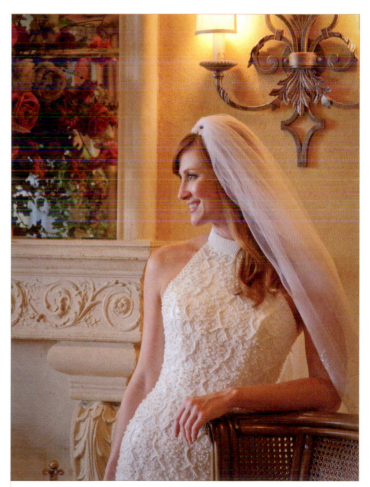

❀ *Figure 8*

(Continued)

I think a profile view is simply an elegant view of the face, and it creates a dramatic portrait. Sometimes, we are really lucky to have the perfect light available (❦ *Figure 9*). Here, the large window and outside light combined for a beautifully lit profile view, and we had the choice of doing everything from a tight head-and-shoulders view all the way down to the full-length view.

Step Two:

If you have a problem getting the proper illumination on your subject (you may be a fair distance from the window), you can adjust your exposure with aperture or shutter speed. But, with today's digital cameras, I'd just kick up the ISO.

Step Three:

Another problem that can pop up is with the overly contrasty look and feel in the shadows. In a profile view, most of the subject's face is in shadow. We want to be careful that the shadows are not too dark, and we don't lose detail on the shadow side of the subject's face. In that situation, it's easy to bring in a reflector or use the on-camera flash bouncing off the ceiling to create the needed fill light.

Remember, window light is just another type of light source, albeit a light source that can't be moved. But it is still a beautiful, natural, soft light source. Here are a few reminders about using window light:

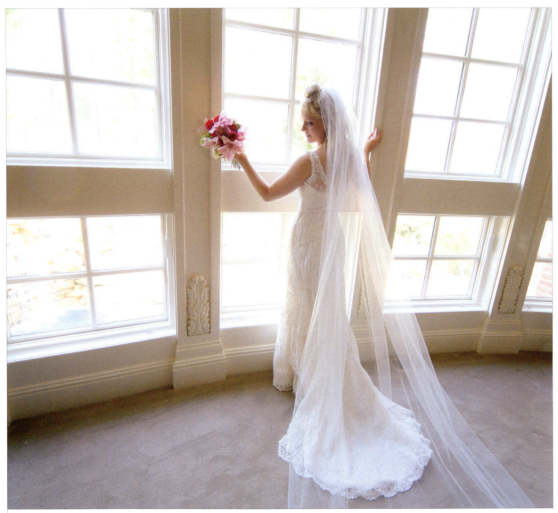

❦ *Figure 9*

Figure 10b

Figure 10a

Figure 10c

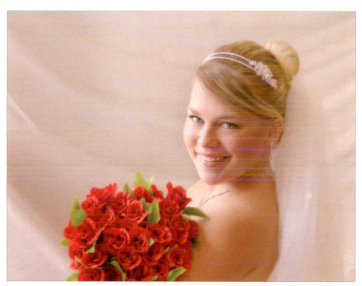

Figure 10d

Always keep the subject's shoulders facing away from the window (creating short light) to have the light skim her gown and give it added detail. It's okay to turn the bride's face back to the window light, but be sure the wedding gown isn't receiving the full blast of light, killing the detail of the gown.

Always check the contrast ratio—the brightness of the highlights when compared to the shadows—of the scene. My preferred method of softening the contrast is to use my on-camera flash bounced at the ceiling, with the light output adjusted downward to fill the shadows.

Always be sure, when making your window light images, that the background, whatever it is, is pleasing to the overall photograph. In a pinch, you may even be able to use the draperies themselves, by asking your assistant (in this case, one of my Master Class members; see *Figure 10a*) to pull and adjust them behind your subject, as a nice background to the scene (*Figure 10b*). I use a wide aperture, like f/4, on a long lens (120mm to 200mm) for these shots, so the drapes go nicely out of focus (*Figure 10c*) and create a very pleasing background for the photograph (*Figure 10d*).

This is particularly important: Verify where the directional light is really coming from when you're using a window as your main light source. If the sun is illuminating light-colored pavement outside the window, then the directional light is going to come from the ground upwards. If there is a big stand of trees or the wall of a

nearby building blocking the light, then the real direction of light may be coming down from a patch of open sky and from a very high position. These two situations are not uncommon, which is why I mention them. Remember, always pose your subject's face toward the light while, at the same time, trying to maintain a proper loop lighting pattern on their face.

Stepping Outside: Porch Light

Okay, let's move onto the porch (veranda, covered patio, portico, deck, etc.). "Porch light" is any situation where the light from above is blocked by a structure, but where large areas of light are still coming in from the side, illuminating the scene. Getting decent light on your subject can be tricky in these situations. The background may not be optimal, and the wind may be blowing, but the good news is that we generally have a very soft quality of light.

The main difference between window light and porch light is that porch light is usually a very broad light source, and we have less control over the direction of light on our subject. But there are a couple ways we can still control it:

Step One:

First of all, analyze the situation. If I position my subject in a porch light location, what I have is very soft, beautiful light pouring in on her. This is a good thing. Let's see if we can make the best of the situation. In *Figures 1a* and *1b*, the subject is looking almost directly back into the camera, and on her face is almost a soft, split lighting pattern.

Step Two:

Now, if I ask her to turn her head a bit more away from me, the lighting falls beautifully on her face (see *Figures 2a* and *2b*).

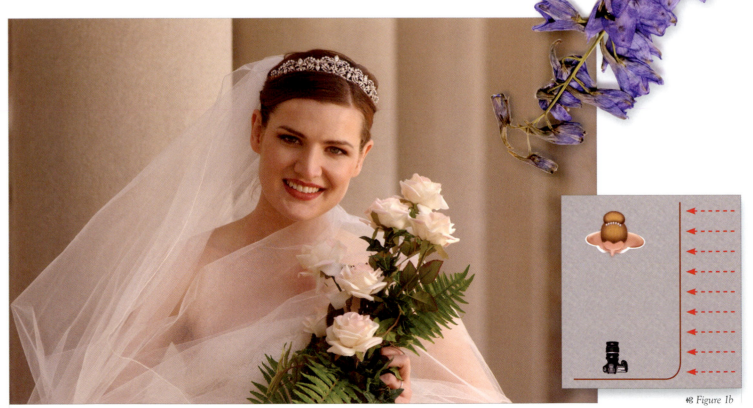

Figure 1a

Figure 1b

Step Three:

Notice in ✉ *Figures 3a* and *3b* that if I turn her head to a nearly profile view, I am turning her into the light, and completely lose the face-shaping, flattering, loop lighting pattern. I am left with the very flat butterfly pattern—not the best.

Step Four:

If I want a full-face view of my bride, the simple solution is to block the light coming from the bride's left side. There are a few ways that we can do this. In ✉ *Figure 4a*, most of the light is blocked, with the bride illuminated by the light coming from slightly in front of her. We also pick up some of the light coming from behind her. This backlighting should help illuminate the veil, as well.

Step Five:

How do I block the light? One way is to just simply hold up a light panel to block the light coming in from, in this case, the bride's left side, as shown in ✉ *Figure 4b*. But if you don't have a light panel, just have someone hold up one of the groomsmen's tuxedo jackets, placing it next to the bride. This technique works for the profile view, too (see ✉ *Figure 5*).

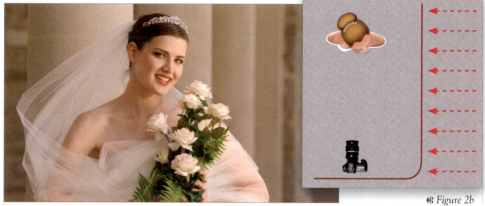

✉ *Figure 2a*

✉ *Figure 2b*

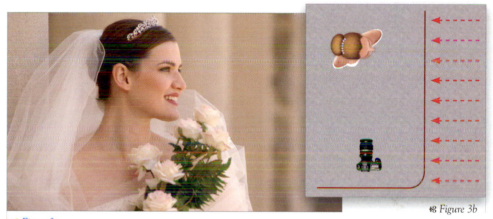

✉ *Figure 3a*

✉ *Figure 3b*

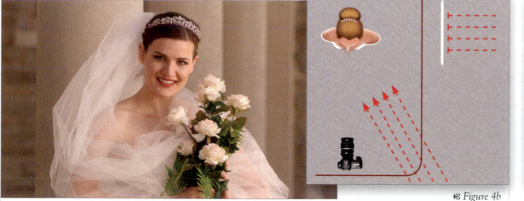

✉ *Figure 4a*

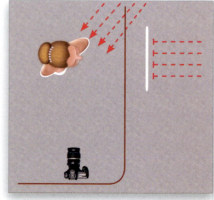

✉ *Figure 4b*

✉ *Figure 5*

(Continued)

Step Six:
I'll tell you, though, the best thing to do is just determine the direction of light in any given situation and pose your subject to the light until you get your flattering loop lighting pattern. Adjust your camera position, as necessary (see ❧ *Figure 6*).

❧ *Figure 6*

Into the Garden: Natural Light Outdoors

Finding the naturally occurring direction of light outdoors can be challenging, and, once again, we don't have the luxury of moving the light relative to the subject. Our challenge then is in finding the true direction of light with which to illuminate our subject, while trying to create a classical portrait lighting pattern on their face.

You'd think it would be quite easy to find and see light outdoors, but it's not as easy as you think. The reason is that, often, the light is so soft outdoors that there aren't clearly defined shadows to determine exactly which direction the light is coming from.

To help train your eye to see the direction of light, take a walk in the park, find a stand of trees, look up, and find a hole in the canopy of branches and leaves. This is your direction of light. Now, just walk in a circle around those trees. As you do, watch how the shadow characteristics change. When you can clearly see the highlight next to the shadow on the trunk of the tree, you have determined the direction of light falling on the scene. This directional light is going to be your new best friend as you make photographs of your subject(s) outdoors.

Of course, once you find a beautiful direction of light, and are able to place that light on your subject(s), you also have to hope that the background is not cluttered with street signs, cars, ugly buildings, or telephone wires. So, for me, the real challenge is finding a really beautiful direction of light, being able to get that light on my subject(s) in the most flattering way, and still have a great looking background. Let me show you how I do it:

Step One:
Find some really nice open shade outdoors. Open shade is your best friend. If some areas of my outdoor location are illuminated by the bright sunlight, I know I'm going to run into some exposure problems. I will sometimes visit the bride's home prior to the wedding day, at the same time of day as when I'll be at her home on the wedding day, just to see what the lighting and background possibilities are around the property.

(Continued)

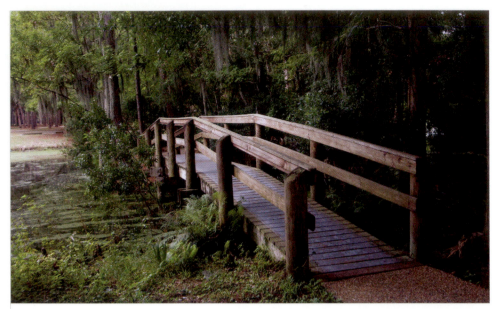

Figure 1a

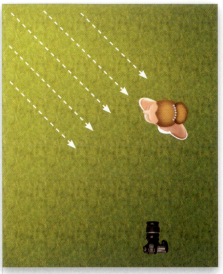

Figure 1b

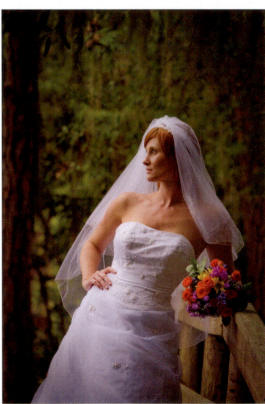

Figure 2

Step Two:
Analyze the lighting on the scene and determine which direction it's coming from. Once you determine the direction of light, you can determine which classical view of the face would work best. Take a look at ✦ *Figure 1a*. The light falling on the bridge came from slightly behind and above the bridge. That meant that my best portrait of the bride would probably be a profile view (✦ *Figure 1b*).

Remember, I'm always trying to put a classic portrait lighting pattern on one of the classical views of the face. In this case, I'm just going at it backwards. I'm first finding a light, and then posing my subject to that light, giving me a beautiful loop lighting pattern on my subject in a dramatic profile view.

Step Three:
Analyze the scene again, and see if, after positioning your subject in the scene, the background still looks good. In this situation, I was really lucky to have all the elements come together—a flattering

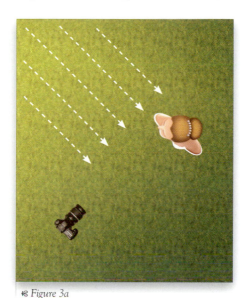

Figure 3a

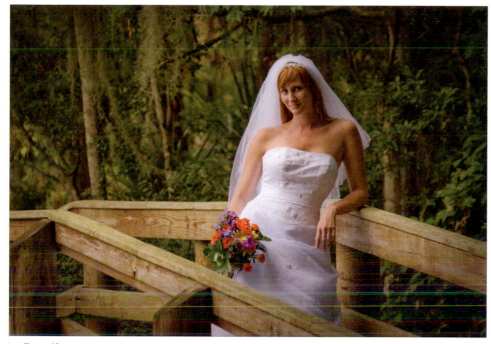

Figure 3b

pose, great lighting, and a dynamic background (see *Figure 2*).

Step Four:

Rotate around the subject to see if you can pick up another view of the face (*Figure 3a*). By making my way around the trees to my left, I found a camera position that allowed me to photograph the bride from a different angle (in this case, a two-thirds view). The background held together, as well, and the light was coming from the right direction (see *Figure 3b*).

Step Five:

But, I've got some lighting problems going on. If you look closely, you can see how dark the eye sockets are. That's because the light is coming in from too high an angle. The bride's head tilting down toward her right shoulder makes matters worse. Watch what happens when we tilt her head back toward her left shoulder (*Figure 3c*)—the eyes light up again.

Figure 3c

(Continued)

❦ *Figure 4*

❦ *Figure 5a*

Step Six:
Once all the pieces have come together, work the location. Change up the pose a bit (see ❦ *Figure 4*).

Step Seven:
Ask the groom to come in and join his bride (❦ *Figure 5a*) and let the couple have some fun (❦ *Figures 5b* and *5c*). Here's the cool part: your lighting now looks great for all these shots, because you took the time to get it right.

Step Eight:
We could continue rotating around the bride here, and photograph her in a full-face view (see ❦ *Figure 6*). There was only one problem for me in this location— I was at the edge of a lake. Two more steps to my left and I would have been alligator bait.

Step Nine:
Don't forget to consider the color balance of the scene, as well. Light is bouncing off of everything that's green, which will bring a greenish cast to the light illuminating your subject. Whether shooting JPEG or RAW, I would recommend getting a custom white balance of the scene. One of my favorite tools for this is ExpoImaging's ExpoDisc (pick up their portrait version). It just gives you a better color balance for photographing people.

Here are a few more tips for getting great shots outdoors:

❦ When shooting outdoors, I prefer to use a really long lens (my favorite is Canon's 70–200mm f/2.8 IS lens), and a fairly wide aperture (f/4 is my aperture of choice here). Because of the speed-limiting factor, I seldom shoot with the tripod, so image stabilization is vitally important for me outdoors.

❦ Try to have the background a good distance from your subject. That way, when shooting at the f/4 aperture, the

Figure 6

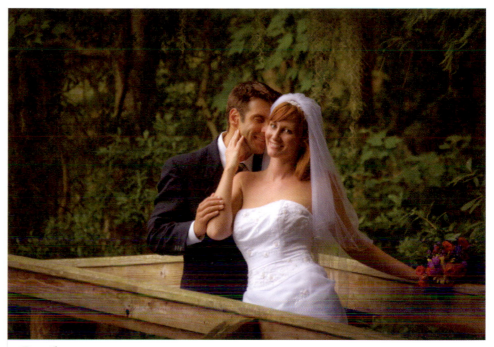

Figure 5b

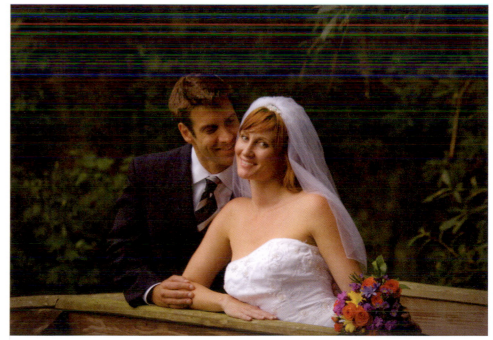

Figure 5c

background will go quite soft and out of focus, enhancing the overall look of the scene (see Figure 2 again).

- Be careful not to have bright, direct sunlight or splotchy foliage shadows in your background, and *never* on your subjects. If you do incur direct sun, it will blow out that area and really detract from the look of your overall image. No one looks good with splotchy sun patterns all over them!

- Watch where you position the horizon line in the scene, if there is one (refer to Chapter 7 [on composition] for a discussion of horizon lines).

- Explore the photo. Once you've found the ideal location, positioned your subjects, and captured the image you imagined, then move around, change camera direction, go high, shoot low, zoom in, zoom out, adjust composition slightly, encourage your subjects to change expressions…explore, explore, and explore some more.

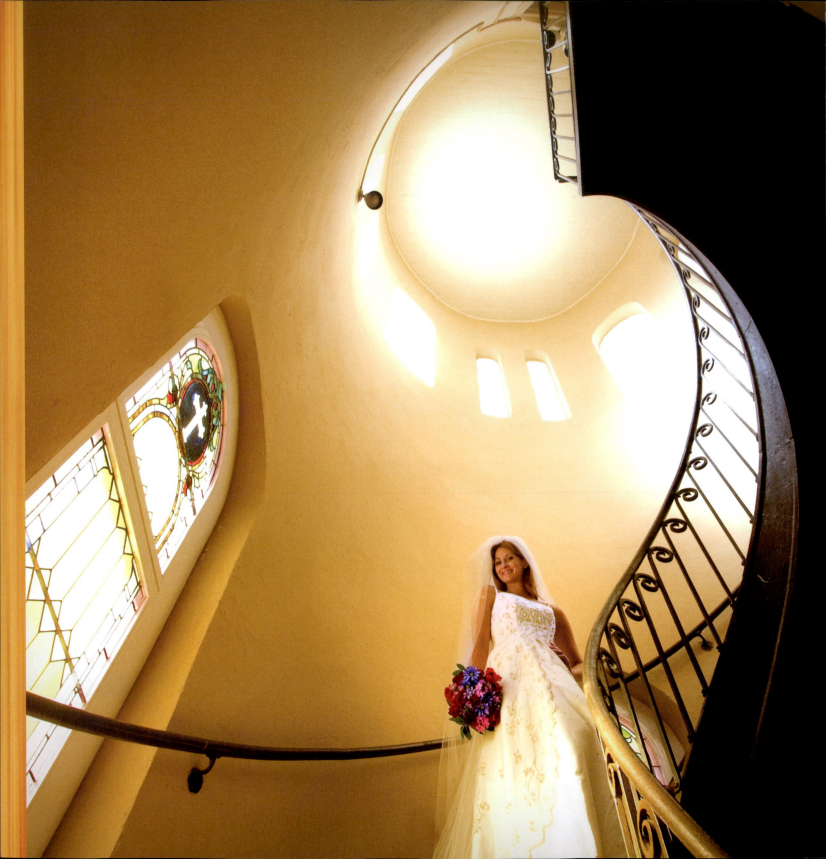

Learning to See Differently

Rules of Composition

Let me ask you this: Have you ever gone out and photographed a wedding and known immediately that you had taken some of your best photographs ever (the couple was beautiful, the lighting was perfect, the locations were outstanding)? When you get back to your studio and download the files, you can't wait to see those fantastic images that you created.

You're right, they are the most beautiful wedding images you've ever taken! You are as proud as can be with yourself and can't wait to get the opportunity to do it again. A few weeks go by, maybe even a month or two. You check the booking sheet. It's true—you're going to be at that same beautiful location you were at two months earlier. You're excited! You'll be able to pull off another fantastic series of images. Once more, the weather is perfect, the couple is gorgeous, and everything is right with the world on this particular wedding day.

But this is where the problems start to creep in. Try as you might, the shots just don't seem to come together. Why is that? You've got a gorgeous couple, beautiful location, great lighting, perfect day—it's just the same as last time. But for some reason, the images just aren't soaring as spectacularly as they did a few months earlier.

Has this ever happened to you? It happened to me plenty of times, and I was frustrated by the fact that I wasn't able to consistently produce the same results. Was it just a fluke? I had a lot of self-doubt and frustration.

The problem seemed to be that I was unable to duplicate all the image elements reliably from one wedding to the next. How could I determine where to place the bride and groom in the scene? How could I make the basic elements of the composition work for me in my finished photographs? What rules could I follow that would give me predictable and repeatable results wedding after wedding? That is when I started studying composition.

In this chapter, I'm going to walk you through several different scenarios, applying the basic rules of composition. I think as you follow me through these steps, you will find that the doors will open to much more exciting images for yourself. The bottom line is this: knowing these simple rules of composition will give you a newfound confidence to be able to create awesome wedding images week after week, month after month, and year after year. So let's get to it.

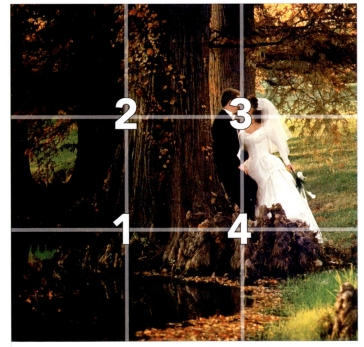

The Rule of Quadrants & Rule of Thirds

When we look at an image, what do I mean by composition? It's the placement of the subject within the image area, which creates a visually balanced image. How do we determine the positioning of the subject within our image area? Let me show you:

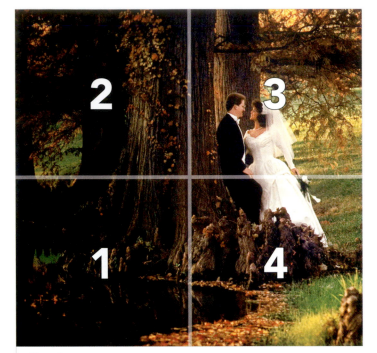

❀ *Figure 1*

One of the easiest rules to follow, which I discovered years ago, is what I call the "rule of quadrants." Take a look at ❀ *Figure 1*. You can see that I've bisected the image both vertically and horizontally, making four quadrants. My rule of quadrants is this: just put your subject in one of the four quadrants and you'll create a nice visual balance.

I know you're thinking: "David, make it a little harder than that. This is way too easy. Surely there's a more sophisticated rule within your rule of quadrants." Okay, I'm going to make it a little tougher, but not that tough. Let's refine the quadrant rule a little bit. This is called the "rule of thirds":

Step One:
Let's first divide our viewfinder into one-third increments both horizontally and vertically (see ❀ *Figure 2*). I know the diagram looks like a simple tic-tac-toe board right now, but hang in there with me.

Step Two:
Where the lines intersect are what I'm going to call the nodal points. We have nodal points 1, 2, 3, and 4.

Step Three:
Now, folks, here is the refinement of the rule of quadrants: Basically what I want to do is put the main part of my subject at one of the nodal points. It's just one way of refining the positioning of the subject within the image area. It draws the viewer's attention to the subject that much more effectively, because of the nice visual balance that we've created. Check out ❀ *Figure 3* to see what I mean.

❀ *Figure 2*

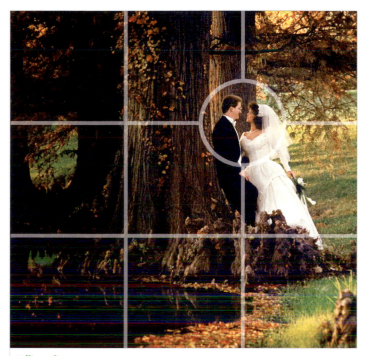

❧ *Figure 3*

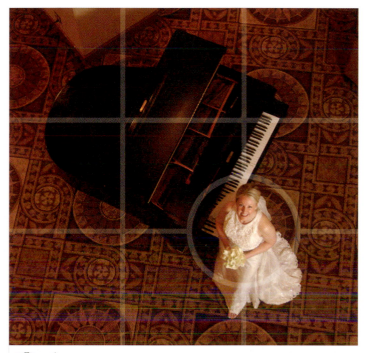

❧ *Figure 4*

Step Four:

Take a look at this next photograph (❧ *Figure 4*). We have the nice diagonal line of the carpet and the diagonal line of the piano—everything seems to work together very nicely. One reason the image feels right is because my bride is in the fourth quadrant. More importantly, though, she's at nodal point #4, as well.

Step Five:

Our next photograph (❧ *Figure 5*) is an image I took of my good buddies, Jenn and RC. The setting sun and dramatic clouds certainly add to the impact of this image, but you know what else adds to the balance of this image? Could it be that the subjects are hanging out at nodal point #4, too?

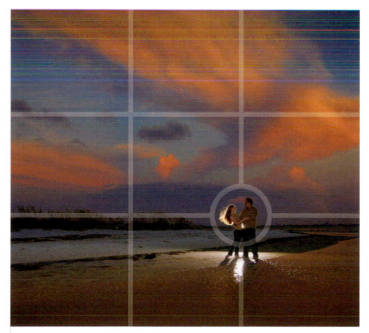

❧ *Figure 5*

Centered Symmetry Composition

There are times when the rule of quadrants and the rule of thirds aren't the best rules to follow for composing our subjects. Sometimes, because of the architecture of the location, the subjects may look best dead center in the composition.

Check out ❦ *Figure 1*. Trying to position the subject here using the rule of thirds, which we discussed in the previous technique, just wouldn't have worked as effectively or have had the impact of the centered composition I chose.

How about our next image (❦ *Figure 2a*)? The bride and groom in this beautiful natural setting are dead center in the composition. But notice as I move them around into one of the other quadrants, it doesn't seem to improve the composition. If I put my subjects down in between the first and fourth quadrants, what happens then? I'm going to have quite a bit of mass in the top of the image—the image is top-heavy, visually speaking of course (❦ *Figure 2b*).

Let's reposition them on the #2 or #3 nodal point. As soon as I do that, I have inadvertently focused the viewer's attention to the detail at the bottom part of the image, thereby pulling the viewer's attention away from our main subjects, the bride and groom (❦ *Figure 2c*). Again, not a good thing.

They look best dead center, and that's where I ended up placing them. Anyway, keep it in mind and explore the different positioning of your subjects within your image area. You can improve the positive aesthetic feel of your imagery with these simple compositional rules. I also believe that it becomes a great differentiator for us, separating us from the competition. Most photographers have never even considered this information.

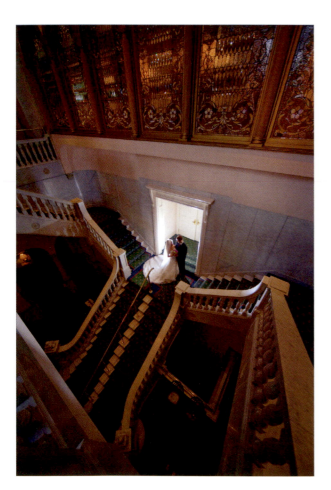

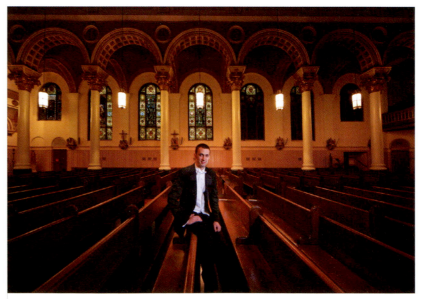

❦ *Figure 1*

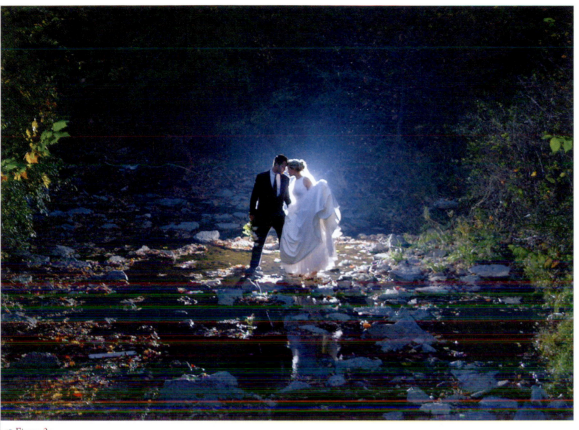

❧ *Figure 2a*

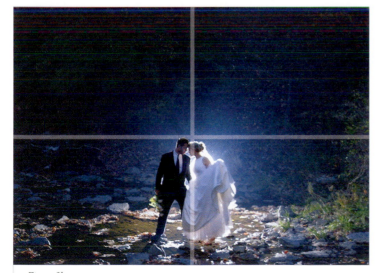

❧ *Figure 2b*

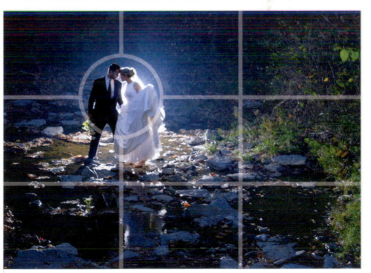

❧ *Figure 2c*

Crash Point
Symmetry

Let's take a look at the main image below and ✱ *Figure 1*. These images represent a different kind of symmetry, called crash point symmetry. I learned this lesson from my good friend Jerry Interval, who, unfortunately, is not with us anymore. I heard Jerry speak about 25 years ago at one of our quarterly photography meetings in Kentucky. He talked about crash point symmetry. With my background as an engineer, this made me sit up and give him a good listen. Here's Jerry's lesson:

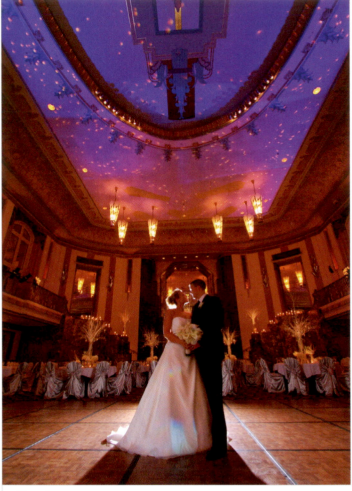

✱ *Figure 1*

Step One:

Survey your entire three-dimensional space and, in your mind's eye, view it within a two-dimensional compressed space. In ✱ *Figure 2*, the three-dimensional space is a stairwell at the Ritz-Carlton New York, Battery Park, in New York City.

Step Two:

Now, view that two-dimensional compressed space and determine if there are any lines within the image area that you can use to point to your subject. Basically, I want to see where the lines are leading in the scene. I've drawn my compositional pointers on Figure 2, and you can easily identify where all the lines are leading.

◆ *Figure 2*

◆ *Figure 3*

Step Three:

The final step is to simply place your subject at the intersection of all the lines. That's how I determined the positioning of my bride in Figures 1 and 2. This really speaks to how I compose my photographs. Many photographers will drag the bride and groom from one location to another trying to get a shot. What I like to do is survey the location first, determine where the leading lines are pointing to, and then bring the bride and groom into the composition that I've envisioned.

In the next photograph (◆ *Figure 3*), it's pretty evident where the crash point is. We can actually see all the V-shapes just crashing down onto the subject. We also have the curve of the arches pushing back up into the photograph. All the tension is happening at one spot: the crash point. That was the obvious position to place my groom.

This is a really fun way to look at your imagery, and pre-visualize where you might put your subjects. Finding these leading lines can also be a great way to add drama to your wedding photography.

Understanding Horizon Lines

What's the big deal about horizon lines anyway? Many photographers don't give much thought to the concept. They just say to their bride and groom, "Mary, let's have you stand next to pew #12 and hold the flowers with both hands in front of you. Okay, John, let's have you join Mary, and put your arm around your beautiful bride." Then they click off a couple quick photographs without considering the placement of their subjects in relation to the horizon line.

It's too bad we don't pay much attention to the horizon line, because proper placement of the subject against it can really give your wedding images a stronger composition—a look that feels better when you view the finished images. Let me walk you through three horizon line scenarios and show you how you can improve an image with your understanding of this concept.

Horizon Lines Indoors

So, where are they? Folks, that's where the wall meets the floor. Most churches have steps in front leading up to the altar, pulpit, choir area, etc. We will let these steps represent our horizon line in this example.

Step One:
Notice that, in ❧ *Figure 1*, the horizon line is crossing my subject right about at her waist—right across her middle, literally bisecting her body into two even sections.

Step Two:
But, what happens when we change the position of the horizon line? Suppose I want it positioned much lower behind the bride. I need to drop to my knees, getting the camera much closer to the floor in order to lower that horizon line substantially—it now hits my subject right about at the knees (❧ *Figure 2*). The camera is probably about 3 feet off the ground, and I think this photograph has a much stronger impact. Repositioning the horizon line gives her a much more stately look than we had with the horizon line cutting through her waist. Notice, too, that my bride is at nodal point #4.

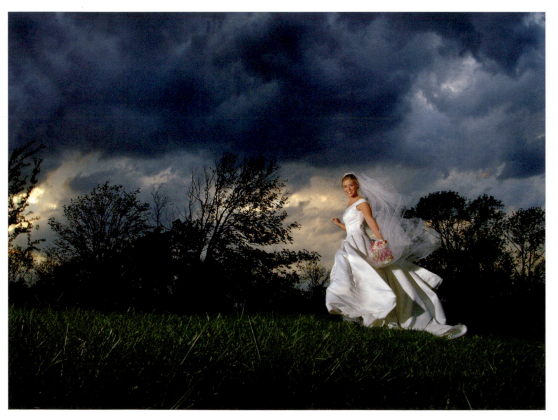

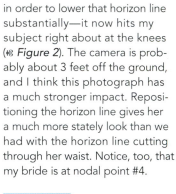

Step Three:
Take a look at ❧ *Figure 3* (I love our digital zoom lenses—sure makes life easier than the old medium format days. We can stay at the same place, and just zoom in closer and take another nice photo). This time the horizon line is hitting her about one-third of the way into her body from the bottom of the frame.

This is ideally where I position my subject relative to the horizon

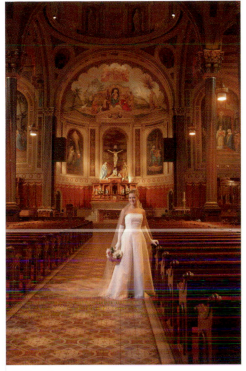

Figure 1

Figure 2

Figure 3

line. I want the horizon line intersecting my subject right at the knees or at the bottom one-third of the pose. And, in this beautiful bridal portrait, I positioned her halfway down the aisle.

Horizon Lines Outdoors

Outdoor horizon lines are where the sky meets the ground. Let's look at several scenarios that will help you find the optimum subject placement when photographing brides and grooms outdoors and a horizon line comes into play.

Step One:

When working outdoors where the composition includes a horizon line, I always put my subject at the highest point of the horizon (❧ *Figure 4*). Notice, too, that the bride is positioned at nodal point #1. See how following the compositional rules really makes it easy to create a great photograph?

❧ Figure 4

(Continued)

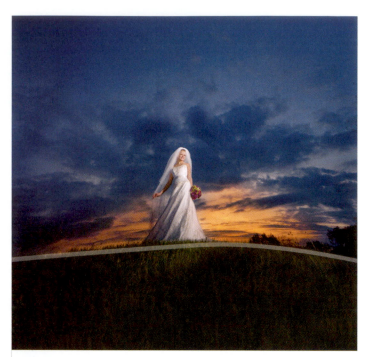

Figure 5

Step Two:

Let's go ahead and analyze the original shot, before I reframed it (❦ *Figure 5*). As I mentioned, the subject is at the highest point of the horizon line.

Step Three:

Now let's add my rule of thirds tic-tac-toe board to the scene, so I have a roadmap of where the subject's best position would be in this scene while I compose the photograph (❦ *Figure 6*).

Step Four:

The next step is to reposition the camera and then reframe the image, so that my subject falls on one of those nodal points—in this case, nodal point #1 (❦ *Figure 7*). Now the image looks much better balanced and is dynamically stronger as a result.

Step Five:

If you're wondering if the image would be improved by positioning the bride at nodal point #4, let me explain why that doesn't quite work: If I move her to #4, see how her upper body is turned, almost as if she's going to look behind her? At #4, the right side of the image is cut off, and she has nowhere to look, which is not the best composition (❦ *Figure 8*).

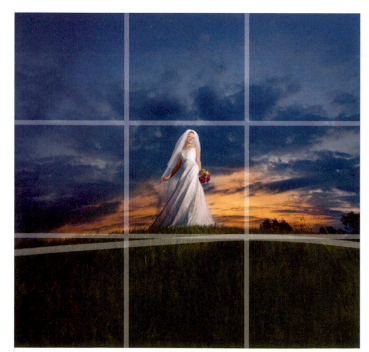

Figure 6

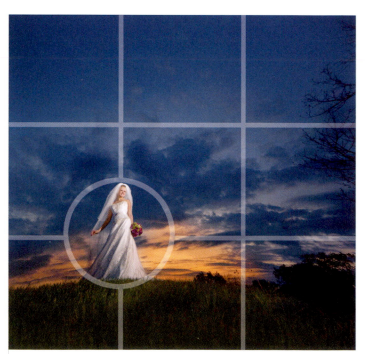

Figure 7

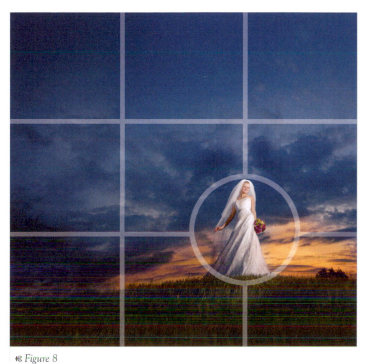

Figure 8

Figure 9

Anyway, I think with our bride positioned at the highest point of the horizon line and positioned at nodal point #1, we dramatically improve the image (*Figure 9*).

Step Six:

By the way, the inverse of that is true, as well: we can put our subject at the lowest part of the horizon line, too. I like to call it the resting point of the horizon line (*Figure 10*).

Figure 10

(Continued)

Figure 11

Figure 12

Implied Horizon Lines

Now, let's take a look at Figure 11. I know what you're thinking, "Hold on one second, David. I don't see any clouds or skies or a wall intersecting the floor, or anything. I don't even see a horizon line in this image." But, this image has a railing running through it directly in front of the subject. This is an implied horizon line.

So, how do I position my subject with respect to an implied horizon line? That's easy. There's an old car commercial where they rolled a ball bearing around the seams of a car to show its fine craftsmanship. So, pretend that this is a grooved railing. If I drop a ball bearing from near the top and it starts rolling downhill, eventually it will come to rest at the lowest point of the railing, and that's where I position my subject (Figure 12). Just like in our outside images, we can also position them at the highest point of an implied horizon line, say if the angle of the image makes a curved railing seem to bulge in one spot (Figure 13).

Now, it looks like I don't have my subject in Figure 12 positioned on one of those nodal points. She looks like she's in the vertical center of this image. Well, she does at first glance, but hang in here with me for a few more pages and I'll show you how I specifically positioned her within this image for the best composition.

I hope you're getting the feeling that, as you learn and understand the simple rules of composition, you are giving yourself a tremendous set of tools that will enable you to go out and create dynamic, impacting images consistently week after week, month after month, and year after year. Your clients will see a difference in your work.

Figure 13

The concept of repeat elements can be seen in the main image here in the fountain leading directly to the bride and groom. Can these repeat elements be considered an example of the crash point symmetry we discussed earlier? They sure can. So you can see that we can maximize combinations of compositional elements to increase the interest in the image. An excellent example of repeat elements is the pillars we often see in the architecture of churches and synagogues.

Let's discuss repeat compositional elements in a different context:

Step One:
The first repeated elements in ⊕ *Figure 1* are the diagonal lines of the subject. They are also repeated in the image of the lady in the painting.

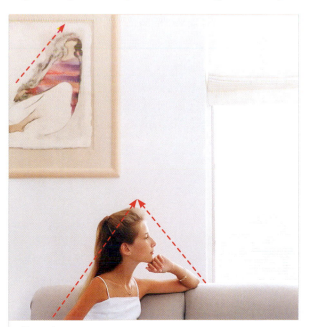

⊕ *Figure 1*

(Continued)

Figure 2

Figure 3

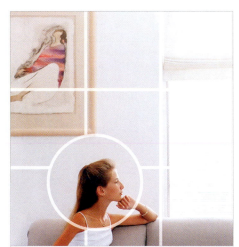

Figure 4

Figure 5

Step Two:

Now check out the tonalities of the scene (*Figure 2*). When I look at this scene, I see color tonalities in the flesh tones of my subject that are pretty similar in tone to the colors in the painting. So this represents another example of repeat elements.

Step Three:

If we look closely, we can see yet another illustration of repeat elements within the scene: the rectangles scattered throughout. There are rectangles in the blinds, in the window itself, the settee that the girl is sitting on, and the frame and matting of the painting (*Figure 3*).

Step Four:

We have one more repeat element that I would like to point out: the profile view of the young lady. It's repeated in the profile of the lady in the painting (*Figure 4*). So, we have four repeat elements in one photograph. They are inner voices that subconsciously speak to us, and the combination of these elements allows us to enjoy the image on several different levels.

By the way, did you notice that the subject is in nodal point #1 (*Figure 5*)? I have the repeat elements going on, but I have some of the basic compositional rules happening, as well. Also, she's in a profile view, which we discussed in Chapter 2. And yes, there's a loop lighting pattern on her face, as well. Don't you love it when a plan comes together?

Interior Frames: Frames Within Frames

So far, we've had a lot of discussions about the rule of quadrants and rule of thirds. Everything we've been talking about so far with respect to composition has been in relation to the exterior frame. But there are also interior frames sometimes within our compositions. They may be rectangles, squares, triangles, trapezoids, etc., but we need to be aware of them.

In this photo of our groom (❧ *Figure 1*), he is positioned with respect to our exterior frame. But, the picture frame hanging on the wall behind him is an interior frame (outlined in red). Now, the rule of thirds applies with respect to the interior frame, as well. If we lay our tic-tac-toe grid on this image (in white), where's the groom going to be? At nodal point #4.

It's pretty cool how this works with both the exterior and interior frames. Sometimes, the nodal points of the exterior frame line up with the nodal points of the interior frame, and by placing our subject at the same nodal point, we actually get an expanded feeling of depth in the image.

Two Little Exercises on Interior Frames

Let's go through the process of finding the interior frame and then determining the best position to place the subject within it. Remember, the same rules of composition that hold true for exterior frames also hold true for interior frames.

❧ *Figure 1*

(Continued)

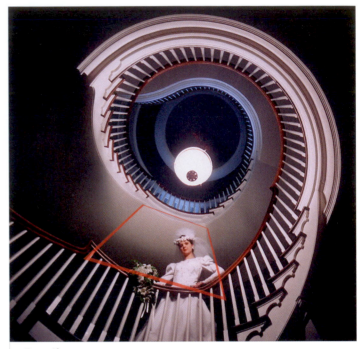

Exercise 1

Step One:
Remember our bride on the stairs, from earlier in the chapter, who seemed to be positioned in the vertical center (✿ *Figure 2a*)? Where is the interior frame in this example?

Step Two:
Take a look at ✿ *Figure 2b*. It illustrates the position of our interior frame.

Step Three:
Now let's lay our tic-tac-toe board (rule-of-thirds grid) on the interior frame, and it's easy to see that the bride falls on nodal point #3 (✿ *Figure 2c*).

So, even though she was centered with respect to the exterior frame, using our rule of thirds, we positioned her on one of the four nodal points of the interior frame.

Exercise 2

Step One:

In the next image, my subject is pretty much centered with respect to the exterior frame, but where is the interior frame? The interior frame happens to be the triangle behind her created by the railing, base of the stairs, and the edge of the wall (☙ *Figure 3a*). If we lay my tic-tac-toe board (rule-of-thirds grid) on the interior frame, we can see the bride is positioned on nodal point #2 of the interior frame.

Step Two:

But wait, there's more. There's another interior frame in this image—the view through the arch in the middle of the photograph (☙ *Figure 3b*). She's pretty much centered within the arch.

I would encourage each and every one of you to start looking for interior frames within your compositions. They are everywhere. Most churches have features that represent interior frames—an arch, stained glass window, or doorway—within which we can position our subject for a more exciting composition.

When you start refining the position of your subject with an interior frame, improving the horizon line placement behind your subject, placing a direction of light on your subject's face, and placing them into a classical position, you start to create images consistently that will tickle your brain juices. These small details definitely make a difference!

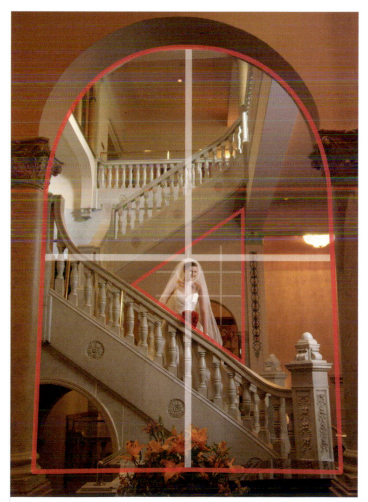

☙ *Figure 3a*

☙ *Figure 3b*

Vanishing Point: From Here to Infinity

One of my favorite compositional elements is the use of the vanishing point. It's also something many shooters don't consider when composing their images. Let's discuss the different ways you can position your subject with respect to the vanishing point (this is super-cool. I get goose bumps even thinking about it):

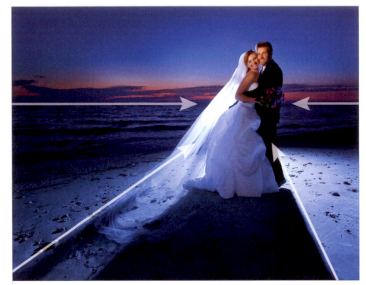

✿ *Figure 1*

Positioning Your Subject at the Vanishing Point

Intuitively, the first place a photographer wants to position his subject in the scene is at the vanishing point. Sometimes that's a good idea, and sometimes it's not. Let me show you what I mean:

Step One:

In ✿ *Figure 1*, I've drawn in the vanishing point, so you can easily see what I'm talking about. Notice, too, that the couple is positioned at nodal point #3. (Isn't it fun how all these composition rules continue to work their magic?) I've got a little backlighting on them, as well, just to add pizzazz to the image.

Step Two:

Take a look at our next image (✿ *Figure 2*). The vanishing point in this example is easily described by the direction in which all the stairway spindles are pointing, as well as the spiral staircase itself. Every single one of those spindles is pointing down to my bride and groom. Everything leads to the vanishing point, and subconsciously our mind is directing our eyes to follow those leading lines. So when we begin to understand that our mind is leading us to this destination, then it makes sense that this is the position we need to place our subject. But not always.

Step Three:

There are times when positioning your subject at the vanishing point is not a good idea. One of the first times I made this mistake, I was at a beautiful location lined with long rows of pillars. I asked my clients to stand at the end of the row of pillars—at the vanishing point, if you will. I looked through the viewfinder and couldn't find

✿ *Figure 2*

them anymore. They were just small specks in the image.

I thought just moving closer to the bride and groom would solve the problem of their size in the image. They did indeed become larger in the image, but as I got closer and closer to them, I lost the dramatic impact of the long row of pillars.

In ❧ *Figure 3*, I positioned my subject, LaDawn, at the vanishing point. I have my beautiful repeating line of pillars, but it's very difficult to spot her in the composition.

Step Four:

So, just as I attempted to re-solve my problem so many years ago, I approached the subject to make her larger in the viewfinder. But notice in ❧ *Figure 4* that now I've lost the very dramatic row of pillars. This is where you go to Plan B (read on to find the solution).

❧ *Figure 3*

❧ *Figure 4*

Positioning Your Subject in Front of the Vanishing Point

Before we get to Plan B, let's look at another way to position the subject with respect to the vanishing point. Here, we'll position her in front of the vanish-ing point (❧ *Figure 5*). Notice how your eye is still led to the subject because all lines in the composition still lead there, even though the subject is in front of the vanishing point.

Now, Plan B was to take up my original camera posi-tion, but this time have LaDawn walk closer to me, as opposed to me walking closer to her. Since I'm not changing my camera position, I continue to have the long row of pillars in the viewfinder. What happens to the vanishing point as LaDawn approaches the camera? The vanishing point continues to stay behind her, and all the leading lines continue to lead to my

❧ *Figure 5*

(Continued)

Figure 6

the bride and groom. When you look at the image, the eye has two points of interest to explore: The position of the vanishing point naturally draws the viewer's attention opposite the main subjects, and invites the eye to explore the entire beautiful ballroom. But, the viewer sees the bride and groom as an important part of the composition, as well. Literally, your mind subconsciously jumps from point of interest to point of interest.

So, there you have it: three places to position your subject within the image area relative to the vanishing point of the scene. It's another great compositional tool to improve your wedding photography.

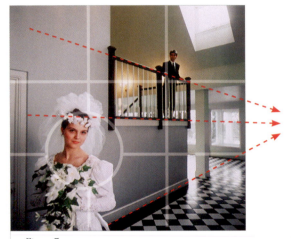

Figure 7

primary subject (*Figure 6*). Placing the subject in front of the vanishing point can be a great solution and a strong composition.

Positioning Your Subject Opposite the Vanishing Point

If you ever check out executive portraits in *Inc.* magazine or *Business Week*, this is often the portrait composition rule of choice for them. From the reader's point of view, we see the subject and the subject's surrounds. This is also one of my favorite ways to position my subjects in the composition.

Step One:

The third place to position your subject is opposite the vanishing point (*Figure 7*). We can see that the vanishing point is actually outside the camera range in this example. So if you follow the lines, you will see that I have positioned my subject opposite the vanishing point. She is standing at nodal point #1, in a modified two-thirds view, and has a loop lighting pattern on her face. Those basic rules keep coming back, don't they?

Step Two:

Let's take a look at another image (*Figure 8*). Here we have our bride and groom in a beautiful ballroom. Notice that the vanishing point is still within the field of view of my viewfinder, and is opposite

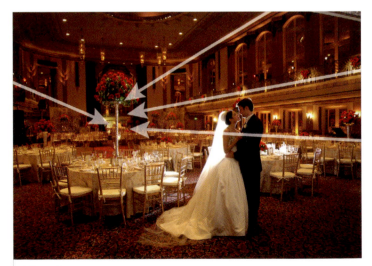

Figure 8

Figure 1a

Figure 1b

Figure 2

Compositional Pointers

The bottom line is this: look for the lines in the scene, see where they are pointing, and put your subject there. Let's look at how this rule, along with the other rules we have discussed so far, can really help us produce some striking images:

Step One:

Look at our next image (*Figure 1a*). Let's follow this curved architecture from the top of this small room—I've drawn an arrow on top of it. See how this leading line points to the bottom right-hand side of the image area?

Step Two:

Next, I drew an arrow all the way down the S-curve of the railing (*Figure 1b*). See how it's pointing to about the same location? Then, I drew an arrow on that line on the ceiling where the chandelier is hanging. Notice how it also points to the same spot? Very interesting, isn't it?

Step Three:

This clearly indicates to me that the best place to position our subjects is where all the leading lines are pointing, and that is what I've done. As you go through the same exercise, determining where the leading lines are pointing and placing your subjects in that position, just be sure to recompose the scene so that your subjects are also falling on one of the nodal points we discussed earlier. In this image, they are positioned at nodal point #4, my groom is in a nice profile view, and there's a loop lighting pattern illuminating his face. Check out *Figure 2* to see the same exercise repeated with a different image.

The Best Compositional Tool of All: Focal Length

Boy, this sounds pretty geeky, doesn't it? Well it might, but choosing the correct focal length for your shot is one of the most powerful tools in your composition gear bag. Here, I want to talk about how to use the focal length of the lens to change the perspective of the subject relative to the scene.

Step One:

Take a look at our first image (☞ *Figure 1*). This was taken with a wide-angle lens. I want you to notice the size of the arch over the altar in the background, with respect to the groom in the foreground—the groom is twice the size of the arch. When I ask if this is a small, medium, or large church, almost everybody says it's a pretty small church. That's what it looks like at first glance.

Step Two:

Now let me change from a wide-angle lens to a normal focal lens, back the camera up a few steps, and recompose the image. The groom is still standing next to the exact same pew, but see what happens to the size of the arch relative to the size of my groom in ☞ *Figure 2*? Now the arch is about the same size as my subject.

Step Three:

Now let's change to a telephoto lens and see what happens. I have to back up way down the aisle in order to fit the entire arch into the field of view, but look what happens (☞ *Figure 3*). The arch is now twice the size of my groom. Can you see the tremendous amount of creative control that we get just switching from a wide-angle lens, to a normal lens, or even to a telephoto lens?

Most of us think we need a wide-angle lens to get everything into our shot, and we need a telephoto lens to bring everything in closer within our image. But if we understand how the focal length of the lens can change the size relationships of objects in the background to subjects/objects in the foreground, and vice versa, it can be a tremendous creative tool.

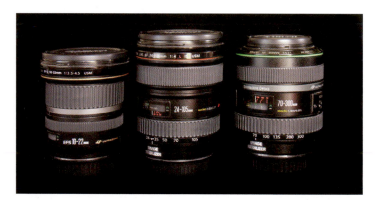

☞ *Figure 1*

☞ *Figure 2*

☞ *Figure 3*

Step Four:

Now, look at all three images again. The one on the left was taken with a wide-angle lens, the middle with a normal lens, and the one on the right with a telephoto lens. Let me ask the same question I raised earlier. Is it a small, medium, or large church? It seems to get a little bit larger as we keep looking at it. The conclusion you might draw from this is that wide-angle lenses make spaces look small, and longer focal length lenses make them look larger. Well, maybe and maybe not.

Step Five:

Let's go to the back of the church, attach a very wide-angle lens to the camera, and reposition the groom. This church looks quite large now, doesn't it (⨳ *Figure 4*)? What makes the space look so large? Remember the repeat elements we talked about earlier? We've got a lot of repeat elements here, represented by the rafters in the ceiling and the pews. In fact, we have repeat elements over about 60% of the image area, making the space appear large.

Step Six:

If I can increase the repeat elements over a greater area of my image, do you think I can make this space look even larger? Maybe so, but how am I going to do it? Right now, I'm at a fairly low camera position, approximately 3 to 4 feet off the ground, using my wide-angle lens. The pews at the bottom of the image are fairly compacted together, kind of like an accordion. So if I raise my camera position, maybe to about 6½ feet, that will "un-accordion" those pews and give me a whole lot more of those repeat elements in the bottom part of my image area, while maintaining the ones in the ceiling area (see ⨳ *Figure 5*).

Doesn't the space look like it's been increased substantially? It's amazing. You can visually see a difference and, actually, you can feel a difference. The space is larger. That means our imagery can create an emotional home run with our viewers. Knowing how to fine-tune our images with these compositional rules becomes a huge differentiator for us when our clients compare us to other photographers.

The Bottom Line Is…

Understanding compositional dynamics is power! I think one of the biggest benefits of understanding the rules of composition is that it gives you a newfound sense of confidence. It's like bells and whistles going off. It's a revelation, and it's just plain cool to see these elements come together in your final image.

Each new location presents wonderful opportunities to create exciting images for our clients—images they will recognize as different from the competition, images that will speak to them and tickle their brain juices, images that you yourself will find timeless enjoyment creating.

⨳ *Figure 4*

⨳ *Figure 5*

Cameras, Lenses, and Lights, Oh My!

What's In My Gear Bag

Every photographer likes to peek into another photographer's gear bag. What's he shooting with that I don't have? Why's he using that lens instead of the one I'm using? How many cameras does she shoot with at a wedding? Everybody wants to know.

On that note, let me give you a peek into my bag. Now, I happen to be a Canon shooter, but that doesn't mean I am trying to get everyone to switch. I encourage looking beyond the brand of gear to study the reasons why I've made my choices for this set of gear.

With that said, let's take a look....

Cameras

We'll start by looking at the cameras I shoot with:

Canon EOS 7D and 5D Mark II

Why do I shoot with the Canon EOS 7D (❀ *Figure 1a*) and 5D Mark II (❀ *Figure 1b*)? Here are a few reasons:

1 ISO, ISO, ISO. Yep, speed freaks like me love the new higher ISOs available in the Canon 5D Mark II. The 7D does a commendable job, too, but the 5D Mark II lets me go all the way up to ISO 6400 without a problem. If I get a slight bit of noise, I just fix it with Nik Software's Dfine 2.0.

2 I love the larger, crisper LCD monitor and its ability to give me a decent indication of the correct exposure.

3 I like the faster focusing ability, especially on the 7D, with its brand new focusing system. Getting those low-light shots at the wedding reception is now a breeze.

4 I love the three custom user-definable settings—three cameras in one at the turn of a knob. For instance, my first custom setting is always set to 1600 ISO at 2800K, P (program mode), and center spot metering. So, when I find myself in a tight situation, I can simply turn the dial to C1, turn off my on-camera flash, and shoot away in the available light of the scene, getting some great candid images. I set C2 to 3200 ISO, with all the other settings the same as C1. I don't use this one very often, but in a pinch at a wedding reception, it may just fit the bill. I reserve the C3 setting for specifics relating to the current job.

5 Resolution. The Canon 5D Mark II has 21.1 megapixels and costs $2,700. The Canon 1Ds Mark III also has 21.1 megapixels, but costs $8,000. Ummm...what a tough choice. A $5,000+ difference. (The Canon 7D has 18 megapixels and costs $1,700.) For me, buy a lens, or maybe three, with the savings.

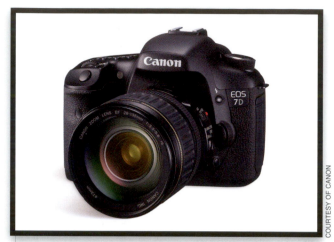

❀ *Figure 1a*

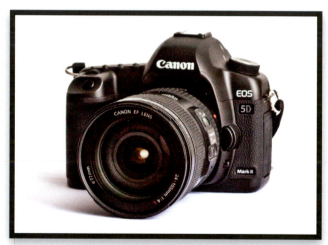

❀ *Figure 1b*

6 The sRAW and mRAW settings. Okay, I've wrestled with this one ever since I burned through 56 GB shooting a Bar Mitzvah right after I got the 5D Mark II. Heck, I almost blew a tire coming home with the weight of all those RAW files. But, I think

Quality	SRAW 1
Beep	Off
Shoot w/o card	Off
Review time	8 sec.
Peripheral illumin. correct.	

Canon

❀ *Figure 2*

I found the solution—sRAW on the 5D Mark II and mRAW on the 7D (❦ *Figure 2*). At that setting, I get files that are about 30% smaller than the full RAW format.

7 I love my Sigma 12–24mm lens on the full-frame 5D Mark II camera body. It's about as wide as you can go. (More on that lens later in this chapter.)

8 What don't I like about the 5D Mark II? No pop-up flash. What can I say, I still like that little guy every now and then when I don't want to attach the 580EX II flash. But with all the other 5D goodies, I guess I can live with it missing. And, hey, I still have it on the 7D (❦ *Figure 3*).

9 On the Canon 7D, I still like the little pop-up flash. Don't think I'm crazy here, because at the end of the night, after we pack everything up, say our goodbyes to the bride, groom, and their parents, and we're walking out the door, what invariably happens? Somebody wants one more picture. No problem. I don't have to unpack the bag. I know this photograph is going to be a quick-grab candid, so I simply pop up the flash, capture a couple of images, wave good-bye, and continue on my way.

10 I love the video capabilities on both the 7D and 5D Mark II. Using Animoto's new video capabilities, I don't even have to know how to use any video software to create very cool slide shows with the short 3-second video clips built right in. Animoto lets us upload our favorite stills and short video clips, select one of the 1,000 royalty-free songs they offer, and with only one more mouse click, produce a very exciting product for our clients. We've been offering the high-resolution version burned to a DVD as a booking bonus. The clients love it too.

11 Highlight Tone Priority. This feature alone is what made me switch to the 40D right after it was introduced. Highlight Tone Priority (❦ *Figure 4*) basically adds 1¼ stops of overexposure latitude to the image. This is particularly useful for a wedding photographer shooting brides in white gowns (often very shiny, reflective, white gowns) at high noon or in late-afternoon sun. I love the added protection this feature allows me in my shooting routine. (*Note:* It's discussed in detail in Chapter 2.)

12 I also like the speed at which the 7D and 5D Mark II shoot. When I used my 5D Mark I, I just didn't like it for reception coverage. It wasn't fast enough for me—focus-wise or motor-wise. The 7D and 5D Mark II are plenty fast, though. The 7D has

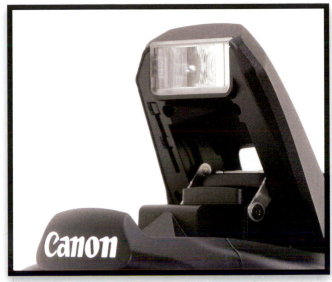
❦ *Figure 3*

❦ *Figure 4*

two speed settings: 3 fps and 8 fps. Three fps is adequate for almost everything that I do. I have to admit, though, I like the 5D Mark II's 3.9 fps just a bit more. But, 8 fps is just too quick for me in most cases. I've occasionally set it to this, but I find that is way too many pictures per second, and I really don't need the setting very often. If you're a fast-action event photographer, such as a sporting event or race car photographer, or a Kentucky Derby photographer, then this 8 fps setting would be great.

Whether you are a Nikon or Canon shooter, I hope this gives you some insight as to what features are important to me in my cameras.

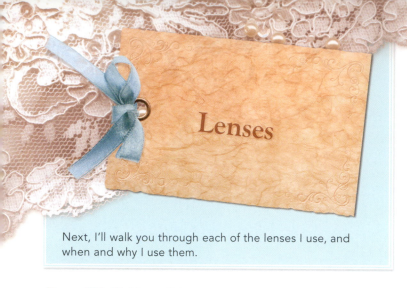

Lenses

Next, I'll walk you through each of the lenses I use, and when and why I use them.

Canon EFS 17–85mm IS Lens

This has been my favorite all-around lens for years (but that may be changing), and here's why:

1 I love the range. When I first switched to Canon, the 17–85mm IS lens (❦ *Figure 1a*) was my only shooting lens for several weeks. It gave me "W-I-D-E" (❦ *Figure 1b*) without having to change lenses, and it gave me reasonably "close" (❦ *Figure 1c*) when I needed it. Why didn't I choose faster glass? I've never been a big fan of fast glass, but I'm a *huge* fan of image stabilization. The 17–85mm IS was the perfect focal length wedding lens for me.

❦ *Figure 1a*

Pause points, by the way, are typically the ends of sentences during the wedding ceremony. That's when everyone is mostly still, and when you want to make your exposures if you're shooting at lower shutter speeds. The f/4–5.6 is not a problem for me either, because of image stabilization and a higher ISO (800). Higher ISOs are even less of a problem with the new crop of cameras available today.

❦ *Figure 1b*

❦ *Figure 1c*

2 It's the perfect lens for spontaneous, candid shots. Because of its focal length range, it is the perfect lens for most of my candid images. Again, the ability to zoom from a fairly wide 17mm to a decent telephoto 85mm gives me ample opportunity to capture the action wherever and whenever it happens (❦ *Figures 1d* and *1e*).

3 Easy ceremony shots. I can capture shots from the balcony with ease during the service with this image-stabilized lens. I just wait for "pause points" in the action to be sure the subjects are sharp (❦ *Figure 1f*). The lens does the rest of the work.

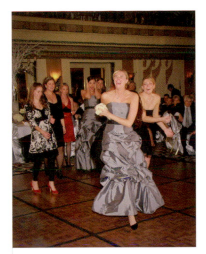

Figure 1d

Figure 1e

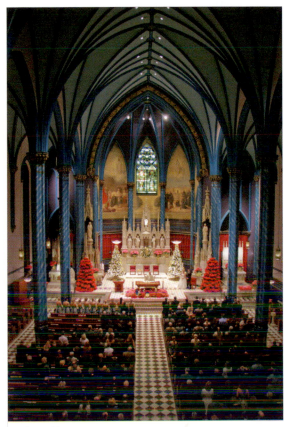

Figure 1f

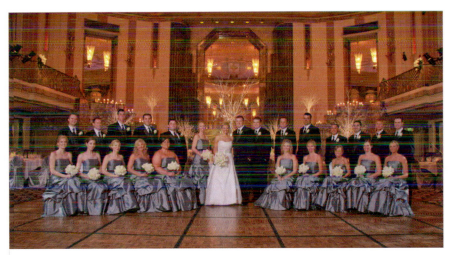

Figure 1g

4 It's perfect for group shots. I know somebody is going to gripe that I'm not getting the sharpest image because I'm not using the Canon L-series of expensive lenses. Hey gang, we're talking about a picture that's going to go up to maybe 8x10" in the album—I don't need to be able to make wall murals from these shots. This lens is plenty sharp for the family/wedding party shots. I typically stop down to f/6.3 for most of these shots anyway. That puts me pretty much in the "sweet spot" of the lens for sharpness, so everything looks great (*Figure 1g*).

5 Bigger prints? No problem. So, how big a print can I go with this optic? Easily up to 24x36" images, and they look fantastic! I was shooting a Bat Mitzvah

(Continued)

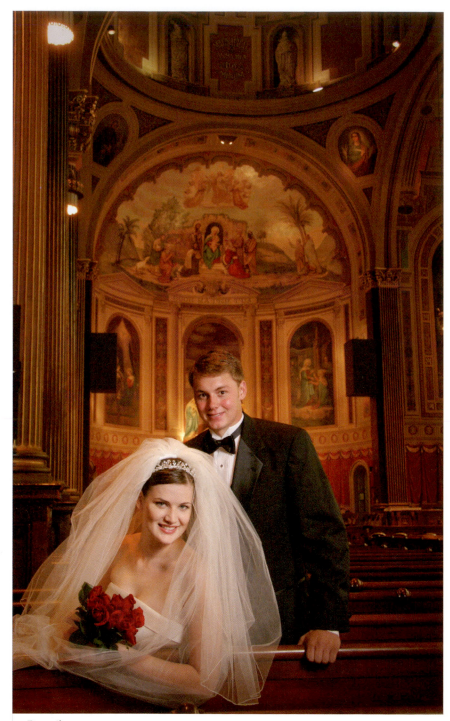

⊗ Figure 1h

once, and took some preliminary images at the temple. I enlarged one of the images to 24x36", printed it on my Epson 9600 printer, presented it to the client the day of the party, and promptly proceeded to "blow them away." (I made the shot at 1/13 of a second, ISO 800, and handheld.) Here is a wedding image, which also went to 24x36" (*⊗ Figure 1h*).

6 It's the everything lens for wedding receptions. The 17–85mm has been my long-time favorite lens for reception coverage—its focal length is perfect for most of the four- to five-hour receptions we tend to have here in the Midwest. That means hardly ever a lens change, except for special circumstances. I do have to watch out for overexposure when shooting "cocktail candids" at the 17mm setting at 5 feet away. Being that close to the subject in a tight situation means that I have to reduce the power of the flash to get the perfect exposure. For the rest of the evening, I can easily capture all the festivities by remaining wide, or just as easily zoom in for a tighter shot.

I want to share something else about the 17–85mm IS lens. A lot of photographers think the 24–70mm lens is a better choice—it's that fast glass thing again. Here's my answer to an email I received on the subject: "Re: Lens Choices. The 24–70mm is sharp as a tack, but only goes down to 24mm. I sometimes put my 24–105mm IS lens on, but always change back to the 17–85mm—it's that 17mm setting that's the magic number for me. Also, 24–70mm is not IS. I know it's a favorite lens for many shooters, but I still prefer the 17–85mm range with the IS—it's always about the range for me. Call me lazy. Re: Sharpness. My guess would be that one could not see the difference between the lenses when presented with an 8x10" print on luster paper. The paper surface would also disguise some of the 24–70mm lens sharpness. On glossy paper, that may be a different story, but most of us don't deliver wedding images on glossy paper. So the 24–70mm and 17–85mm would be too close to call in my opinion...."

Canon EFS 18–200mm f/3.5–5.6 IS Lens

This lens may be my new favorite, and after going through all the reasons I love my 17–85mm lens, will I ever switch to the 18–200mm IS lens (⊗ *Figure 2*)? I've been shooting with it for a little while and really like it. It could easily replace my 17–85mm IS lens, although I'm a little concerned about its sharpness for groups, but I love it for candids. Overall, though, I'm pretty pleased with it and it may replace my 17–85mm IS lens as my primary photojournalist shooting lens. Here's the lowdown:

1. The lens does just fine—actually, it's really sharp for about all of its zoom range. I shot a few images of a client with the 18–200mm, and I thought the images were plenty sharp.

2. The lens' wide-angle performance looks good, too. I've checked my table shots—eight people around a table—and although the lens was set to 18mm, the groups were not so tight as to be at the edge of the lens, and were perfectly sharp. I've done some scene setters, taking a few shots of the country club entrance, which reached from edge to edge of the frame. Again, things were just fine.

3. At 200mm, I also think the lens has respectable sharpness. I compared images between the 18–200mm and my 70–200mm f/2.8 IS lens, and thought they were reasonably close for balcony shots. Would I use it for family portraits? That would be a big "no"—the aperture isn't wide enough to give me the shallow depth of field I need. But that doesn't matter when shooting candids. What I love about the lens is its ability to get my reach-out-and-touch-somebody candids at the party.

4. As with any wide-to-telephoto lens, it's been my preference to zoom to focus, then pull back to frame the shot. I use center spot focusing and want to be sure I'm in sharp focus before I press the shutter button. When I am more careful about my focus, I achieve much more consistent results.

5. The image stabilization works great. I sorted several images made with the 18–200mm in Lightroom and looked at the exposure specs of most of the images. I was pleasantly surprised to see I had sharp images even at $1/6$ and $1/10$ of a second.

6. And lastly, the close-up focusing capabilities of this lens are fantastic. I love doing my very young baby shots with it. It gets me up close and personal real quick. It's great for detail shots at the wedding, too.

As a wedding photographer, most of my subject matter does not go edge to edge, so any sharpness fall-off is of less concern for me. I vignette nearly all my images in Lightroom, so the vignetting that shows up in some test reports is of little concern to me, as well. All in all, I *love* one lens on my camera for most of the time. The bottom line is this: the focal length lets me work extremely fast and get the shots I otherwise might miss if I was doing too many lens swaps. It's also a great lens for party candids, so for this application, it's a "one size fits all" solution.

Canon EF 50mm f/1.4 lens

This lens has been the rarest of the rare for years: the lens that used to come with every 35mm film SLR, the lens you took off the camera and stashed in a drawer somewhere, the lens that hardly ever found its way back on the camera once it was removed. Digital has changed all that now, making one of the least favored optics one of the fair-haired boys in the ol' gear bag (⊗ *Figure 3a*).

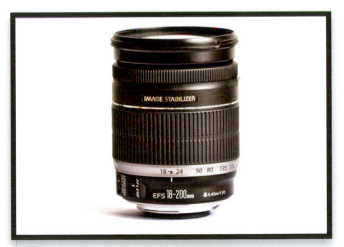

⊗ *Figure 2*

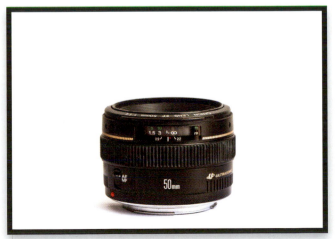

⊗ *Figure 3a*

(Continued)

Figure 3b

Figure 3c

Figure 3d

Be sure to have your camera in AI Servo mode (Continuous Focus on a Nikon)—that's the focus mode that locks onto the subject as they change their distance to the camera. When shooting under the low-light conditions of a wedding ceremony or reception with your aperture wide open, AI Servo is the way to go.

I remember photographers singing the praises of Canon's 85mm f/1.2 lens back in the film days—super-fast, shallow depth of field, super-sharp, and it cost about $1,800 (enough to give your wallet a hernia). Then digital rolled around and a lot of us started switching.

I got to thinking about the 85mm f/1.2 lens and said, "No way!" With my digital camera's 1.6x multiplication factor, that conveniently makes my 50mm lens an 80mm optic and only ½ stop slower than the super-pricey 85mm (the 50mm is only $325). I'll take the $1,500 savings and pick up another camera body. That's how my poor forlorn 50mm lens became one of my favorites for use on the wedding candids.

Here is the setup for me on the wedding day when shooting two APS-size sensor cameras: Camera #1 is fitted with the 17–85mm (probably changing to the 18–200mm IS lens) and the 580EX II flash in place. That camera is in my hands and ready to go. Camera #2 is around my neck and fitted with the 50mm f/1.4. It's set to aperture

priority at f/2, ISO 1600, 2800 Kelvin, and spot metering. I'm ready for the candid action. Here are some quick reasons for Camera #2's settings:

1 50mm: Because it's really an 80mm lens and perfect for those reach-out-and-touch-somebody candids, which I'll talk about in Chapter 10. It's perfect for low-light, natural-light images (*Figures 3b, 3c,* and *3d*).

2 Aperture priority: Because I like f/2 the best, but there are times when I like to cruise the f-stop ring for a different effect.

3 f/2 setting: Because I prefer not to open up more than that if I don't have to. I just get too many missed-focus shots

at the wider aperture. The f/2 setting works *consistently* better for me, but that doesn't mean I wouldn't go to f/1.4, if I needed to. I really like f/1.4 to capture those low-light images at the reception—you get a cool flavor of images there when shooting wide open at a high ISO (⊛ *Figures 3e* and *3f*).

4 ISO 1600 or 3200: Because I need a high enough ISO to stop the action. Most often these action candids are only going to be smaller images in the wedding album. If by chance they are larger images in the album, using Nik Software's Dfine 2.0 or Noise Ninja will knock the noise right out of those high-ISO images anyway, so I'm not very concerned about the higher ISOs.

5 2800 Kelvin: This is my preferred color temperature for tungsten-flavored images. The tungsten setting on most cameras is balanced for 3200 Kelvin—a color temperature we rarely see in the real world. But the 2800 Kelvin setting saves the day. It's beautiful.

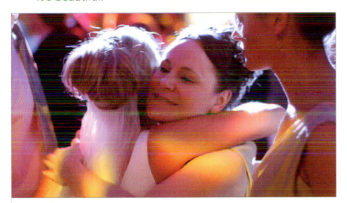
⊛ *Figure 3e*

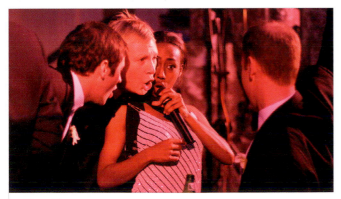
⊛ *Figure 3f*

6 Spot Metering: This setting has taken me a little while to settle into, but it's my preferred choice now when shooting in quickly changing, mixed-light situations. Too many times I have shot in situations where the light was so weird that I got a decent exposure only about half the time.

Here's what happens: I'm shooting the bride getting ready. The windows in the location are all around my perimeter. If my vantage point includes the windows at all, the shot is underexposed. The bright light of the windows is the culprit. It happened too many times, so I decided that spot metering was the exposure solution. As long as I hit the subject with that center spot and hold the exposure, I can shoot away and know I got a properly exposed photograph every time.

That pretty much explains why I like the 50mm so much. It's perfect for the spontaneous photojournalistic wedding day images (we used to call them candids, and I still do). But, wait, there's more. Want to save about $215? Then opt for the 50mm f/1.8. You lose another ½ stop, but pocket $215. Rumor has it that the f/1.8 is pretty darn sharp, even when compared with the f/1.4 lens. Just a little food for thought if your budget is tight.

Canon 70–200mm f/2.8 IS Lens

Let's take a peek at one of my favorite lenses in my gear bag—the inestimable Canon 70–200mm f/2.8 IS zoom telephoto (⊛ *Figure 4a*). This is the best portrait lens in the business.

If you are a Nikon shooter, then the Nikon version is a must-have lens in your gear bag for all the same reasons I've stated here:

⊛ *Figure 4a*

(Continued)

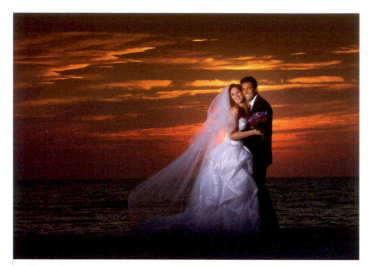

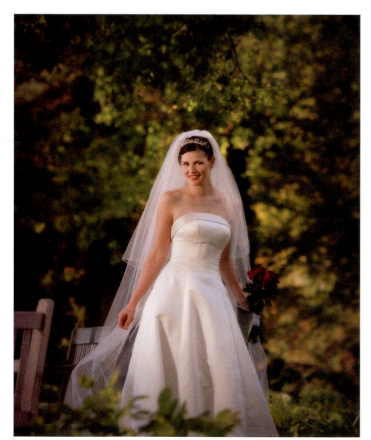

Figure 4b

Figure 4c

Some quick words of advice: even though this lens is available in a non-image-stabilized version, spend the big bucks and stick with the image stabilized version—it's worth it. If you need to save a few dollars, then opt for the 70–200mm f/4 IS version of the lens. It's a very sharp lens and saves you about $600.

Let me say flat out, this is my only choice for outdoor bridals (*Figure 4b*) and family portraits. Why? Because of the beautiful way it renders the background—the geeks call it bokeh—at my shooting aperture of f/4, while still keeping the subjects tack sharp. Its rock-solid image stabilization also lets me shoot at unheard of slow shutter speeds (*Figure 4c*).

Here are four quick techniques for using this lens, and why I use it for them:

Pictorial Bridal and Family Portraits

1. Set the aperture to f/4—I find that's best for shooting portraits. Close it down any more and you bring the background in too sharp a focus. The f/4 setting is perfect for creating wonderful subject separation from the background.

2. Rack out the lens to at least 130–200mm and enhance the soft background bokeh even more with the longer focal length. Whether you shoot full-frame or APS-size sensors, you still obtain a great result (*Figure 4d*).

Figure 4d

Be sure to pose what I call a shallow group—with all the subjects' heads in the same plane of focus. At f/4, the depth of field is somewhat shallow—that's good, as previously stated, but you'll want to keep the subjects' faces sharp, so shallow posing is key.

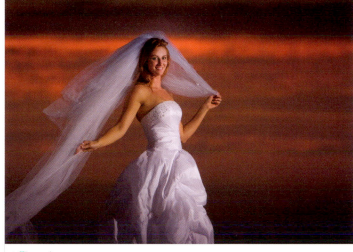

Individual Portraits

I love it here for all the same reasons mentioned for pictorial bridals and family portraits—except in this case, I can reach into the f/3.2 and f/2.8 range to soften the background even more. One quick point on softening the background: be sure your subject is pretty far away from that background for the best visual effect. If you get too close, you will not get the best visual effect. Look how the beautiful and soft background in **&** *Figure 4e* enhances the image and brings your attention right to the bride.

Ceremony Candids

This lens is also about the best "balcony lens" for wedding and Bar/Bat Mitzvah shooters. I gave up carrying a tripod to weddings years ago, once I experienced image stabilization. I typically shoot at 200mm at about $1/50$ of a second. Even at ISO 1600, applying a little noise reduction gives a great result that will easily hold up as an 8x10" in the album.

Available-Light Reception Candids

I know you think I'm crazy here, but with the image stabilization on this lens, I can capture some super-exciting, natural-light candids. For example, here's the father of the bride making a toast to his daughter (f/2.8 at $1/20$ of a second; **&** *Figure 4f*), and the reaction to his words (f/2.8 at $1/10$ of a second; **&** *Figure 4g*), both at ISO 1600. Again, no tripod, just a steady hand and waiting for the pause points of the sentences. This is how I get some of my most touching images at the reception.

There you have it—my favorite telephoto lens and my third favorite lens in my gear bag. The light gathering capabilities of the glass, quality of the image, and the super-solid image stabilization make it one of my top choices.

& *Figure 4f*

& *Figure 4g*

(Continued)

Canon EF-S 10–22mm f/3.5–4.5 Wide-Angle Zoom Lens

Here's the next lens in my gear bag (❀ *Figure 5a*). I'm listing them in their order of importance and usefulness to me at a wedding. So, even though I'm listing this lens fourth in the series, that doesn't mean it's my fourth favorite lens. It actually is one of my top favorite optics to shoot.

❀ *Figure 5a*

I'm a wide-angleaholic, going back to my Hasselblad days, where I loved shooting with my 40mm and 30mm Distagon fisheye lenses. That combo added up to about $18,000 back in the film days.

The 40mm Distagon on my Hasselblad had only an 89° field of view—equivalent to a 24mm lens on a full-frame DSLR or 17mm on an APS-sensor-size DSLR. Heck, I shoot with two lenses that give me that angle of view every day now (17–85mm for my 7D and 24–105mm for my 5D Mark II). It was a *big* deal when I picked up my Canon 10–22mm lens. The first time I used it, I thought, "Wow! This is about the widest-angle optic I'll ever need—a full 107° field of view!" That super-wide-angle field of view has allowed me to really play with composition.

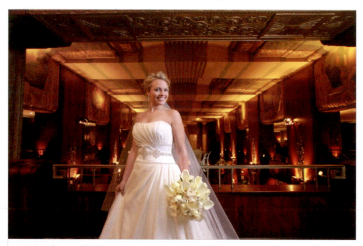

❀ *Figure 5b*

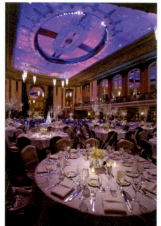

❀ *Figure 5d*

This lens is my favorite when it comes to dramatic portrait shots (❀ *Figures 5b and 5c*). The secret to using it when people are in the image is to keep them near the center of the composition to minimize any distortion, at least when shooting near the 10mm side of the zoom. If you get them too close to the edge of the viewfinder, you will create some really weird "Gumby" effects.

It's great for immense interior location images (❀ *Figure 5d*)—I can capture nearly everything in the frame. With interior room shots, I try to keep the lines in the scene parallel to each other

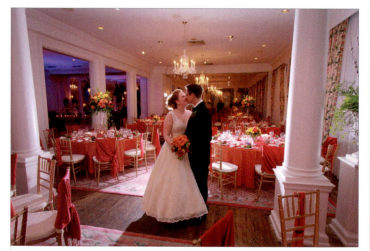

❀ *Figure 5c*

❀ *Figure 5e*

❧ *Figure 5f*

to get the best visual effect and the least distortion. Sometimes, though, I want the converging lines to enhance the composition because I love how it adds to the soaring effect of large spaces (❧ *Figure 5e*).

Another great application of the lens is in landscape photography. I know this is a book on wedding photography, but I'll show you one landscape shot. I took ❧ *Figure 5f* at sunrise in Annapolis, Maryland. Notice how the sky takes on rich blue tones at the top of the frame? That's because of the lens' long wide-angle reach into the sky, where the sun's light has not yet fully penetrated.

Here are a couple more images made with this pretty cool lens (❧ *Figures 5g* and *5h*). Do I wish I had a wider optic to shoot with? I do have one, and I'll cover it next.

All the images I shoot these days are handheld. The rule is that you can hand-hold a lens down to a shutter speed equivalent to 1/(focal length) of a second. That means, with a 50mm lens, I'm good to go down to $^1/_{50}$ of a second. With my 10–22mm lens at 10mm, I'm good down to $^1/_{10}$ of a second. That doesn't mean I can be sloppy, though. I still have to use my best slow shooting technique.

❧ *Figure 5g*

❧ *Figure 5h*

(Continued)

Sigma 8mm Fisheye

This is another one of the really fun lenses in my gear bag (⊕ *Figure 6a*). I came by it quite by accident. A photographer at a convention I spoke at recommended it to me. I checked it out and ended up purchasing the lens. It was a steal at $700— about one-tenth the cost of the fisheye I had for my old Hasselblad film camera. Anyway, I started shooting with it and found it was quite a blast to play with at a wedding.

⊕ *Figure 6a*

⊕ *Figure 6b*

I'll tell you, what I like about the lens is the unique perspective it brings to a scene (⊕ *Figure 6b*). It's great for dramatic interiors (⊕ *Figure 6c*), really unusual portraits, and any number of other creative ways you can think of to view the world.

When attached to a full-frame DSLR, you get a complete circle in the image area (⊕ *Figure 6d*). That's okay if that's what you want. I have found it to be not to my taste—too many pixels get lost. But on the Canon 5D Mark II, I still end up with about 14 megapixels in that circle, and that's plenty.

My preference with the Sigma fisheye lens has been to use it on the APS-size sensor cameras. It fills the frame more effectively because of that 1.6x magnification factor, and if I crop it square, I'm back to my Hassey-type images at about one-tenth the cost. Even on the 18-megapixel Canon 7D, that's plenty of pixels left over for a large print.

Here are 11 things to keep in mind when shooting with this lens:

1. When shooting straight lines, you can end up with some very unusual compositions, as the lines will not remain straight (⊕ *Figure 6e*).

⊕ *Figure 6c*

⊕ *Figure 6d*

⊕ *Figure 6e*

2 When shooting scenes with curved lines, the curved lines disguise the effects of the fisheye distortion and can add to the composition, thus looking quite dynamic and very interesting (⌗ *Figure 6f*).

3 If you are going to include people in the shot, try to keep them as close to the middle as possible (⌗ *Figure 6g*). This will minimize their distortion.

4 Know that the center of the lens is plenty sharp, but the edge, not nearly so. That's okay as long as you keep the important parts of the image near the center of your composition.

5 Try hanging—using the camera mounted to a monopod and fitted with the fisheye lens—over the crowd's head while taking a shot. Very cool perspective. (*Note:* You'll see this near the end of Chapter 10.)

6 Try the reverse too, again using the monopod, by keeping it very close to the floor and having selected groups of partying reception guests look into it for a fun and creative candid (⌗ *Figure 6h*).

7 Don't overuse it at an event. It is not everybody's "cup of tea."

8 Try a few reception candids up close, in your face, and personal for a really different result.

9 Remember, if you attach it to a full-frame DSLR, you get a circle.

10 When attached to a full-frame DSLR, you *will* take a picture of your on-camera flash.

11 Just go out, play, experiment, and have a blast with it.

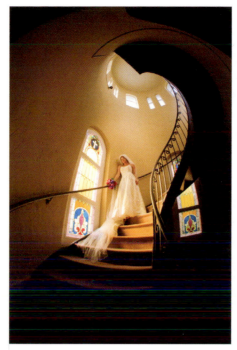

⌗ *Figure 6f*

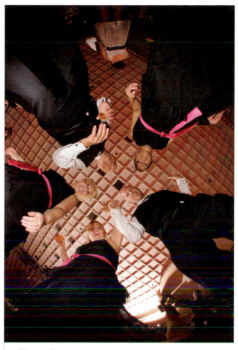

⌗ *Figure 6h*

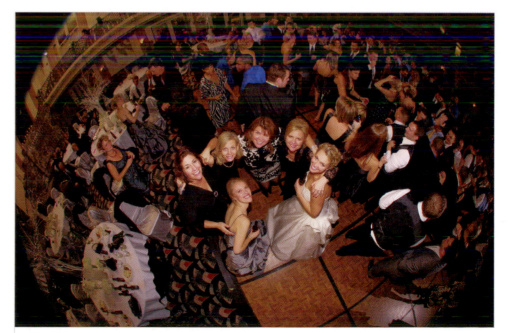

⌗ *Figure 6g*

(Continued)

Canon 70–300mm DO IS Lens

I picked this lens up a few years ago (❧ *Figure 7a*). It was image stabilized and I was looking for that 300mm going through the 1.6x magnification factor on my 30D at the time. You can do the math yourself: 1.6 x 300mm = 480mm focal length! That's a pretty long reach.

❧ *Figure 7a*

Some of you may ask why, if I already owned the 70–200mm IS lens, did I opt for this optic? I was building a gear bag for a second shooter and, instead of a repeat performance with the 70–200mm IS (and to save about $500), I went with the longer lens to add a little more variety.

The first time I used the lens, I was blown away by how close I could get to the subject(s) when I racked that baby out to 300mm (❧ *Figures 7b* and *7c*). I was also amazed at how good the image stabilization is, since I shoot everything handheld at weddings. I was shooting images at ¹/25 of a second and slower.

I decided to make it my default lens for the ceremony shots when the action is slow and I need to come in close (❧ *Figure 7d*). The lens is much lighter than my 70–200mm IS, and is just easier to carry around my neck.

I've also used it on my full-frame 5D Mark II when I want the background to go really soft and out of focus (❧ *Figures 7e* and *7f*). The longer focal length of the lens allows the background to go softer than I would have achieved with my 70–200mm lens. I've even used it on some family portraits for that same effect when I really wanted to separate the subject(s) from the background.

❧ *Figure 7b*

❧ *Figure 7c*

❧ *Figure 7d*

❧ *Figure 7e*

❧ *Figure 7f*

Figure 7g

For most wedding and family shots, I shoot the lens at f/5.6. For low-light wedding shots, I shoot at ISO 1600 or 3200 (*Figure 7g*). Normally, the wedding images I produce using this lens will be 5x7" or smaller in the wedding album, so a little noise reduction works just fine. Under higher ambient light conditions, I use the appropriate ISO for the shot: ISO 200–400 (*Figure 7h*). I have also used this lens as the sole optic for a day or two of shooting on vacation or as a special project, just to get those brain juices flowing.

It's quite an experience to zoom in tight on the subject matter, just isolating a bit of it in my composition (*Figures 7i* and *7j*). I've found it's a new way of thinking photographically, with this lens as my only choice during some of these shoots.

The bottom line is this: I love it for weddings. It's my lens choice while capturing long telephoto shots and balcony shots when the motion is subdued (see *Figure 7k*). I love the "reach out and touch somebody" available-light candids I get with it from the side aisles during the services (especially during a full Catholic mass, where the ceremony may last an hour or more and I can roam a bit more freely.) And, I love it for capturing unique and exciting travel images.

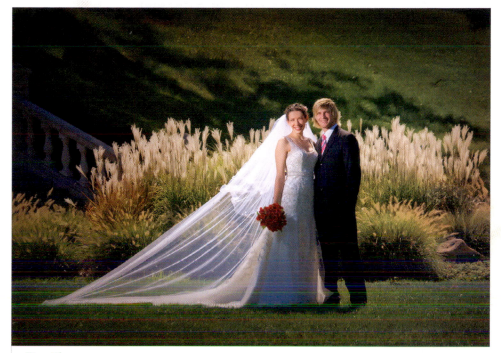

Figure 7h

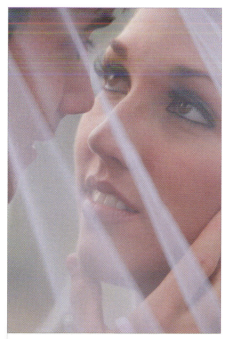

Figure 7i

Figure 7j

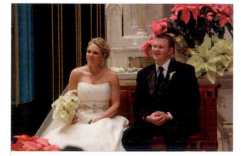

Figure 7k

(Continued)

Canon EF 24–105 f/4 IS Lens

This is my favorite full-frame lens, and one of Canon's sharpest tacks in the (lens) box (⚜ *Figure 8a*). When I owned the first Canon 5D, I thought the 24–105mm focal length would be perfect for my full-frame DSLR, which it is. I particularly like the lens at the 24mm setting. It is pretty darn wide for me, yet I also get the fairly long reach of the 105mm setting.

⚜ *Figure 8a*

I eventually started using the 24–105mm lens on my 7D, which works most of the time, but there are just too many times when I need to be wider. However, the full-frame 5D Mark II fitted with the 24–105mm IS lens is now my default shooting camera for events. With this setup, I don't really feel I need to go to any fast glass, because with the ISO 6400 setting at f/4, I'm plenty wide to capture everything I need, even in lower-light situations.

Here's why this is one of my favorite lenses:

1 I love the 24–105mm focal length range of the lens. I particularly like the 24mm setting, since I'm a wide-angle nut (⚜ *Figure 8b*). On a full-frame sensor camera, it is plenty wide to create some of the dramatic wide-angle images that I love.

2 The 105mm setting is also a very convenient focal length when shooting portraits of the bride, the groom, or both of them together (⚜ *Figure 8c*). It lets me get close without getting too close (⚜ *Figure 8d*). At the f/4 setting on close-up portraits, I'm still able to maintain the background substantially out of focus.

3 The intermediate range of the lens also works nicely for all the wedding party group photographs, letting me work very quickly in capturing those images (⚜ *Figure 8e*).

⚜ *Figure 8b*

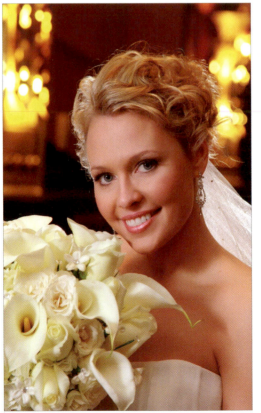

⚜ *Figure 8c*

⚜ *Figure 8d*

⚜ *Figure 8e*

4 The f/4 aperture is certainly fast enough for me in most instances (⚜ *Figure 8f*). Now, particularly with the new higher ISO cameras becoming available, f/4 should be more than adequate.

5 I've always been a huge fan of image stabilization. The IS on this lens works beautifully (see ⚜ *Figures 8g* and *8h*). I have no qualms whatsoever shooting at shutter speeds as slow as ¹/₁₀ of a second—handheld. Yes, I do have my motor drive on multiple firings, but most of the time, the images are more than adequate.

⚜ *Figure 8f*

⚜ *Figure 8g*

⚜ *Figure 8h*

That pretty much wraps up what I love about this lens. It's sharp, has a nice focal length range, a wide enough aperture for most situations, and great image stabilization. If you're a Canon shooter, I give it my highest recommendation. It's really the ideal focal length–f/4 f-stop–IS combination, and it lets me be attuned to the actions and reactions of the day without worrying too much about which other lens I may need.

Sigma 12–24mm f/4.5–5.6 Lens

As I mentioned, I've always been a *big* fan of wide-angle optics. One of my favorite lenses in my medium format days was Hasselblad's 40mm Distagon. It was wonderfully wide and let me capture dramatic compositions. One of my first challenges in digital was finding an optic that gave me a reasonably wide-angle view with my APS-sensor-size camera. The 1.5x magnification factor killed me with the then-current crop of 35mm lenses I already owned. I had to rethink my collection and make additional purchases.

When I picked up my first Canon 5D, I was thrilled that it was a full-frame sensor. That meant that when I put a wide-angle lens on it, I'd get a really wide-angle view. Years ago, a 24mm optic was considered very, very wide. Then, the 18mm was introduced with an unimaginable field of view. But I was

⚜ *Figure 9a*

greedy. I wanted it wider. Well, along came Sigma with their introduction of their 12–24mm lens a few years ago (⚜ *Figure 9a*).

I knew that on my full-frame DSLR it would provide a super-wide field of view. The lens cost around $650 at the time—a far cry from my $5,000 40mm Distagon lens. When I put it on my camera, I was blown away. It was simply the widest-angle optic you could put on a full-frame sensor, and was literally the widest field of view—122°—you could

(Continued)

Figure 9b

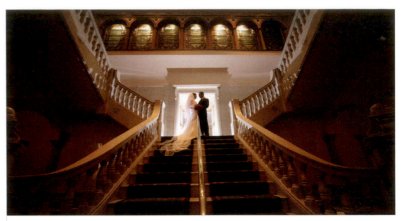

Figure 9c

mount on a full-frame DSLR. I love how the image encompasses such a dramatic view of the surrounds (*Figures 9b* and *9c*).

Obviously, one use for this lens is architectural photography. While that generally connotes that all parallel lines remain parallel, I think a super-wide-angle optic can really bring some great drama to the composition with all the converging lines it can supply. I like to see the soaring pillars reaching to the ceiling of the cathedral, the lines converging and adding to the sense of height and size (*Figure 9d*).

I typically shoot this lens at f/5.6, which, as I say throughout this book, I call my "aperture of convenience" because of my shooting routine with my off-camera flash.

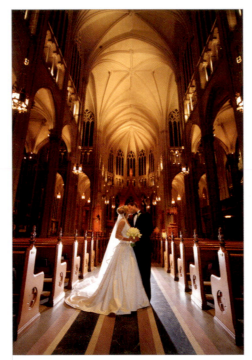

Figure 9d

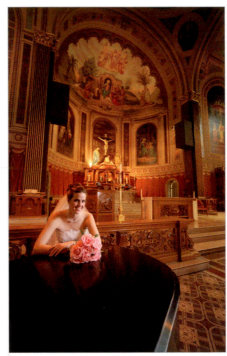

Figure 9e

So what's the bottom line on this lens for me?

1. I just love its super-wide-angle view. Remember, you get the best effects and widest view with this lens matched to a full-frame digital SLR (see ❧ *Figure 9e*).

2. This is a fantastic lens, especially when shooting interiors of some of the beautiful ballrooms in which I get to work (❧ *Figure 9f*).

3. It's great for pulling off some really dramatic views of the ceremony, whether shot from a side aisle (❧ *Figure 9g*), the back of the center aisle, or the balcony.

4. It's a great backup to my Canon 10–22mm lens when used on my Canon 7D.

5. When photographing people, be sure to keep them at the horizontal or vertical center of the frame to avoid any nasty distortion of the body parts, just like on the 10–22mm lens I discussed earlier.

6. Crank up the ISO on newer Nikon or Canon digital cameras, and get really low to the floor, stretching out those shadows to get some really cool party pictures for your clients.

If you're a wide-angle lens fiend, then this lens may be for you. It's a kick to use, and gives you some really unusual views, along with the opportunity to create some really cool compositions (❧ *Figure 9h*). It takes a little practice to get used to, but it's one of my favorite fun lenses in my gear bag. I just can't wait for somebody to come out with an 8mm, 270°-field-of-view, rectilinearly corrected, wide-angle lens! Who knows, maybe in the next few years. ;~)

❧ *Figure 9f*

❧ *Figure 9g*

❧ *Figure 9h*

What About the Light? The Most Important Light of All!

Anyone who has gotten this far in this book knows that my gig is getting great lighting on the subject. Most of the time, this is achieved with my off-camera flash. Sure, the camera is the most important piece of equipment that I use in my photography. But, my off-camera flash is the second most important piece of gear I use. As I've said so many times before, you've got to get the light coming from a direction other than the camera to create detail, depth, dimension, and color saturation on the scene.

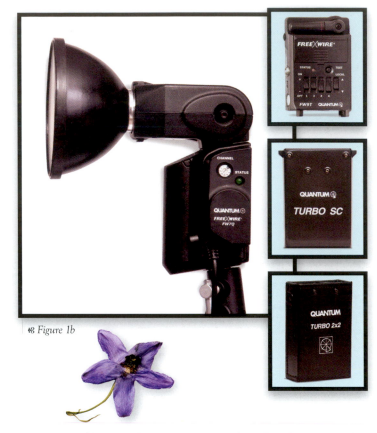

⊛ Figure 1b

Here's a quick rundown of my off-camera flash gear: I use a Quantum T5d-R flash head powered by a Quantum Turbo 2x2 power pack. I may switch to the smaller power pack—the Quantum Turbo SC—at the wedding reception. I also use this smaller pack for any smaller photo sessions (for example, family portraits or high school seniors). The flash head is mounted on a Bogen/Manfrotto monopod via a Bogen/Manfrotto 026 Swivel Umbrella Adapter (⊛ *Figure 1a*). The flash is fired remotely with Quantum's FW7Q radio receiver attached to it (⊛ *Figure 1b*). The Quantum flash head powers the Quantum receiver directly. The radio transmitter is attached, using Velcro, to the top of my on-camera flash—a Canon 580EX II (see ⊛ *Figure 1c*). Check out the beginning of Chapter 5 for more on this.

That's pretty much it. It's a simple setup that gives me great portability, flexibility, and speed when shooting any event. Its portability is so very important when I'm photographing on-location, such as an engagement session or a family portrait in the park. My lighting gear is simply fast and easy to use.

Quantum Radio Transmitter and Receivers

Probably one of the most important pieces of lighting gear is my Quantum radio transmitter and receivers. As you may have deduced, I am a *huge* fan of off-camera flash and have been for a number of years.

⊛ Figure 1a

⊛ Figure 1c

The Quantum FreeXwire FW9T transmitter is held by Velcro to the top of my Canon 580EX II flash (see *Figure 2a*). The radio is plugged into the sync input on my camera (see *Figure 2b*). There is the rare, occasional instance when I get some high-frequency interference from the 580EX II flash that keeps the radio from transmitting. My solution is to simply reposition the radio transmitter a little further back on the flash head. That seems to solve the problem.

The moment I release the shutter, the signal is sent from the transmitter to the receiver that is attached to my Quantum T5d-R flash head (*Figure 3*). The Quantum FW7Q receiver fits neatly into the side of the T5d-R flash head and is actually powered by it, as well. I like the fact that it appears to be all one piece of equipment.

When shooting receptions, I also have a room light set up to give additional illumination to the reception scene. This additional illumination is created with any medium-power AC-powered studio strobe, which is also attached to a Quantum FreeXwire FW8R receiver. My strobe choice over the years has been Paul Buff's White Lightning flash units, which have worked reliably for a number of years.

So, I'm pretty well covered with one transmitter on my camera, one receiver on the mobile flash unit my assistant carries, and one receiver attached to the room light that is supplying the additional illumination to the reception.

The Quantum radio transmitter and receivers also allow me to place each flash on different channels—up to five channels. I can choose to fire both channels at the same time or I can choose to turn off one channel, say the channel on my room light, and only fire my off-camera mobile flash held by my assistant. This is particularly helpful when I'm creating backlit photographs of the bride and groom dancing.

I think that the lighting results far exceed what so many wedding photographers are producing. A single on-camera flash, whether bounced off the ceiling, off a fill card, or any other type of flash modification, simply does not give the beautiful, and sometimes dramatic, lighting that we can obtain with the additional lights that travel with me. But, I couldn't pull it off without my radio transmitter and my two radio receivers, which is why they have such an important position in my gear bag.

Figure 2a

Figure 2b

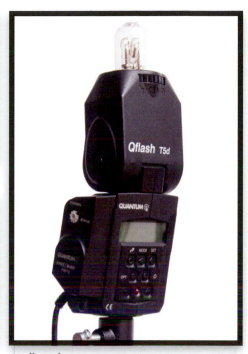
Figure 3

(Continued)

The Case for the Room Light

You know, when you look at many wedding photographs, particularly reception candids, the illumination is far too often flat and two-dimensional. The main reason for this is because so many photographers are just relying on their on-camera flash to supply the illumination.

Granted, some photographers use the fill flap on their on-camera flash or even add larger fill flaps and light adapters to their on-camera flash. Folks, I'll say it again now as I've said it a million times, unless you get the light off of the camera—let me rephrase that, unless you get the photons coming from a direction other than the direction the camera is pointed—you will never create detail, depth, and dimension in your lighting.

Earlier in the book, I discussed how I use my off-camera flash to create that wonderful three-dimensional effect in my lighting, and that off-camera flash works great in most situations. At a wedding reception, I want my light to have even greater detail, depth, and dimension, and the only way I've found to accomplish this in really large reception venues is to add an additional room light.

This is easily accomplished, and the cost doesn't have to break the bank. I prefer to use inexpensive studio lights like Paul Buff's Alien Bees or White Lightning flashes. As I said, they do not break the bank, but they're really effective.

Regardless of what studio light you decide upon for your room light, I would suggest at least a 400- to 600-watt-second unit. When using a studio light of this power at the reception, you'll most often have the power setting turned down to half, or maybe even one-third, power. This gives you a very quick recycle time that can keep up with the rapid firing of your DSLR as you quickly follow the action. The fisheye shot here (❀ *Figure 4*) shows the relative locations of my assistant on the far right and the room light in the upper left.

Check out the reception images in Chapter 10, and you can see how much the room light adds to the overall look and feel of the reception candids. Notice how much more depth there is in the lighting, particularly when looking at the larger overall views. Even in the cake cutting photographs, you can see that guests are illuminated in the background because of the room light.

It basically helps us avoid what I like to call the "black hole of Calcutta" reception lighting, where we have the subject in the foreground nicely illuminated, but then everything goes very dark in the background. The room light gives us a much better look to our images, and adds a bit of accent light to the scene, too.

Now, here's some good room light news: As I've said, the way to create more business is to constantly differentiate yourself from the competition. When I present programs to photographers around the country and the world, I ask how many of them use a room light for their wedding receptions. The answer, unfortunately, is that most do not. So, the photographer who uses the room light brings a substantially nicer look to his wedding photography. This becomes one of the *big* differences that allow his images to stand head and shoulders above the others. When your clients are selecting you for your differences, chances are they will pay a little bit more for them, too.

❀ *Figure 4*

What Bag Do I Put All My Gear In?

So, you want to know how I carry all my gear? Which bag do I use to get it all to the wedding? Take a look.

I use Lowepro's Pro Roller 2 to store and carry my gear. It's my favorite: it's well-designed, sturdy, and fits on an airplane in the overhead compartment (see ❧ *Figures 1* and *2*).

So gang, that's a quick peek in my gear bag—all the "whys" and the "why nots." Everyone has their favorite lenses, cameras, and gear, and I've given you my choices. Whether you agree or not, that's what I run and shoot with. Hope it helps.

❧ Figure 1

❧ Figure 2

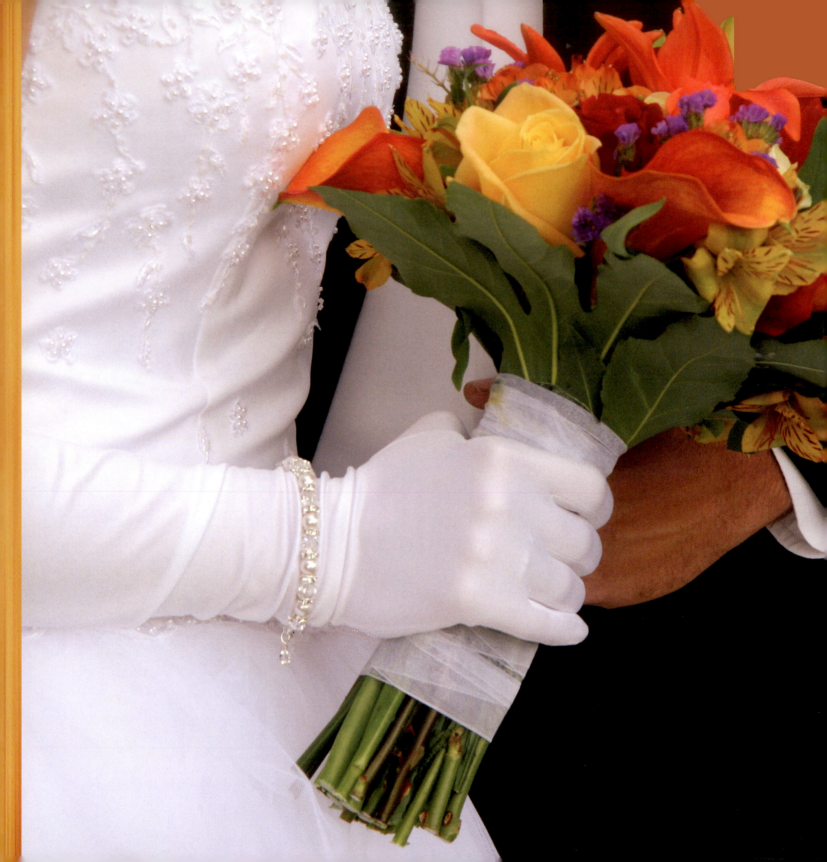

Walk with Me

My Workflow at the Wedding

We can talk lighting and camera techniques until we are "blue in the face." We've done enough of that already, so how about I take you on a wedding shoot with me? We are going to cover every aspect of the wedding, from packing the bags before we depart for the event to saying goodbye to the family at the conclusion of the evening.

I've divided the big day up into two chapters: the wedding and the reception. This chapter covers the wedding, from preparing for the day, to the girls getting ready, to the ceremony and formals, to leaving for the reception. The next chapter covers all aspects of the reception, including the last minute photos as we are packing up to leave.

Anyway, hop into the passenger seat and off we go....

Part 1: Studio Preparation for the Wedding

First things first, let's get our heads on straight and get the gear together. Here are the steps I take to do just that:

Step One:

The very first step, for me, is to pull the client file—I do this four or five days before the wedding—review all the pertinent information about the wedding (times, locations, etc.), and review any additional notes I have made or my staff has collected. After reviewing all the details, I contact the bride, and review and confirm them with her.

I always ask if there is anything else I need to know. Are there any special family members or friends coming in from out of town that we want to be sure to photograph? Any special family relationships we need to be aware of? Have there been any changes since we last discussed the wedding? How about the health of grandparents or elderly relatives that may only attend for a short

period of time? Any special planned events? In this conversation with the bride (and sometimes with her mother, too), I obtain all the details I need. Then, I fine-tune the timeline of the event.

Step Two:

Now let's get to the gear setup. We work as a three-person team when photographing an event. I'm the main shooter and work with an assistant who carries my gear bag, lighting gear, and anything else I might need. This assistant is also my lighting assistant, whose most important role is to not only read my mind about what the next photograph may be, but most importantly, to get that off-camera flash in the right position 110% of the time.

The third team member assists with moving gear from location to location, and setting up the lighting gear at the reception. But, their primary role has evolved into being a second shooter. It's the third team member's responsibility to see and shoot the peripheral happenings. This is done mostly at their discretion, with some direction from me. That means I've got two gear bags to set up before we leave.

Step Three:

My second gear bag is an abbreviated version of the first (which I covered in Chapter 8). What's important to me is that the gear itself is in top-notch shape—lenses polished and cleaned, memory cards cleared, sensors cleaned, and cameras time-synced (⊛ *Figure 1*). Any memory cards not still in my camera case from the week before are verified as backed up before they are wiped clean and formatted for the current weekend's big event.

⊛ *Figure 1*

All cameras are time synced the day of the wedding. This makes things easy during the post-production Lightroom 2 sorting process.

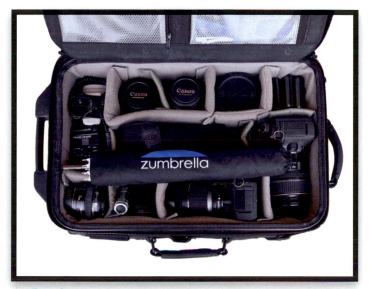

❧ Figure 2

❧ Figure 3

Step Four:

The next step is to get the batteries charged. I charge all my Quantum flash system batteries and camera batteries the day before the event. We carry three Quantum batteries with us: two Turbo 2x2 batteries, which are fairly high capacity and can really go the distance for all or most of a single event, and the Quantum Turbo SC battery, which is a very lightweight battery, but with lower capacity (my assistants appreciate the lighter battery at the reception). So, basically, we have more than enough batteries to get us through any event.

Step Five:

We take four cameras with us to an event. My own gear bag includes a Canon 5D Mark II and a Canon 7D, along with the array of lenses (*❧ Figure 2*). I covered my gear bag in Chapter 8. The second gear bag contains two Canon 40Ds. Each camera has its own battery and one backup battery with charger that keeps us going should we need to change batteries during the day. Even with our heavy shooting, we rarely have to change batteries during the shoot. Camera batteries (and flash batteries) seem to last forever these days. I attribute that to the higher ISOs at which we shoot, meaning much less power dumped each time the flash fires.

Step Six:

I charge the Canon 580EX II flash batteries on the day of the wedding. I'm still using Eveready NiCd batteries that I purchased a

couple of years ago—they do just fine. The only problem I've found is that they don't hold their charge all that long when charged the day before. I know other batteries hold a charge over a much longer period of time, but frankly, I've never gotten around to purchasing them. Charging the batteries on the day of the event has them in peak condition, and easily lets us finish the event.

Just for backup, I carry the NiCd battery charger with me (see *❧ Figure 3*). It can charge four AA NiCd batteries in about 15 minutes. I'm generally shooting with one flash at a time, which gives me two spare sets of NiCd batteries in my gear bag.

Step Seven:

Lighting gear also needs to be checked out. I still use my trusty old White Lightning studio lights from years ago. I pack two in the lighting gear bag, along with the necessary stands and 50-foot extension cords. We only use one of them on the job, but it's always smart to be over-prepared with backup gear. My assistants affectionately call the lighting bag the "death bag," because it seems to have more stuff in it than we could ever need and weighs a ton—maybe two.

That's what we take to a wedding. It seems like a lot of equipment, but I have to admit, I'm from the old school of thought that says, "Be prepared for anything that can happen, because it usually does."

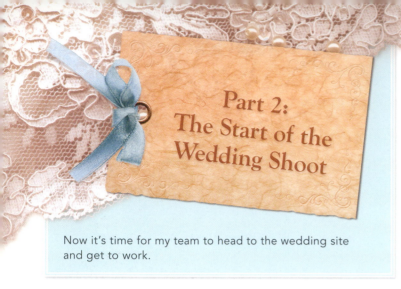

Part 2: The Start of the Wedding Shoot

Now it's time for my team to head to the wedding site and get to work.

Step One:

My team arrives at the studio about one hour before we are due to be onsite. We review all the details of the wedding, and what each person's responsibilities will be for the event.

Step Two:

We arrive onsite about 30 minutes before we have to start photographing the event. This gives us a chance to review locations for group photographs and special photos of the bride and groom. It also gives us a chance to introduce ourselves to the wedding consultants, florists, lighting technicians, hotel staff, etc. This entire public relations procedure helps the day go more smoothly, with all of the vendors working as a team.

Step Three:

Typically the shoot goes like this for me: If the event is happening at a large hotel, we ring the bride's room to announce our arrival and to see how everybody is progressing getting ready. The girls are generally at some stage of hair and makeup. I love to make this part of my wedding day coverage.

My first images are usually images of the bride, her bridesmaids, and other female family members getting ready (❀ *Figures 1a* and *1b*). That, as I have said, could be in the hotel suite or at the bride's home, or even within the bridal room/ladies' room at the church.

Step Four:

We then seek out the groom, his groomsman, and his parents and try to get some photographs of them, as well (❀ *Figure 2*). I have to say, it's always more exciting covering the girls. The guys are usually just hanging around, playing cards, drinking a beer or two, or watching a ball game on TV. Nevertheless, it's an important part of the story and needs to be recorded.

Many of these images are taken with just the available light, but sometimes I use my off-camera flash or my on-camera flash bounced off of a side wall to give me some directional light illuminating the scene (see Chapter 3).

❀ *Figure 1a*

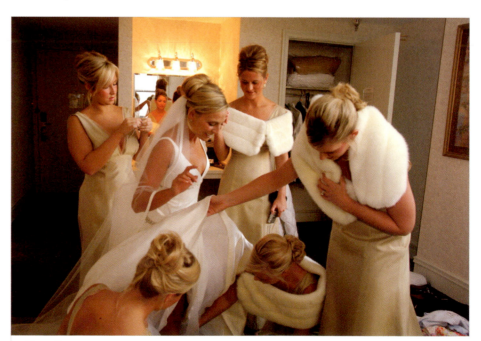

❀ *Figure 1b*

Figure 2

Figure 3

Figure 4a

Figure 4b

Step Five:

At this point, we generally check back with the bride as she goes into her final moments of preparation. This is a great time to get some detail photographs of her attendants buttoning up the back of her gown or adjusting the jewelry, or her mother placing the veil on her head (see ⚜ *Figure 3*).

This is also a great time to capture those wonderful, often emotional images of the bride's father seeing his daughter in her wedding gown for the first time—all the actions and reactions, the special moments, the special feelings of the day. We take several images during this part, knowing that only a few will be in the wedding album. We also know that capturing at least one spectacular expression or wonderful emotion will add priceless, treasured memories.

Step Six:

We often begin our coverage up to three hours before the ceremony. You might think I'm crazy, but I've done it that way for years. This is pre-planned with the couple, and allows us ample opportunity to get all the group photographs and special bridal images that our clients love (see ⚜ *Figures 4a* and *4b*). One of the

Figure 4c

highlights of this pre-shoot is our couple seeing each other for the first time. With our clients, we arrange where and when that will take place. Once everybody is ready, the bride gets her cue and the cameras start clicking (see ⚜ *Figure 4c*).

Figure 5a

Figure 5b

Figure 5c

Figure 5d

Figure 6a

Figure 6b

The next series of images is usually at the church (or the location of the ceremony). We arrive, survey the area, and start shooting several scene setters. These include exterior views, close-ups of the church, its signage, details of the structure, the wedding programs, floral arrangements, guest book, and anything else we see that is interesting (*Figures 5a* and *5b*).

We also get pretty thorough coverage of the interior of the church, including wide-angle views of the church itself, close-ups of the flowers and candles, and various views from the front and the back of the church—whatever can serve as added backgrounds and points of interest in the finished album (see *Figures 5c* and *5d*). It's at this point that we begin photographing some of the guests as they arrive, the special attendants passing out the programs, any ushers seating the guests, and parents greeting them.

Step Eight:
We want to be sure to capture the bride arriving at the church and making her way to the waiting room in the moments before the ceremony. If time allows, we track down the groom as he waits those last few minutes. This is a great time to capture some wonderful, emotional images between the bride and her attendants, as well as the groom, his best man, and their other loved ones (see *Figures 6a* and *6b*).

That wraps up Act 1. Now we'll head for the ceremony.

Figure 1a

Part 3: The Ceremony

Let's move on with the ceremony coverage. Obviously, this is critical, and we should pull it off with panache and style. Let me walk you through my steps to better ceremony coverage. Here we go:

Step One:

It's time for the procession. The bride, bridesmaids, and the bride's dad are lining up in the back of the church. I love to capture the interaction during these short moments before the procession (see *Figures 1a* and *1b*). My assistant is usually positioned near the front of the church on the right side. He will cover the mothers and grandparents as they are seated, and the processional of the bridesmaids once it begins. His camera is always on AI Servo auto-focus mode, which means that it follows the subjects down the aisle. All of his images are made without strobe or flash of any kind.

Step Two:

I'm not a big fan of photographing each of the bridesmaids coming down the aisle. To me, that's not the bride's view. The bride's view is watching her girls go down the aisle from the back of the church. Besides, I capture several images of each bridesmaid earlier as they prepare for the wedding—sometimes with the bride and sometimes alone.

That's why I capture the procession from the back of the church, with several bridesmaids walking toward the front (see *Figure 2*). As the last bridesmaid is making her way down the aisle, and the bride stands calmly with her dad, waiting for her

Figure 1b

Figure 2

(Continued)

walk, I'll get a wide-angle lens shot, low to the ground, of the bride and her father from the back for a really unique image.

Step Three:

I then make my way about halfway down the aisle into an unoccupied pew. In this position, I can get a great photograph of the bride and her father coming down the aisle—I don't take just one shot, I take several, capturing a range of expressions on both the bride and her father.

Next, I quickly make my way to the front of the church via the left aisle and capture the father offering his daughter's hand to her groom (❀ *Figure 3*). All this time, my lighting assistant knows exactly where he or she needs to be to cover the beginning of the event—at the eight o'clock position (remember our clock face in Chapter 4?) on the far right side of the church.

Step Four:

If it's a Catholic ceremony, it runs longer, so I hang out up front, in the left aisle of the church, for just a few minutes and try to capture some great expressions from the bride's mother and father, the bridesmaids, and maybe even the grandparents (see ❀ *Figure 4*). These images are always made without flash of any kind, and are done very discreetly and quietly.

Step Five:

I then make my way to the back of the church to continue the ceremony coverage (❀ *Figures 5a* and *5b*). My lenses range from a Sigma 8mm

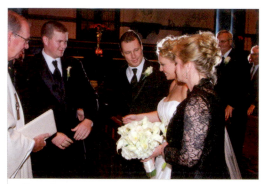

❀ *Figure 3*

❀ *Figure 4*

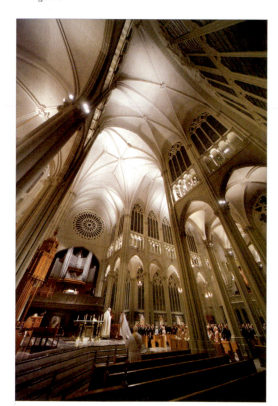

❀ *Figure 5a*

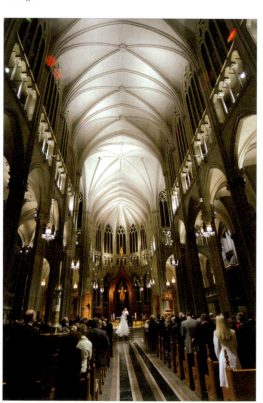

❀ *Figure 5b*

Image stabilization and high ISOs are my salvation in this instance. If it's a full Catholic mass ceremony, I may place a long lens on one of my cameras, very quietly and discreetly make a trip up the left side aisle, and capture some really good close-ups of the bride and groom, celebrant, bridesmaids, bride's mom and dad, and guests (see ❀ Figures 6a and 6b).

fisheye all the way to my Canon 70–300mm IS telephoto lens. I never use a tripod, hence the importance of image-stabilized lenses in my gear bag. Tripods are just too slow, clumsy, and balky to move discreetly around a church.

Step Six:

Yes, we do make a trip to the balcony if we have access to it, and I always try to get some images from that vantage point (❧ *Figure 7*). Or, I send my assistant to cover the ceremony from that perspective as I hang out at ground level. Again, I run the full gamut of lenses from the balcony vantage point.

Step Seven:

As we near the end of the ceremony, I take up my position about a third of the way down the main aisle. My lighting assistant is in position as the celebrant announces the bride and groom as husband and wife. I capture that moment with a long telephoto lens and a high ISO (see ❧ *Figure 8*). I have absolutely *no* flashes going off at this point, or at any point during the ceremony.

Step Eight:

Then, I change to my "flash" camera for the series of images of the couple coming down the aisle. As the bride and groom make their way down the aisle toward me, I take several images while they look at each other, smile and greet their guests, and make their way back up the aisle (❧ *Figure 9*). After so many weddings, I've gotten pretty good at walking backwards.

Step Nine:

I really don't do much coaxing of expressions of the bride and groom—some photographers do, but it's never been my gig to "rig" the moment. I don't ask them to stop, or kiss, or look into the camera, or any of those coaxed candid images we so often see. I prefer to capture the best natural expressions and emotions of the couple and photograph the action as it evolves (❧ *Figure 10*).

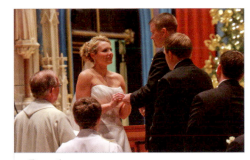
❧ *Figure 6a*

❧ *Figure 6b*

❧ *Figure 7*

❧ *Figure 8*

❧ *Figure 9*

❧ *Figure 10*

As you back down the aisle, just be sure there's no videographer or church lady behind you that you're unaware of. Also be aware of any low-lying baptismal founts that may be troublesome.

(Continued)

Figure 11a

Figure 11b

Figure 11c

This, many times, is a fake exit. They will circle the block and come back around to the church, with the guests mostly dispersed, and we finish any other couple or group images we need to take (❧ Figure 12).

Figure 12

Step 10:

Next up the aisle are the bridesmaids, grooms-men, moms, and dads—that's when all the hugging and kissing begins. I'm right there to capture it all—constantly moving, circling the couple as the tears, laughs, hugs, and kisses abound.

Step 11:

There are a couple scenarios that can happen as the couple leaves the church. At one wedding, as people came out of the church and were greeted by the bride and groom, the attendants handed out liquid bubbles to them and instructed them to line up on both sides of the sidewalk.

As the bride and groom made their exit from the church, the guests were ready with the bubbles. Many of the children had been practicing for quite some time, and bubbles were flying everywhere (❧ *Figure 11a*).

This is a wonderful opportunity for wide-angle images (see ❧ *Figure 11b*). At this point, I ask my second shooter to cover the bride and groom from behind as they exit the church and head to the limo (❧ *Figure 11c*). Covering the action from the front with my wide-angle lens, I'm careful to keep my assistant hidden behind the bride and groom. We get a great series of images as the couple moves through the gauntlet of guests, makes their way to the limo, and drives off. I love to get a wide-angle shot of them beside, and then inside, the limo. As the limo pulls away, I may reframe the image, including the guests, and signal by waving my hand for them to wave back to the limo.

Figure 1

"Altar return photographs" is a term photographers use to describe the shots of the wedding party, family groups, and bride and groom at the conclusion of the wedding ceremony. Whether in a hotel lobby, in the backyard, under a gazebo, or in the front of the church at the altar area, I'm going to call all these group images altar return photographs. I give myself about 35 minutes to capture all of them.

Here and in the next part, I'll cover my 24 quick steps for getting these photos as efficiently as possible. Note that efficiently means quickly, professionally, and yet still flattering of the client. Here we go:

Step One:

Have someone—the best man or the maid of honor—help you wrangle the members of the wedding party, family members, grandparents, and anyone else the bride and groom want to include in these group photos.

Step Two:

I like to have everyone gathered in the pews on the left side of the church. This allows my assistant to move freely through the right-side pews to position the off-camera flash. I have them sit about five or six pews from the front, so they are close enough to be called for photos, but far enough away so as not to be accidentally included in any images.

I also mention to all of them that I'll be working quickly, and would appreciate it if they held their photos until the reception—if additional cameras are firing, some of the wedding party may look into the wrong camera, and that can be quite expensive for the bride and groom because of the additional retouching to get the eyes centered properly. My goal is to have everybody finished up in about 20 or 30 minutes, so they can head to the reception and begin the celebration.

Step Three:

I always start with the bride's family, followed by the groom's family groups (*Figure 1*). Since the bride's mother and father usually host the reception, it's my goal to get them photographed as quickly as possible, so they may leave and begin their hosting duties.

I invite the bride and groom to come forward and position them in the front center of the church, if that works best for the groups we're photographing. This generally is *not* on the church steps. I hate the stair-stepped posing of groups—it's so '50s. Working with the bride's family, the group is generally not that large, so I prefer to have the bride and groom at the floor level of the church.

Step Four:

When posing the bride and groom, always have the groom on the left side of the bride, with his boutonniere positioned on his left and his right arm around the bride (*Figure 2*).

Figure 2

(Continued)

Step Five:

Always have the bride and groom turn about 45° toward each other, with the front of their feet pointed slightly closer to the camera and all their weight on the back inside of their feet. At this point, I don't spend any time fussing with the bride's train—I actually have my assistant tuck it behind the couple, so I don't see it for the group shots. I'll showcase her dress later, in other photographs.

Step Six:

Next, we bring the bride's mother and father into the scene. I like to have the bride's father stand next to his daughter and the bride's mom next to the groom. I ask the groom to offer his arm to the bride's mother, as if he were escorting her down the aisle. I'm also careful to be sure that he's not showing me the back of his hand, but instead rotates his wrist, revealing the side of his hand, because it looks a bit more graceful.

Step Seven:

The positioning of the feet of all four people is important for everyone to look their best. The bride's father should bring his right foot just slightly forward, with all his weight balanced over his left foot. I also ask him to put his arm around the bride, under her veil. The bride's mother should point her left foot slightly toward the camera, with all of her body weight on her right foot (see ❧ *Figure 3*).

Avoid individuals positioning their arms around subjects to both their left and right. This widens their composition, pulls at the tuxedo or suit jacket (for the men), and is typically very unflattering.

Step Eight:

I then fine-tune the group, so that all faces are looking back to the camera and they are parallel to the film/CMOS sensor plane. This is moderately important, and makes for a better-looking group.

Step Nine:

If anybody is wearing glasses, I ask them to tilt their head down just a bit to minimize the reflection from my on-camera fill flash or my off-camera flash.

Step 10:

The next step is to just get the best expressions, and we all have our own methods for that. I never use any suggestive words or

❧ *Figure 3*

❧ *Figure 4*

phrases—I think it's improper and unprofessional. I may try a corny joke, ask them to show me more teeth, or keep shouting my famous "Happier! Happier!" line. The bottom line is: the client has to be happy with you, and feel comfortable with you, for you to be able to get the best expression from them. Practice your own wording until it feels comfortable and professional, and evokes the response you desire.

Step 11:

My routine over most of my years as a wedding photographer has been to frame up these groups as full-length photographs. In these

Curiously enough, these close-cropped images have become the most popular group selections for the bridal album, but I still take a few of the full-length group shots just to have them as part of the selection.

❧ Figure 5

last few years, though, I've found myself zooming in for a tighter group shot. My group photos these days very often are cropped right at the knees or just below the waist (❧ *Figure 4*).

Step 12:

After taking the full-length and three-quarter-length group photographs, I quickly encourage my subjects to give each other a group hug. At this point, arms can reach around anyone. I cheer them on for a tighter and tighter group hug, which always heightens the expressions.

This often allows me to sell more than one photo of the same group for the wedding album. I suggest that the more traditional group shot be a larger-sized image in the album, and the "huggy" shot be inset next to it to show even more feelings and emotions. In any event, the "huggies" are a big part of the fun imagery we try to produce for our clients.

Step 13:

After photographing the bride with her mother and father, I ask the siblings to join the group. If any of the siblings are married and have children, their spouses and children are also asked to join (as seen in ❧ *Figure 5*). If one of the siblings is with a boyfriend or girlfriend, I take one family photo without the boyfriend or girlfriend and then take a second with the boyfriend or girlfriend included.

The ongoing wedding photography joke when including a boyfriend or girlfriend is to always pose them on the outside of the group—you know, just in case they aren't around in the future, they can easily be removed.

(Continued)

Figure 6a

Figure 6b

Step 14:

If grandparents are present, I ask them to join the family group next. I always position them between the bride and groom, making them the center of the group. The grandparents often comment that they don't want to come between the couple, but I explain that they are the matriarch and patriarch of the family and, therefore, are entitled to the center position. Once again, I go through my routine of full-length, three-quarter-length, and group hug.

Step 15:

With the entire group photographed, I know I still have to capture the grandparents with the bridal couple. They're already in position, so I just ask the rest of the family members to leave the grouping. I make a few more quick photographs—generally three-quarter-length photos and "huggies"—and finish the series (*Figures 6a* and *6b*).

Step 16:

I then ask the bride and groom to stand away from the grandparents as I take a few more shots of these very special people in their lives. If both sets of grandparents are present (the parents of the mother of the bride and the parents of the father of the bride), I photograph each grandparent or couple separately.

Sometimes, we are asked to photograph the extended family members, too. These groups can get quite large and take time to set up. The church is the best place to take these shots, because once they get to the reception, it will take half the night to round them all up again. Remember, though, that if you take these photographs at the church, you need to plan for the extra time it will take. This should be covered in the pre-wedding meetings with your clients.

Step 17:

Repeat all of the above for the groom's side of the family. That's quick and efficient group posing, which still gives you a great series of images.

Figure 1a

Next, we move on to the second set of altar return photos—the wedding party:

Step One:

The next important group to photograph is the wedding party. Most of the time, I've already photographed the guys individually and/or with the groom before the ceremony, and the same is true for the girls and the bride. So, really all I need to do is get that one great photograph of the entire wedding party. I always start out with a more traditional grouping, eventually moving into the "huggy" images.

What's really cool when working with a very large group is that we can pull off a great series of images that look terrific in the wedding album. Let's look at just such a series to see what I'm talking about:

Notice that I start off with a very traditional photo of the wedding party (see *Figure 1a*). Then, I start walking toward the large group while zooming in at the same time, centering and focusing primarily on the bride and groom (*Figures 1b*, *1c*, and *1d*). Look at the reactions of the bridesmaids and groomsmen around them, and how the excitement kicks up another notch. This series will easily become a two-page spread in the wedding album.

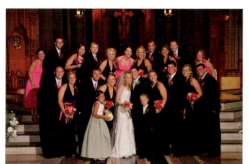

Figure 1b

Figure 1c

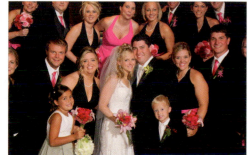

Figure 1d

(Continued)

Figure 2

Figure 3

Figure 4a

Step Two:

It's extremely important that your assistant always gets the proper light on the scene, and that your off-camera flash is powerful enough to keep up with the speed at which you're taking photos. One of my aces-in-the-hole for making this work is a high ISO. This assures me that the light output of my on-camera flash and off-camera flash are minimized, so that the flash recycle times are shortened substantially, allowing me to work quickly.

Step Three:

After photographing each family and the entire wedding party, we may capture some additional photos at the bride's or groom's request—a special aunt or uncle, godparents, special friends that made it in for the wedding, etc. (*Figure 2*). We wrap these images quickly and everybody is released to go to the reception.

Step Four:

You may want to take a photograph of the bride and groom with the best man and maid of honor. I, typically, don't take this photo at the altar area, as I usually shoot these combinations earlier in the day, but we do get a request every now and then. Occasionally, I photograph the junior bridesmaids, flower girls, and ring bearers with the bride and groom, separately (see *Figure 3*). But, again, I typically have already photographed these combinations earlier.

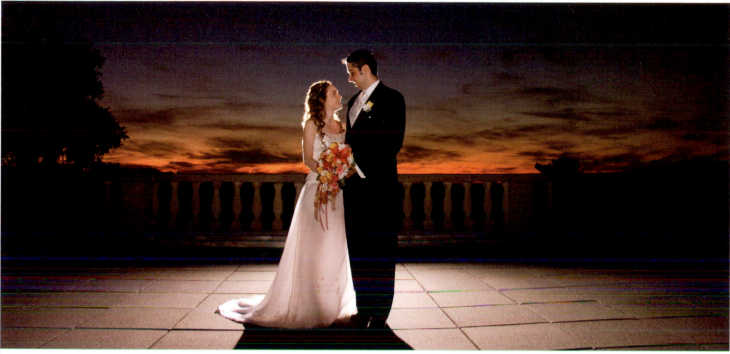

Figure 4b

Step Five:

Once I'm finished with the big crowds, I need a few more minutes with the bride and groom alone. The first photo I take is a full-length one of them together, their bodies slightly turned toward each other, inside arms around each other, and looking back into the camera. It's always taken full-length and shows the bride's gown in its entirety, with special attention to the train (*Figure 4a*). Folks, this is the big money shot—this is the image they will show to the grandkids (*Figure 4b*).

Step Six:

Now, the cool thing is they're already standing in position—I'm shooting with my digital SLR with a zoom lenses attached—so I take several more photographs, zooming in at various settings to capture several additional images of the bride and groom, from full-length all the way to a tight head-and-shoulders shot (see *Figure 5*).

Step Seven:

Another very important shot we need to capture is a full-length image of the bride alone. I simply ask the groom to step aside, arrange the bride into a flattering pose, make sure my assistant is in the right position, and shoot away. Then, once again, I zoom in and capture several additional images of the bride. This is repeated for the groom, but not quite as extensive a shoot as with the bride.

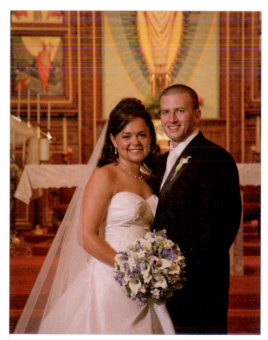

Figure 5

Part 6:
Shooting the
"Signature" Images

In Parts 4 and 5, I discussed basic group shots you need to take of the wedding party, families, and friends. In Part 6, I want to show you how to add some sizzle to that series of images. I call them my "signature" images—a short series that are always a part of my wedding coverage.

These signature images signal the style that my clients seek out and have become familiar with from David A. Ziser Photography over the years (see ❧ *Figures 1a*, *1b*, and *1c*). Let's talk about them and my three more steps for shooting the altar return images:

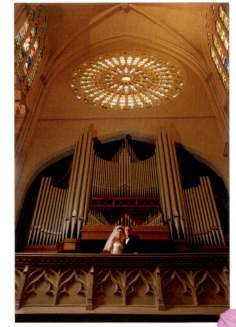

❧ *Figure 1b*

❧ *Figure 1a*

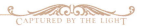

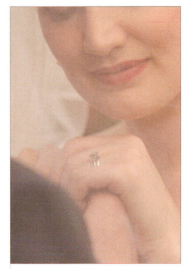

Figure 1c

Figure 2

Figure 3a

Figure 3b

Step One:

These images usually include compositions that are more dramatic than standard wedding photographs (*Figure 2*). The first one is a back-lit aisle photograph. I position the bride and groom about halfway up the aisle. My assistant simply gets about 12 feet behind the couple, with the flash 4 feet off the ground and pointing toward their shoulder blades (I covered this in Chapter 6).

Step Two:

Next, I like to get a couple photographs of the bride and groom within the beautiful surrounds of their church. We move two-thirds of the way back down the center aisle, toward the back of the church (*Figure 3a*), where I set up a few more dramatic photographs—dramatic because of the composition. I want to show the bride and groom in this wonderful location (*Figure 3b*). I allow myself about six or seven minutes for these images, then we head outside.

(Continued)

My Workflow at the Wedding • 203 •

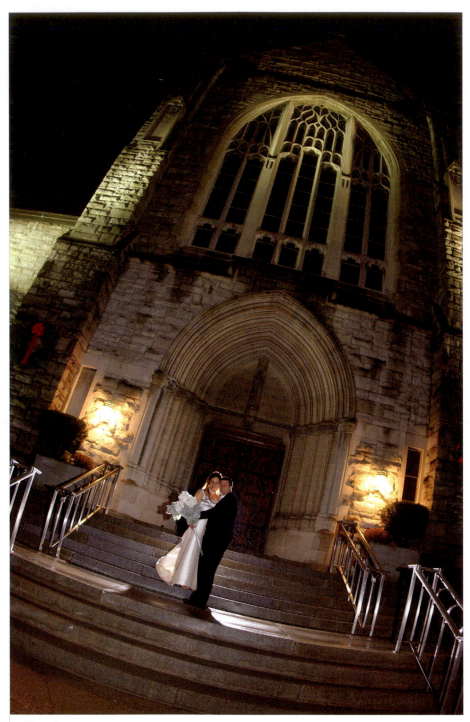

• Figure 4

Step Three:

My assistants and I are pretty well rehearsed at this point: my assistant grabs the gear, and we make our way outside the church first, so I can get a shot of the bride and groom as they come down the steps (*◈ Figure 4*). My other assistant knows to be behind the couple, and I quickly get a few additional shots.

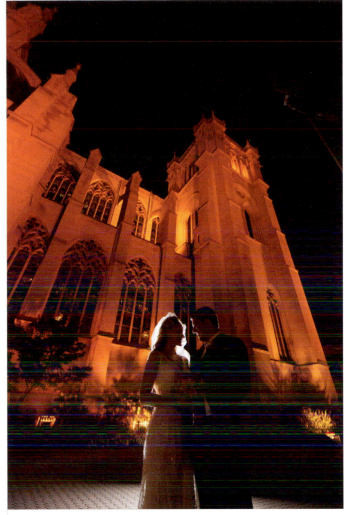

 Figure 1

Part 7: Heading to the Reception

After we get that last great photograph of the bride and groom on the church steps, they are ready to jump in the limousine and head for the party. I generally try to get a few more photos of them coming down the steps.

Step One:

I try to position myself relative to the bride and groom, the limousine, and the church to create an overview shot that will look great in the wedding album (❧ *Figure 1*). I may even ask the bride and groom to wave into the camera.

Step Two:

The next shots I capture are an "inside the limo" series. Once they are seated in the limo, I peek in the back door, ask the bride to fall into the groom's arms, and have them both look back at the camera, giving each other a big hug (❧ *Figure 2*). This is my last photo before they drive off.

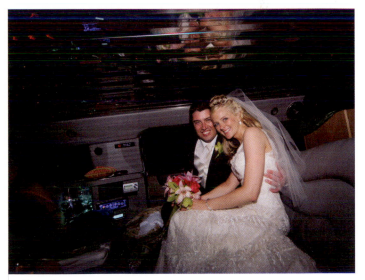

❧ *Figure 2*

(Continued)

Figure 3

Step Three:

With the door now closed and the limo driver approaching the driver side door, I move around the limo, trying to frame up the Just Married sign against the church. After that shot, I move to the front of the limo and try to catch the grillwork against the front of the church, as well (✺ *Figure 3*). Next, if I can, I try to get one more photograph of the front or the rear of the limousine or carriage in front of the church.

Step Four:

It's at this point that I make some scene setters of the church exterior at night to use as fill shots and backgrounds when designing the wedding album.

I moved through this series of images fairly quickly. I hope it gives you a pretty good idea of what I'm trying to capture in those last few minutes before heading to the reception. I work quickly, trying not to detain the couple more than about 10 minutes, yet including these signature images.

On a different note, in some parts of the country, it is traditional to have a several-hour break before the reception is scheduled to begin. In that case, I pre-plan with my clients to head to a park or other interesting location to capture additional images (see ✺ *Figures 4a*, *4b*, and *4c*).

The total time to do all these photographs—family, wedding party, bride and groom, and signature images—needs to be only 30 to 35 minutes, no more. Don't forget, it's not your show, it's the bride's and groom's day.

❧ *Figure 4a*

❧ *Figure 4b*

❧ *Figure 4c*

Talk with Me

My Workflow at the Reception

The weddings we photograph are generally some of the nicest in town. However, I started my business working in church basements, civic halls, VFWs, and the like. Several years ago, we were covering a wedding reception that was held at the fire department. The trucks were pulled out of the garage most of the way to make room for the DJ, guest tables, and guests.

Well, you can guess what happened. About halfway through the evening, the fire alarm went off. Half the guests were firemen, so they donned their fire gear, hopped into the fire trucks, fired up the big diesels, and gassed all the remaining guests, including yours truly. Needless to say, it put a damper on the festivities. The good news is that it was a false alarm—the fire trucks and firemen returned about 45 minutes later, and the party picked right back up where it left off. Yep, we got some good shots at that reception.

In this chapter, which is really a continuation of the last one, we'll take a look at what I normally shoot at the reception, from the room setup before the reception starts, to the cocktail hour, the cake cutting, the first dance, the party, and packing up as everything winds down.

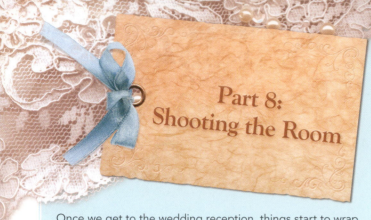

Part 8: Shooting the Room

Once we get to the wedding reception, things start to wrap up for us. We've been on the job for about six hours, and we're now in the home stretch. Often, there is a cocktail hour, which we need to cover when we arrive at the reception venue. At the same time, the final preparations are being made in the main ballroom before the guests enter—the water is poured, the votive candles are lit, and it's just moments before the doors will open on this beautiful setting.

My job is to capture some beautiful images of the room before the guests enter (see ✿ *Figure 1*). The challenge is getting them while the staff is still fussing with last-minute details of the room. Time is ticking away and the doors need to open in the next few minutes.

I quickly find the banquet captain to learn what the timeline is, and to ask how much more time the staff needs to finish their preparations. I usually have about seven or eight minutes to get the room photographed. That's really all I need. I shoot at about a million miles an hour, constantly changing lenses for the room shots from a super-wide-angle to a telephoto, and come up with a tremendous variety of images. Here's a play-by-play for the series:

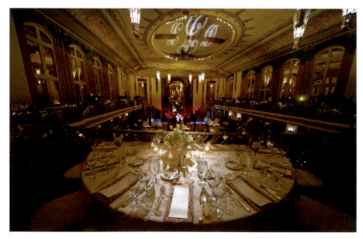

✿ *Figure 1*

Step One:

I take several wide-angle photographs of the entire room, from several different positions (✿ *Figure 2*). My lens of choice is my 10–22mm lens on my Canon 7D, or the 12–24mm Sigma on my Canon 5D Mark II. The camera is set to anywhere from 800 to 3200 ISO. With the new higher-ISO cameras on the market, my job is even easier, since I *never* use a tripod for these shots.

Step Two:

I make sure to cover the room with a wide-angle lens from the left side, the middle, and the right side, so I have plenty of different points of view (✿ *Figures 3a* and *3b*). A lot of these images find their way back to the venue, event planner, and florist for use in their promotions—with my byline, of course.

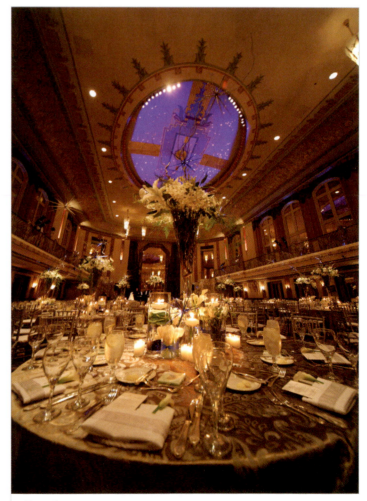

✿ *Figure 2*

Step Three:

I try to get some very low-angle views, as well, by featuring one of the centerpieces in the composition against, maybe, the ceiling of the grand ballroom.

Step Four:

Next, it's time to run up to the balcony. Once again, with the wide-angle lens in place, I shoot the room from different angles (❧ *Figure 4*). If there's no balcony, try placing the camera on a monopod, set the self-timer, lift it over your head, and take the shot from as high as possible to create a different vantage point.

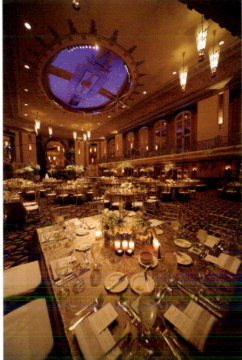

❧ *Figure 3a*

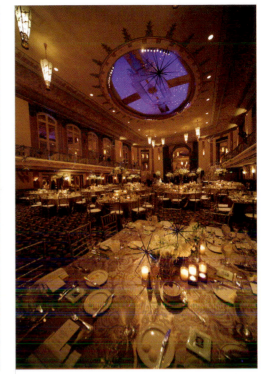

❧ *Figure 3b*

❧ *Figure 4*

(Continued)

Figure 6

Figure 7

Step Five:

While up in the balcony, I'll change optics to the 24–105mm IS lens and isolate some tabletops, again, to the show different aspects of the room.

Step Six:

Also while up in the balcony, I'll put my 8mm fisheye on the camera and take a few photos with this unusual perspective, then run back downstairs and get a few there, too (*Figure 5*).

Step Seven:

It's at this point that I know we're about out of time. But, I've taken all of my wide-angle shots, so when the guests start trickling in, I'm still in good shape. I switch to my 50mm f/1.4 lens, and do some detail photographs of the tables and the items on them (menu cards, a unique fold of a napkin, the chocolates, the centerpiece, etc.), and, of course, the wedding cake (*Figure 6*).

Step Eight:

In shooting these details, I'll sometimes use a wide-angle lens like my 10–22mm, so I can really add some dramatics to the items on the tabletop (*Figure 7*).

That about wraps it up. I've got a great series of images to share not just with the clients, but with the venue, as well. In total, I'll shoot anywhere from 30 to 50 images of the ballroom.

My assistant, meanwhile, is responsible for covering the cocktail hour, concentrating on capturing groups of family and friends, couples, and the musicians. These images are mainly candid snaps, grip-and-grin, everyone smiling, looking directly back into the camera. Only a few of them find their way into the wedding album, but they're still important, so we'll talk about them next.

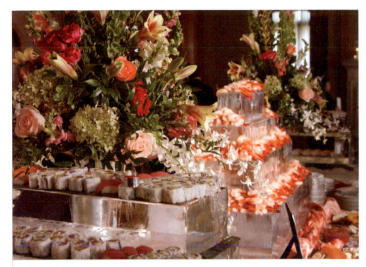

Figure 1a

Part 9:
Cocktail Candids

In my part of the country, cocktail hours are arranged about an hour before the reception. It's a time when the bride's and groom's family and friends, many of whom haven't seen each other for a while, come together, and is a warm-up for the wedding reception. I call the images we create during this time "cocktail candids," and they're important, at least for storytelling purposes. Here's how we shoot them:

Figure 1b

Step One:
We try to get to the venue quickly to shoot as many setup shots as we can of the hors d'oeuvres, ice sculptures, room setup, and whatever else strikes us as an interesting part of the decoration (see *Figures 1a* and *1b*).

Step Two:
Next, I make a few overall photos of the guests being greeted by the mother and father of the bride—the hosts for the event (*Figure 2*). These are usually just a few wide shots that help tell the story.

Figure 2

(Continued)

Step Three:

Then we cruise the crowd, grabbing photos of the guests as they mingle and visit. I need to make an important point here: cocktail candids are *not* photographs of the backs of people's heads, people eating hors d'oeuvres, or people drinking their refreshments. Truthfully, I find no use for those types of photos—they are mostly unflattering pictures of the guests that are never purchased or placed in the wedding album.

Step Four:

I want to see the faces of the guests at the party, so we simply approach a small group of people and request to take their photograph. They always say yes, we ask for smiles, and take a couple of shots (❧ *Figure 3*). To be sure we have no closed eyes or bad expressions, we take at least two photos of each group.

Step Five:

We move through the crowd trying to focus on the groups that include family members and wedding party members (❧ *Figure 4*). This means, generally, that we will be photographing guests who are fairly important to the bride and groom, and their families.

Step Six:

We light these images in the most efficient way possible to get the best photographs. If there are two of us covering the cocktail hour, I use an on-camera flash, while my assistant holds the second light. If we're working in a smaller space with only one of us covering it, then we may use the side-bounce technique to illuminate the guests (see Chapter 4 for more on this).

Step Seven:

If only one of us is photographing the cocktail hour and the space is quite large, then we resort to just the on-camera flash bouncing directly up to the ceiling with a fill flap in place to bring a lot of the light directly back on the subjects. Yes, I'm admitting that we just use straight on-camera flash. It's not the best lighting, but it's adequate for this part of the event. My assistant often covers the cocktail candids, while I photograph the main ballroom.

Step Eight:

If only one of us is photographing the cocktail hour, we generally use the Canon 40D fitted with a 17–85mm lens. If space is quite tight, we may be fairly close to our subjects and set our lens to its widest (17mm) setting. If this is the case for you, be mindful of exposure problems.

On-camera flashes have an optimum working range for their best exposure. Being very close to the subjects is not within that range, and generally overexposes them. We have two workarounds for this: first, back away from the subjects approximately 6 or 7 feet before taking the shot. This is a sweet spot for the flash and assures consistent, well-exposed photos.

The second solution is to turn the power of the on-camera flash down by two-thirds of a stop. The problem with this is that we have to remember to return the flash to its normal power for the rest of the shoot. I tell my assistant to stick with plan A, when possible: stay 7 feet away from the subjects.

❧ *Figure 3*

❧ *Figure 4*

Step Nine:

We occasionally do some available light images during this time, trying to capture the fun and spontaneity of the cocktail hour. We don't take many of these shots, but include a small sampling in our presentation (see ❧ *Figures 5a, 5b,* and *5c*).

Step 10:

As soon as we know we've got the cocktail hour covered, we meet up in the main ballroom, place our gear in a secure and safe place, and get ready for the rest of the evening's festivities.

❧ *Figure 5b*

❧ *Figure 5a*

❧ *Figure 5c*

Part 10: Table Photographs

Table photographs—photos of the guests sitting around tables at the reception—are an integral part of my reception coverage. Couples really enjoy having photos of all the guests at their wedding in their wedding album. So, it becomes my responsibility to not only capture the moments, emotions, and activities, but also to record the attendees. The challenge with these is that we need to do it quickly, smoothly, and discreetly, with as little disruption to the guests as possible.

Figure 2

Figure 1

I know many photographers who, when photographing tables, have the people at the front half of the table get up and stand behind the people at the back half of the table. I gave up that method years ago, because I felt I was disturbing about 50% of the guests. For the past 20 years, I simply have asked all the guests at the table to look into the camera, give me their best smile, and then I've taken the photograph (see *Figure 1*). This allows me to work quickly through all the tables and get the images I need. Here's how I do it:

Step One:
I approach the table I want to photograph and ask the guests to look toward me, give me their best smiles, and remove their napkins if they are in the front, closest to the camera.

Step Two:
I then back up about 15 feet, with my camera at its wide-angle setting (typically the 17mm setting on my 17–85mm lens).

Step Three:
As I take up my position and get everyone's attention, my assistant

As you back up to get the shot, be sure you don't bump into a waiter serving other guests, or even the cake table. I know a photographer who had everyone looking at him with big smiles, then backed up, bumped the cake table, and toppled the top layer. Needless to say, he captured an entirely different set of expressions.

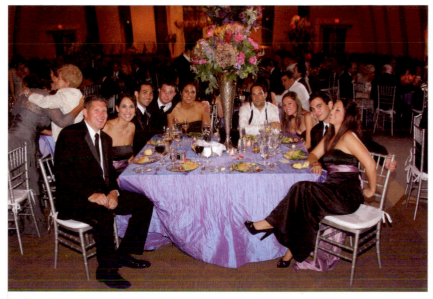

takes up his/her position to the left or right side of the table. As discussed in Chapter 4, I'm at the six o'clock position, and my assistant is at the ten o'clock or two o'clock position, being sure not to align the light with the room light if there is one in the vicinity (see *Figure 2*).

Step Four:

My assistant has to be sure that he/she won't cast any shadows—from people or centerpieces—onto the guests gathered around the table. If I bring my assistant in at the nine o'clock or three o'clock position, the centerpiece will cast nasty shadows on any guest sitting on the opposite side of the table (see *Figure 3*).

If my assistant is too close to the guests, then those closest to the light will be overexposed and those farther from the light will be underexposed, meaning a lot of heavy lifting in postproduction in Photoshop. I've found that the optimum distance is about 25 feet. Remember the inverse square law we talked about in Chapter 6?

With my assistant at the ten o'clock or two o'clock position, shadows are still cast by the flash, but they are cast on the backs of the heads of the people opposite, and I get the added benefit of an accent light that helps separate the guests around the table from the darker background. This just adds more depth and dimension (see *Figure 4*).

Step Five:

Since I use a wide-angle lens, I have to be careful not to include my assistant in my field of view. If I see that he or she is within the field of view, I simply signal with my hand. Also, he or she is about 25 feet away from the table I am photographing.

Step Six:

Once my assistant is in place and I have everyone's attention, I lift the camera as far as I can over my head, tilting it down slightly, targeting the center of the table. I know from experience that I can easily frame the table and guests with the camera over my head.

Guests often ask how I know they are properly framed. I joke that I use laser targeting and can nail the shot every time. The fact of the matter is you can nail the shot every time with a little practice. Remember, I'm using a wide-angle lens, which gives me a little latitude with my targeting method. I leave plenty of space around the table to adjust the crop in postproduction. I may not be dead center all the time, but cropping is an easy fix.

(Continued)

Once you learn this technique, it works well on many of the wedding candids. There is no reason to look through the viewfinder for all your shots once you develop a feel for your camera. Just realize you can point it consistently in the direction of the action and get the shot without taking the time to bring it to your eye and frame the shot.

Figure 5

Step Seven:

Always take at least two photographs, in case someone blinked in the first one. After taking the first, I ask for one more. After taking a second, I thank the guests, and move on to the next table.

Step Eight:

It's important to keep track of all the tables photographed. Often, my assistant sketches out a quick grid of the table positions, and we simply cross them out as we move through the room (see *Figure 5*).

Step Nine:

If there are a large number of tables (e.g., more than 30), then we "divide and conquer" to be sure we capture all of them in the 35- to 45-minute window we have. Unfortunately, when we do this, I compromise on my lighting for the images my assistant takes, as he is working without the added benefit of an off-camera flash assistant.

Step 10:

So, I photograph the key tables in the room, including the bridal table, parents' tables, close friends' and families' tables, and wedding party tables. My assistant, without additional lighting, will photograph the peripheral tables, using the fill flap technique I mentioned in the Cocktail Candids section earlier in this chapter.

It's important that my assistant is far enough back from the table so that the light carries across the distance of the table—that we have sufficient "depth of light"—and can achieve a fairly even illumination

Figure 6a: Original

Figure 6b: After Lightroom fix

on the people in the foreground, as well as those on the far side of the table.

With my assistant at the appropriate distance—at least 15 feet away from the table—and using the fill flap technique, we are able to get adequately illuminated table photographs. We have a preset in Lightroom that includes the Gradient Filter, and which evens out the illumination of these table photographs quite nicely (see ❧ *Figures 6a* and *6b*).

Here are a few additional things to keep in mind when shooting these table photos:

- ❧ The table images are purchased for the bridal album approximately 90% of the time, but you must have the complete set in order to sell them. I've found over the years that if you're missing even one table, the clients may decide not to take all the tables.

- ❧ These table photographs are printed quite small in the album—laid out in the album at six to eight table shots to a page (see ❧ *Figure 7*).

- ❧ Using smaller-size photographs in the wedding album means that the large number of images, say 24 table photographs, does not take up a lot of album real estate—they cover only about two spreads. Clients love the fact that they have images of all the guests who celebrated with them on their special day, and it rounds out the coverage nicely.

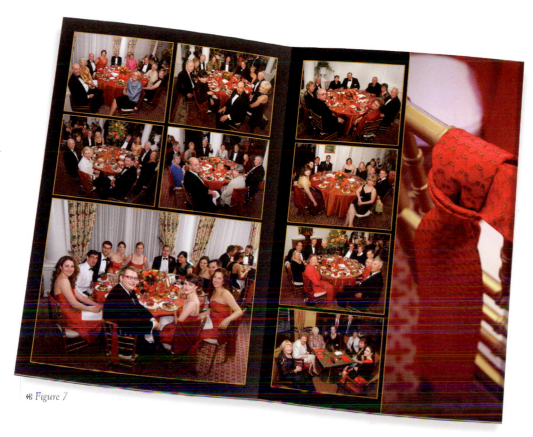

❧ *Figure 7*

Part 11: The First Dance and Dancing with the Parents

Some of my favorite, and some of the most important, images to capture at the reception are the bride and groom dancing their wedding dance. (*Note:* The order of these parts of the reception is simply the way most weddings I shoot happen, but may vary depending on your location.) This is a great time to get some wonderful, romantic images of them both (❀ *Figure 1*). I showed you a lot of these kind of images in Chapter 5, but let's take a moment to walk through the series here:

Step One:
The band or DJ announces the wedding dance, and the bride and groom make their way to the dance floor. If they've been practicing at a dance studio, it shows—they come onto the dance floor with a bit more flair.

Step Two:
As they begin the dance, my assistant makes his way around to the back of the couple (see Chapter 5 for more details).

Step Three:
As I switch off the room light with my radio control unit, I take up my position to get the best shots—I prefer guests in the background, looking on as the couple dances (as in ❀ *Figure 2*).

Step Four:
After I get some good backlit shots, I signal my assistant to take up his regular double-light position (see Chapter 4), switch the room light back on, and continue to photograph the couple, trying to capture as many great expressions as I can (see ❀ *Figures 3a* and *3b*).

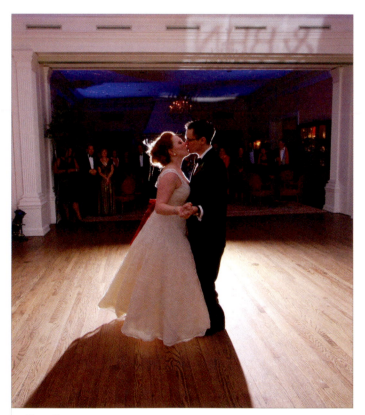

❀ *Figure 1*

❀ *Figure 2*

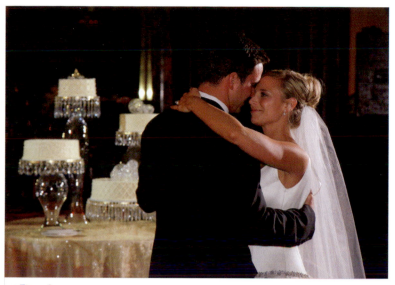

Figure 3a

As the wedding dance gets near the end, be on the lookout for the groom to dip the bride for the big finish. You've got to be in the right position to get that shot, so stay attentive.

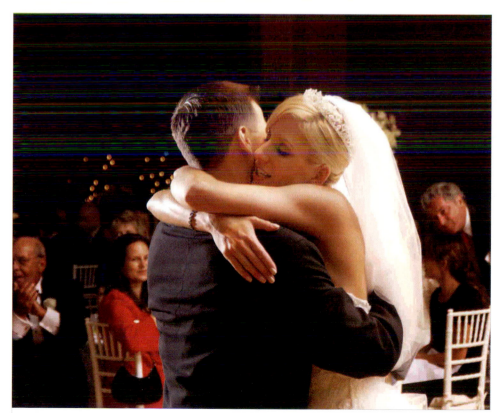

Figure 3b

Another great series of images is the bride dancing with her father, and the complementary series of the groom dancing with his mother. I know, as a father, this would be the highlight of the wedding for me. Watching your little girl grow up over all those years, and then seeing her as a woman marrying the man of her dreams has to be a wonderful thrill for any father.

There are always smiles, and sometimes tears and hugs, all of which need to be captured. I have a regular routine that I follow when photographing these series. Let me walk you through the steps, and share with you what I look for when capturing these images:

Step One:

The band often announces that it's time for the bride to dance with her father. She makes her way to the dance floor, sometimes with her father and sometimes not. I remember one wedding where the bride was already on the dance floor when her dad made his

(Continued)

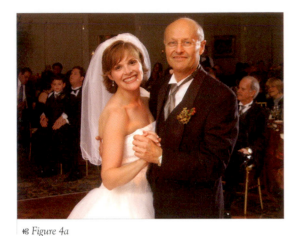

Figure 4a

Figure 4b

Figure 5

Figure 6

grand entrance, approached his daughter, put his arms around her, and started the dance. We need to capture these early moments of the dance, too.

Step Two:

Early in the dance, I try to grab one coaxed candid. This means that, right after the dance begins, I approach them easily, and ask them to look into the camera and give each other a hug. The smiles come naturally. I click off a couple of images (*Figures 4a* and *4b*), thank them graciously, back away, and let them enjoy the rest of their dance together. Back on the sidelines, I follow the action, capturing the many expressions and emotions of this shared moment.

Step Three:

In the opening moments of the father/daughter dance, the bride and her dad usually share reassuring, loving words with each other, and there are some great expressions to be captured.

Step Four:

As the dance proceeds, the bride and her father many times start reminiscing, and you'll see a tear or two well up in the eye of one of them. I zoom in close on their faces and am sure to capture those wonderful expressions (*Figure 5*).

Step Five:

The bride and her father may have rehearsed a dance step or two, and they may break into a Fred Astaire–Ginger Rogers routine. It's always in good fun, and always presents opportunities for great images. Not all my images are made as a tight crop on the subjects. Many are zoomed out to capture the full length of the dancing partners (*Figure 6*).

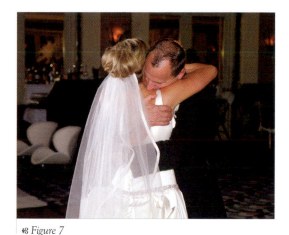

Figure 7

Figure 8a

Figure 8b

Step Six:

As the song reaches its end, be sure that you're ready for what will invariably happen: as the last note is played, the father and the bride will hug each other tightly, maybe kiss, or maybe he'll dip his daughter, and they may hold each other for a moment or two (※ *Figure 7*). Don't miss this—it's a wonderful opportunity to capture some treasured moments.

Remember to get the reactions to the father/daughter dance. Glance over at the bride's mom and see her reaction—often a tear or two. Don't miss this shot. Actions combined with reactions result in a wonderful moment for your photographic wedding story.

I love to take a photo over the father's shoulder, looking directly into the bride's face to capture her emotions as they dance, and also over the bride's shoulder, seeing her dad's face and capturing his emotions. So, remember, it's not just about them dancing together—isolate the dad in some of your shots, and then the bride, to really add to this series.

I do exactly the same thing when the groom dances with his mother (※ *Figure 8a*). Keep an eye on the emotions, the smiles, the hugs, the feelings they have for each other. Be sure to concentrate on images looking over the mother's shoulder into her son's face, and also over the groom's shoulder into his mother's face. Be ready for the end of the music, when they draw together tightly, give each other a big hug, and maybe even a kiss, celebrating the feelings they shared (※ *Figure 8b*).

When we lay out the albums, we often have a two-page spread of the bride dancing with her father (※ *Figure 9a*), and then a two-page spread of the groom dancing with his mother (※ *Figure 9b*). It is one of the high points of the wedding, and really demands that we do our best to capture all the moments possible.

Figure 9a

Figure 9b

Part 12: The Cake Cutting Shots

The bride and groom cutting the cake is another of the reception highlights, and should have thorough photographic coverage. There are many opportunities to capture great action and reaction shots during the cake cutting festivities. Let me walk you through the steps I take to cover it:

Step One:

I take several photographs of the wedding cake by itself, including close-ups and detail photos of the entire cake. Many times, it is illuminated with a spotlight or additional lighting at the reception, and we can make the most of these images by setting our camera to tungsten white balance and not using any additional lighting.

I always try to move around the cake, capturing as many different views as I can: low angle, high angle, close-ups of the different layers, detail shots of the icing and decorations, and flowers (see *Figures 1a* and *1b*). Move around the cake and notice how the light changes and how the background changes. You'll be surprised by how the cake looks from these different perspectives. Think of the cake as getting its portrait taken.

Step Two:

If we don't have the luxury of additional lighting on the cake, then I ask my assistant to come in and we use our regular two-light setup. I still move through an entire series of images featuring the cake table with bridal bouquets, close-ups of the cake by itself (*Figure 2a*), the champagne glasses, the special cutting knife, and several detail photographs, from the bottom of the cake to the decorative top layer (*Figure 2b*).

Step Three:

It's important how we position the bride and groom around the wedding cake for two reasons: first, I like to balance the tonalities in the scene and, second, to get the best lighting on the couple and the cake. If I'm looking at the cake and I want the bride and groom on the right side of it, I ask the groom to step in around the cake table first, and then the bride after him.

As I look at the scene, I see the cake on the left, the groom in the middle, and the bride on the right. Notice that we have the groom in a pivot point in the composition, balancing the cake's white icing on the left with the white wedding gown on the right (see *Figure 3*).

Step Four:

It's also important to be at an appropriate distance from the cake when making your image. If you get too close, your flash will overexpose the cake icing, especially if you are focused on the bride and groom. I back up about 10 feet from the couple and zoom in slightly to frame them in the viewfinder. This ensures that my on-camera flash will put consistent, even illumination on the cake and the bride's gown.

Step Five:

My assistant will take up his/her position to the left side, out of camera range. It's important that the assistant sees the groom on the left, the bride in the middle, and the cake on the right

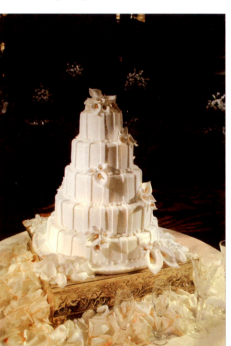

Figure 1a

Figure 1b

Figure 2a

Figure 2b

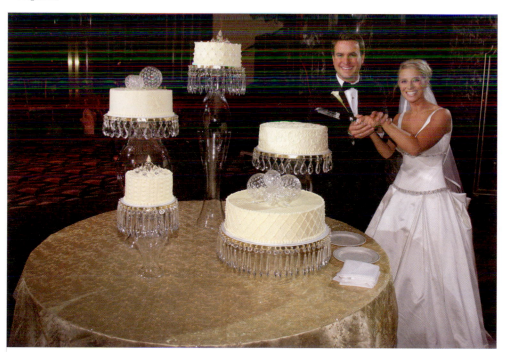

Figure 3

(Continued)

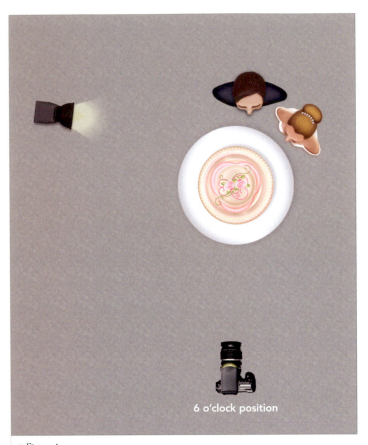

6 o'clock position

Figure 4

(see *Figure 4*). If my assistant is out of place, then he/she may see the groom, then the bride standing behind the cake, and the cake shadow will be thrown directly onto the bride's gown (as discussed in Chapter 4)—a big no-no and lots of Photoshop down the road.

Step Six:

Remember that my assistant is the key light—the light that's making the shot look great. That means that our exposure needs to be balanced, with my flash set about one stop down. With the assistant as the key light and me as the fill, we achieve the depth and dimension I want. You may have to experiment with your own gear to get the settings where you want them for the best result.

Step Seven:

I always coax one image of the bride and groom, asking them to look back into the camera and smile as I take two or three photos (see Figure 3 again). Once I know I've got the image, I ask them to just go ahead and cut the cake.

Step Eight:

As they're cutting the cake, I take several more images—close-ups of their hands on the knife as they cut the bottom layer, and some of the expressions they make as they cut it (*Figures 5a* and *5b*). Equally important is to turn momentarily and explore the guests watching them, and capture some reactions, giggles, smiles, and laughter from them.

Step Nine:

After they cut a small slice of cake and place it on the plate, I may have to help direct—it's time for them to feed each other the cake. I know, things can get a bit messy, but I don't see that too much anymore.

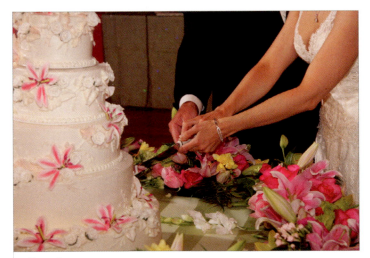

Figure 5a

Figure 5b

Figure 6a

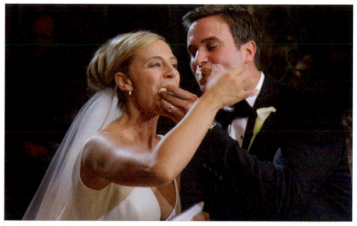

Figure 6b

The bride and groom each take a piece of cake and offer the other a bite (☙ *Figures 6a* and *6b*). I take several photos, and once again, we survey the audience, too, capturing any great reactions the guests may have.

Step 10:

After they feed each other cake, they may give each other a kiss (☙ *Figure 7a*), wipe any icing from each other's faces (☙ *Figure 7b*), and toast with champagne. Keep the cameras rolling—it's digital, every shot is free, and you may get more wonderful emotions and expressions from the couple.

That pretty much wraps up this part of the reception. There are times, as I said, that things get quite messy. If they do, it's another opportunity to knock off some great candids. Just remember that you are capturing the moment, and the moment is a combination of the action of the couple, and the reaction of the guests should anything really funny happen.

Develop a sixth sense. Know who is standing around—left, right, and behind you—watching the bride and groom during the cake cutting. Anticipate their reactions as the couple goes through the motions.

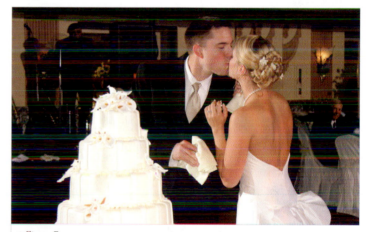

Figure 7a

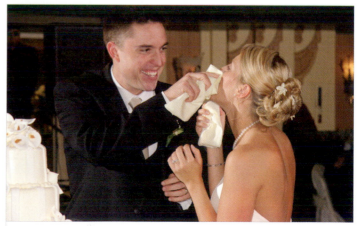

Figure 7b

Part 13:
Slow Dance
Candids

Well, folks, these are the really easy photographs to shoot. Before I begin, let me be clear about one thing: I *don't* take many slow dance photos of guests without some kind of interaction with them. I know this comment will drive some of the photojournalistic wedding photographers nuts, but my clients want to see who attended their wedding, and candids of the sides of heads just don't work for me.

It's important to capture the faces of the couples dancing. If I compare the number of images selected by my clients of two people looking at each other while dancing vs. looking into the camera and smiling, there is a substantially higher percentage—like 10 to 1—of images where the couple is looking at the camera being selected for the wedding album. This will be short, but let's walk through my steps for these shots:

&8 *Figure 2a*

&8 *Figure 1*

Step One:
The main thing I do is look for the principals: the bride's and groom's parents, relatives, and wedding party members. They are my primary subjects. We photographed them earlier, so it's easy to identify them, and sometimes the bride assigns someone to be our "assistant" in pointing them out.

Step Two:
After identifying a bridesmaid dancing with someone, I simply approach the couple, ask them to give each other a little hug and look into the camera, then I take a photograph (&8 *Figure 1*). I often take a second or third photo, just to be sure that I don't have a "blink" I'll have to deal with later.

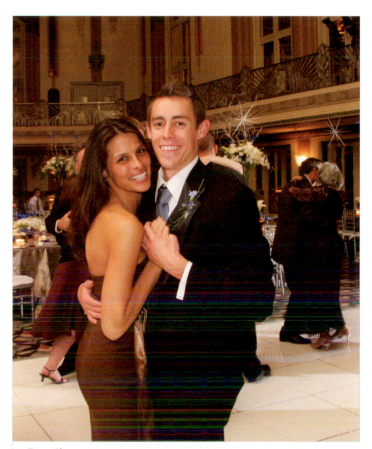

Figure 2b

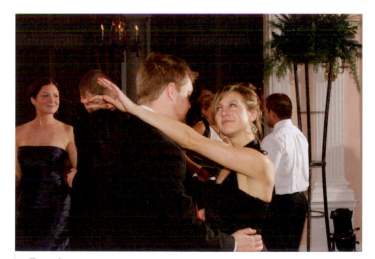

Figure 3

Step Three:

I continue moving through the crowd, coaxing candids for as long as the music is playing. I want to have several dozen images of the bride's and groom's closest family and friends by the end of the evening (see ❧ *Figures 2a* and *2b*).

Step Four:

The lighting for the slow dance candids is the same for all of our reception coverage: my three-point lighting system, described in Chapter 4. With it, I get great separation of the couples from the background and a lot of depth and dimension in the shots.

Step Five:

Occasionally, if a couple is really enjoying the moment, I'll hang back for a bit and take a couple of photos, hoping to capture some great expressions between them (❧ *Figure 3*). Once I think I've got what I need, I'll approach them, ask them to give each other a hug, and take the shot. I'm always watching the action around me to be sure not to miss any of the activities and animation from the guests, or any spontaneous moments.

Part 14:
The Bouquet Toss

The bouquet and garter toss are also high points at the reception. They involve a lot of the guests, and are always good fun. For me, this series of images covers two, two-page spreads in the wedding album. We need to cover them thoroughly, so let me walk you through how I put this series of images together:

Step One:

I usually suggest that the bouquet and garter activities happen earlier rather than later. Wedding receptions pick up momentum throughout the evening. Doing the bouquet and garter toss shots later tends to slow the party momentum, so try to have them happen earlier. You can easily coordinate this with the bride and groom, bridal consultant, band, or DJ.

Step Two:

The bouquet toss is typically first. Coordinate with the band or DJ to ask all the single girls (and all the girls who wish they were single) to join the bride on the dance floor. This is where you need to jump in and organize where they stand, so you can get the best shot. Having the girls spread out a bit will assure that you can see and photograph more faces. Check out ✽ *Figure 1* to see how I prefer to arrange the group.

Never stand in front of the bride, with all the girls behind her, to take the shot. The bride blocks way too many of the girls, and the shot looks awful. It's always about seeing as many faces, and capturing as much excitement, as possible.

✽ *Figure 1*

Step Three:

How about the position of my second light? This is important to get the best image. You can see my assistant's position in Figure 1—notice that the assistant is not pointing the second light directly at the bride. The light is pointing mostly at the girls, with only a small amount of the feathered portion illuminating the bride. It's the assistant's job to light up the far part of the group, since these girls are farthest from my on-camera flash.

Step Four:

How about the exposure? My standard f-stop is f/6.3 on my Canon 5D Mark II fitted with my 24–105mm IS lens, and f/5.6 on my Canon 7D fitted with my 17–85mm IS lens. I also like working with the 18–200mm IS lens. Remember, you have less depth of field with a full-frame DSLR, like the Canon 5D Mark II. That's the reason for using the smaller aperture with the full-frame camera.

Step Five:

Another *don't* for me is the fake toss. Many photographers ask the bride to pretend to toss the bouquet to get a first shot. For me, it looks fake, set up, not real. I prefer to get in position, let the band start the count, and then take several shots, even zooming in on some for added variety, as the bride gets ready to make the toss (✽ *Figure 2*).

Step Six:

As she continues with the toss, keep the camera rolling (✽ *Figure 3*). I try to get at least one shot of the bouquet within the grasp of the person about to catch it. This is the main shot we want.

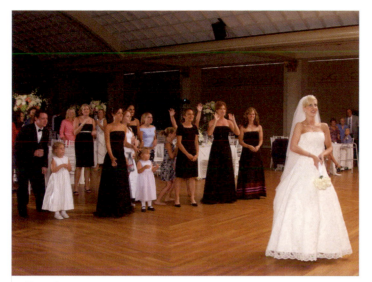

Figure 2

Figure 3

Figure 4a

Figure 4b

Step Seven:

Once the bouquet is caught, the action continues—keep shooting (*Figure 4a*). The reactions from the bride and the rest of the girls add to this series of photos (*Figure 4b*).

Step Eight:

It's at this point that I approach the person who caught the bouquet and ask her to join the bride for a shot. This is a great ending image for the entire series (*Figure 5*).

Figure 5

Part 15: The Garter Toss

The technique for the garter toss series is pretty much the same as for the bouquet toss series. The difference lies in the preliminary setup shots—the groom taking off the garter. Let me walk you through the steps:

Step One:

After you wrap with the bouquet toss, the band or DJ will call for all the single guys to come to the dance floor for the garter toss. It's usually the photographer's job to grab a chair, bring it to the middle of the dance floor, orient it for the best shot, and ask the bride to take a seat.

Step Two:

With the bride seated, and the groom and all the single guys making their way onto the dance floor, I direct the guys to gather around and stand behind the groom and seated bride.

Step Three:

The band or DJ will start the music, and the groom will begin to remove the garter (❦ *Figure 1*). Over the years, I have seen many surprises here, so be ready to capture any of them.

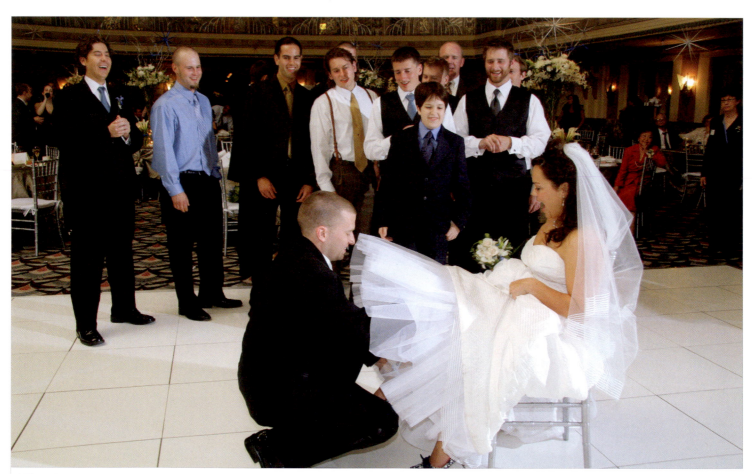

❦ *Figure 1*

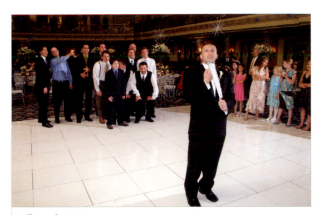

Figure 2

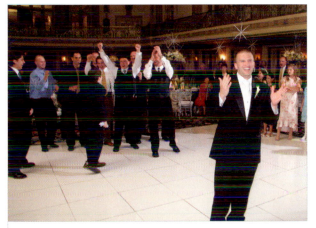

Figure 3a

Figure 3b

Figure 3c

Step Four:
After the groom has the garter in hand, jump in and ask the bride to stand aside, nicely of course, and move the chair off the dance floor. At the same time, get the guys and the groom into the best position for the shot (see *Figure 2*).

Step Five:
From this point, the shots are the same as the bouquet toss for the bride (*Figures 3a*, *3b*, and *3c*).

Step Six:
At many weddings, the tradition is to have the guy who caught the garter put it on the leg of the girl that caught the bouquet. The setup is the same as for the groom taking the garter off of the bride. I also like to have the bride and groom stand near the couple, encouraging their friends as the garter is placed on the bouquet recipient—it just adds to the shot. Keep the camera rolling and you will get a complete series of images.

Part 16: Fast Dance Candids

Fast dance candids are candid shots of people partying on the dance floor. They are more than just backing up, putting a wide-angle lens on the camera, and shooting away. They are more than going up to the balcony with a wide-angle lens and shooting the whole dance floor. Fast dance candids mean capturing the fun, excitement, spontaneity, and all those wonderful party moments during the reception. In this section, I'll take you through the main points I try to cover when doing the fast dance candids:

Step One:

First of all, I think it's important to have great lighting on your fast dance candids. That's why I set up a room light whenever we're photographing a wedding reception (we covered this in Chapter 4). I think the added dimension that this three-point lighting brings to the candids is a huge differentiator from other wedding photographers.

Step Two:

The easiest dance candids are really those that are made with a wide-angle lens. Probably my favorite lens when shooting with a Canon 7D is the 10–22mm lens. I rack the lens out to 10mm, hold the camera over my head, target the crowd, and shoot away (❧ *Figure 1*).

What do I mean by targeting the crowd? It's having a sense of what my camera is capturing as I hold it over my head. I frame up the shot without ever looking through the viewfinder (see ❧ *Figure 2*). This is not hard to learn, and the talent can be developed in about 30 minutes of practice. In the early stages of my practicing, I cut off a lot of the heads of the partiers, but if you keep trying, you'll get it. I do images like this periodically over the entire run of the reception.

Step Three:

Now, get some close-up fast dance candids (❧ *Figure 3*). These images often are taken with my 17–85mm IS lens on the 7D, or

Figure 1

Figure 3

with my 24–105mm IS lens on my 5D Mark II. These are typically my favorite lenses for the fast dance candids.

I try to get in tight on the action, sometimes asking the revelers to look back into the camera, or even asking them to get closer, into a group hug (*Figure 4*). I've found, over the years, that most guests really ham it up nicely and are happy to give me great, fun expressions. I call these coaxed candids, and they are a nice addition to the photojournalistic candids. I think the worst fast dance candids are those that simply show a lot of backs of heads and bad expressions.

Step Four:

There are some songs that really lend themselves to great fast dance candids (*Figure 5*), like "YMCA." Yes, we still hear it now and then, and it's always great for pictures. Another good one is when the whole crowd decides to do the alligator and get down on the floor. This is a great opportunity to get the camera high above the crowd, and shoot down on all the wild and crazy people.

Figure 4

Figure 5

(Continued)

Figure 6a

Figure 6b

Figure 7

Step Five:

The most important thing to capture in fast dance candids is the expressions on the guests' faces (see Figures 6a and 6b). Always go for the best expressions. These kind of images capture the party flavor, add to the wedding album, and are an integral part of the story.

I said it before, but I still think the best way to differentiate your wedding candids from those of so many other photographers is really with the lighting (Figure 7). I think that the lighting you put on the scene either makes or breaks them.

I hate seeing candids taken with a wide-angle lens and only an on-camera flash. You see a lot of people partying, but they seem to be partying in the black hole of Calcutta. There is no depth or dimension to them. The shape, form, and dimension that the room light brings to the scene, along with the added light of my off- and on-camera flashes, makes the scene more dynamic. It's a triangle of light illuminating the subjects.

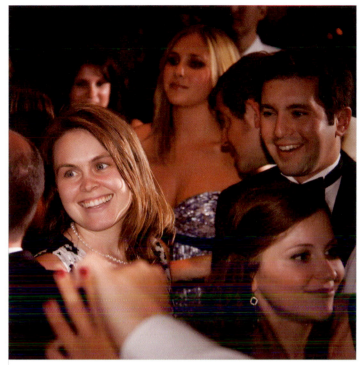

Figure 1

Figure 2

Part 17: Close-Up Candids

A few years ago, I wanted to enhance my reception candids and remembered a reception where I was on the stage with the band, looking out over all the guests partying. It struck me that there must be some way to really zoom in and capture the excitement on their faces.

I used to just use a 17–85mm IS lens to take that wide-angle view of everyone enjoying the party. But then I started experimenting with longer focal length lenses. I tried a 28–135mm lens at 135mm, and it struck me that I had an opportunity to reach out and touch somebody, photographically at least, when shooting a reception. I experimented with these reach-out-and-touch-somebody candids, adding even longer focal lengths to my camera: my 70–200mm lens at 200mm, and even my 70–300mm lens at 300mm. I have to say, 300mm was a bit too much.

Then I tried Nikon's 18–200mm IS lens on a borrowed Nikon camera and fell in love with its zoom range. Canon introduced its own 18–200mm lens, and after shooting with it for a few months, I started to enjoy its 200mm reach. It lets me take my position on the stage with the band, and literally zoom across the dance floor to capture the expressions of the people most enjoying the party (❦ *Figure 1*).

I love it when I capture wonderful expressions on their faces: it may be the bride and groom (❦ *Figure 2*), the bride's dad and mom, or someone out there just really enjoying the moment, the music, and the party. Here are the steps I take to get my reach-out-and-touch-somebody candids:

Step One:
The focal length of the lens is most important. I prefer the 18–200mm IS lens to capture these images. Using it in the longer focal lengths, it gives me wonderful versatility. I can cruise the crowd and find those great expressions as people enjoy the music and party. The 28–135mm lens would probably be a good second choice.

(Continued)

Figure 3

Figure 4

Step Two:

Remember, too, that I have a room light firing, and my assistant is in the proper position to give me great dimensional lighting. The secret is sticking to my three-point lighting system (again, see Chapter 4). This ensures a nice, dimensional lighting on the subject from almost anywhere I choose to shoot.

Step Three:

The main rule is to just cruise the crowd looking for the people enjoying themselves the most. I love the image of the little ring bearer with his mom in *Figure 3*. I'm not looking to take embarrassing pictures of anybody—I think that's in bad taste. I'm looking for the person, or people, who seems to be truly expressing herself in the moment. That's who I focus on, capturing as many images as I need until I get the best one.

Step Four:

I may take up to a dozen photographs of one couple, trying to capture one to three images that will make a great addition to the wedding album. With so much going on so quickly, you really have to work at capturing the moment. Don't just take a couple and think you're finished. Hang with the excitement, and keep on shooting until you know that you have the shot.

Step Five:

I try to find several of these reach-out-and-touch-somebody candids in the course of the evening, usually during the enthusiasm and fun of the fast dancing. I also try to vary my location, so that there is some variety in the background when I present the images to my clients (*Figure 4*).

It's really quite simple, but I think it brings an added measure of excitement to the reception coverage and rounds out the story. There are only so many wide-angle shots you can take, so many backs of heads of people dancing you can photograph. Making a concerted effort to find the peak action happening within the large crowd on the dance floor just adds another level of excellence to your wedding photography.

I think that the dimensional three-point lighting I use to capture my reception candids is what really adds the pizzazz. If you use only the on-camera flash, the light is going to fall off substantially across the distance of the dance floor, and a single flash makes the image look even more flat and two-dimensional at that distance.

Figure 1

Part 18: Available-Light Reception Candids

Back in the film days, the highest film speed was 800 ISO. We shot medium-format cameras back then, which meant that our widest aperture was only f/2.8. Not many photographers shot 35mm cameras at the time, because we were all concerned about the grain when we enlarged the images.

But, today, the high-ISO capabilities of the cameras, and image stabilization and large apertures of the lenses allow us to capture images we couldn't before (see *Figure 1*). Let me say it differently: today we can shoot in ¹/₁₂₈ the amount of light we needed back in the film days—unbelievable!

Figure 2

Several times during the reception, I grab my second camera (typically with the 50mm f/1.4 lens attached), increase the ISO to 3200—or even 6400—and shoot away. With the aperture typically set to f/2, I can easily shoot at ¹/₅₀ of a second or greater in a fairly dark reception, depending on the venue's illumination. These new cameras give us the opportunity to literally see in the dark, and capture the action and emotions evolving on the dance floor without the intrusion of additional lighting (*Figure 2*). Here are a couple of things to keep in mind when taking available-light, high-speed candids:

Step One:
My first lens of choice for these kinds of images is my 50mm f/1.4 lens. Typically I shoot it at f/2, because I like the slightly added depth of field, even at this fairly wide aperture.

(Continued)

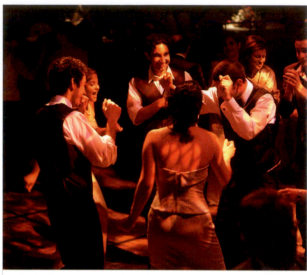

✿ *Figure 3a* ✿ *Figure 3b*

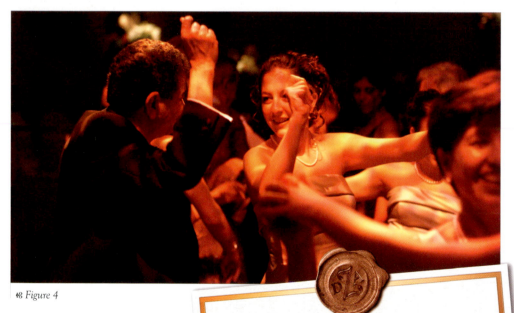

✿ *Figure 4*

Step Two:

One of the challenges here is keeping sharp focus. Shallow depths of field and motion blur are not our friends in low-light wedding photography. But the high ISO and the lens' wide aperture usually give us enough shutter speed to work with (✿ *Figures 3a* and *3b*). If the dance floor is illuminated with some special lighting, and our subjects move into some of these hot spots, then the shutter speed can be quite high, sometimes up to $1/200$ of a second. But, as I said, the bigger challenge is the focus.

Step Three:

I've found that the way to get the best focus in these low-light situations is to put your camera into AI Servo focus mode, or whatever follow focus mode your camera uses. What this means is that, once the camera locks focus on the subject, it will hold the focus on that subject, even as they change their distance from the camera while dancing (✿ *Figure 4*). We need to be locked on the subjects because of the very shallow depth of focus when shooting in very low light.

Step Four:

I would not use an aperture much smaller than f/4 for these images. That's because the cameras themselves need a certain amount of light to be able to focus on the subject, especially in darker conditions. Yes, there have been times when I've used a wide-angle lens at f/5.6, but that's generally for shots of the band, who are usually illuminated with their own brighter lights.

Consider shooting in JPEG mode if you're going to blow through a lot of exposures, planning to only get a few good ones.

Step Five:

Another consideration is whether you want to shoot these images in JPEG or RAW mode. I raise this issue because the dance floor often is illuminated with special lighting, and there can be several hot spots. Shooting in RAW mode gives us the latitude to still capture the detail in the overexposed parts of the scene (❧ *Figure 5*).

Step Six:

I recommend using spot metering mode when taking these photos, simply because the lighting can change so much from highlight to shadow. But, with the use of spot metering, you can be fairly well assured that you'll get adequate exposure on the primary subject within the scene.

Step Seven:

I encourage you to try wide-angle lenses from very low vantage points (❧ *Figure 6a*) and very high vantage points (❧ *Figure 6b*).

Step Eight:

You can take a chance and try to capture some of those reach-out-and-touch-somebody candids I discussed earlier. These are tough to do in low-light conditions, but are still worth a try.

Step Nine:

There are some times when the action isn't so fast, such as when the bride's father makes a toast to all the guests. This is a perfect opportunity to put some fast glass on your camera—I attach my 70–200mm IS lens—and

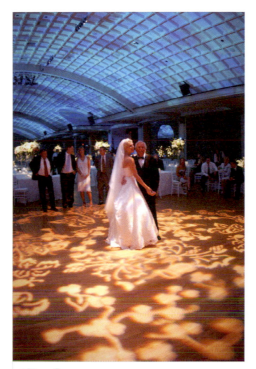

❧ *Figure 5*

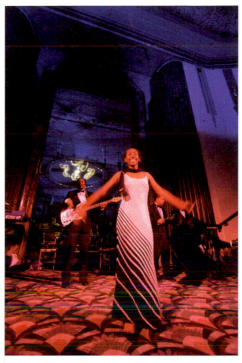

❧ *Figure 6a*

❧ *Figure 6b*

(Continued)

shoot away. I typically make these exposures at f/2.8—the widest aperture of the lens—and at a very high ISO, typically ISO 6400 on my Canon 5D Mark II. This way, I can easily stop the action of the father as he moves through his toast (❧ *Figure 7*).

Step 10:
I've said it many times that a moment is composed of both actions and reactions, so after photographing the father making a toast, focus on the other principals of the day: the bride, groom, groom's parents, and of course, the mother of the bride. Just keep your lens trained on them as the father makes his toast. There are always great expressions to capture.

Step 11:
Another great image here is a wide-angle shot from behind the father, showing him

At one of my favorite weddings a few years ago, I was getting some great images of the father of the bride making the toast, when I turned and saw the bride tear up. The groom took his new wife's hand, holding it firmly. I got some great close-ups of just their hands with my long focal length lens. I also captured some tender expressions from the mother of the bride, watching her husband.

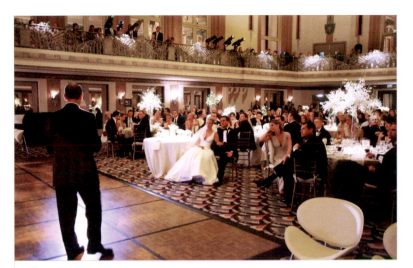

Figure 8

with all the guests listening attentively (✸ *Figure 8*). Carefully position yourself 15 feet or so behind the father of the bride, with the camera over your head targeting the father in the foreground and the guests in the background. This gives a great overall view of his toast. It's a great scene setter and, when taken without any flash, captures the ambience of the moment.

Step 12:
Another view you might try is from behind the bride and groom, over their shoulders into dad's face. Try different vantage points to add spice and variety to these moments.

I love the available-low-light candids simply because of the variety of imagery they bring and their non-intrusive feel (✸ *Figure 9*). It's a completely different flavor for the reception coverage. When they are laid out judiciously in the wedding album, their emotional impact enhances the story even more.

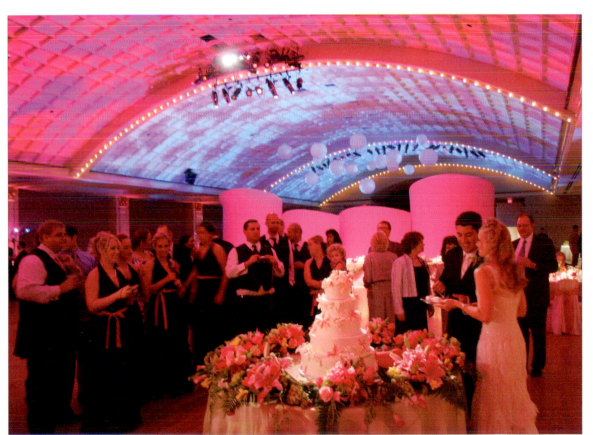

✸ *Figure 9*

Part 19:
Adding Spice to Your
Wedding Candids

Wedding reception coverage can feel and look boring sometimes. So many photographers just shoot with their single on-camera blast flash, creating a series of snapshots that have neither style nor excitement. If a movie director were to create a film with only one light above his camera, the result would be totally awful and uninteresting. It's the lighting, and the variety of lighting styles, that adds that something special to the look and feel of the images.

We've certainly talked at length about how to enhance the lighting for your wedding photography. I've discussed a variety of lighting techniques you can use, so let's review a few as we round out our walk-through of the day. These techniques are typically used sparingly, but they add that certain pizzazz to the coverage that I like.

1 **Gelling the Flash** We talked about this in Chapter 4, where I discussed my technique. Although I may be repeating myself, I think it's important to say that we always spend about 15 minutes or so trying to get a couple of these gelled-light candids (as shown in ✽ *Figure 1*).

2 **Side Light** This is so easy to produce (✽ *Figure 2*): I simply ask my assistant to head across the room, and take up position to the left or right side of the dance floor, outside of the camera range. I switch off my on-camera flash and the room light, which I control with the radio transmitter velcroed to my on-camera flash.

I love it when the bride and groom are doing their Fred Astaire–Ginger Rogers dance routine, sweeping across the dance floor and enjoying their wedding dance. If the lighting is just right, and I catch the swirl of the dress, with my wide-angle lens in place, I can capture some fairly cool photographs of them. The wide-angle lens accentuates the long shadows cast by my single off-camera flash (✽ *Figure 3*).

3 **Long Shadows** The long shadow technique works well when several guests are on the dance floor (✽ *Figure 4a*). With my assistant across the room, and a wide-angle lens on the camera, we can get some truly dynamic party shots to include in the album. This also works when shooting from behind the band (see ✽ *Figure 4b*).

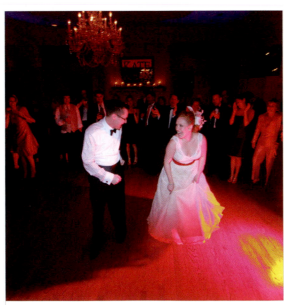

✽ *Figure 1*

✽ *Figure 2*

Figure 3

Figure 4a

Figure 4b

(Continued)

4 **Backlighting** If you're not backlighting some of your images (see Chapter 5), like the couple's first dance (❀ *Figure 5*) or the bride and father dance, you are missing a great sales opportunity, and a wonderful opportunity to bring some exciting imagery to your client's album.

5 **The Pole Cam** It's not a lighting technique, but it's still one of my favorite hardware techniques. I call it the "pole cam." Here's what I do:

I put my 8mm Sigma fisheye lens on my camera. Next, I fix the focus to 7 feet (when I'm holding the camera over the guests' heads, I don't want it to search for focus). Then I pull out the wide-angle diffuser, so the cone of light from the flash gives the widest possible coverage. Next, I set the camera on self-timer, press the self-timer, count off a few seconds, and with about four seconds remaining, lift the camera over the heads of the crowd, encourage them to look up at the camera, and—voilà—a great shot (❀ *Figure 6*).

This discussion of the special shots is important, because I want to bring us full circle on the type of imagery I create for my clients—imagery that is spontaneous, emotional, beautiful, flattering, imaginative, creative, dramatic, and storytelling.

❀ *Figure 5*

❀ *Figure 6*

Part 20: The Wrap-Up Photographs

In this short section, I'll describe the last few images we take at the reception before we say our goodbyes to the bride and groom, and their parents. Many times, these images become scene-setters with which to close the album (✺ *Figures 1a* and *1b*).

✺ *Figure 1a*

✺ *Figure 1b*

(Continued)

Figure 2a

Figure 2b

These images may include an overall view of all the guests dancing. Because of the slow shutter speed used, sometimes the dancers are blurred, but that's okay, as we're just trying to capture the mood and feelings of those last moments.

Often, when working at one of my favorite locations in downtown Cincinnati, I'll try to capture a few more special decor elements, such as the ceiling details or the centerpieces playing against the ceiling just to round out the coverage (see ❧ *Figures 2a* and *2b*).

At a wedding a few years ago, even after I said my goodbyes and was wheeling the equipment back to the car, I turned and looked back in on the reception through a window and saw a great photo of the bride and groom. The joke among my assistants is that "Ziser always has one more photograph to take." And that's how it should be—always ready for what might happen before you climb into your car and head home.

The final, final photographs I make are usually the images of the venue at night. This may include the sign at the country club entrance, the marquee of a hotel (❧ *Figure 3*), showing where the reception was held, or a special moonlit night. It can be anything that represents the end of the evening and a wonderful day of celebration.

There you have it, the entire road map of a wedding from start to finish. Sure, all weddings are different, but the things I covered here are really the common denominators for a wedding shoot.

I've watched weddings take place around the world, but one thing stands out for me. I was in Korea, at a big wedding center, and as I climbed the stairs to the next level, I heard a commotion

over my shoulder. I turned to see a lady in a red silk dress (maybe an aunt) run up and embrace a lady in a blue silk dress (maybe the mother of the bride). I could only guess what they were saying—it was all in Korean.

About two years later, I photographed a Korean wedding in Cincinnati. Mom was in a blue silk dress, and then it happened: a lady in a red silk dress came rushing in the room and embraced the mother. This time it was in English, and I could hear the words. The aunt was telling the mom she was excited for her sister and her niece. Tears were flowing, and hugs were tight and long.

Now I know what I heard and saw years earlier in Korea—the same feelings of love and excitement everybody has on the wedding day. That is the universal language of weddings everywhere. It's our job, as wedding photographers, to capture all the feelings, emotions, tears, joy, happiness, and love of the day (๒ *Figure 4*). If that is where we target our energies and efforts, and if we do it uncompromisingly, we will produce a wonderful result for our clients.

๒ *Figure 3*

๒ *Figure 4*

Lauren and Brent

Our Wedding Celebration

September 22, 2007

Bringing It All Together

The Final Presentation

Today, in this digital age of wedding photography, our job is more than just knowing what shots to capture and how to take them. The photographs may look beautiful, but if they are presented poorly in the album, then the talents of the photographer are lost in the lackluster final design.

The finished product we deliver to our clients is more than just the images. The design and layout of the album, with the images presented in an exciting, storytelling manner, truly brings life to both the finished album and the story we are trying to tell with our photographs. To offer the client any less than that compromises our ultimate service to them.

In the following pages, I have tried to capture that wedding day excitement and beauty with the images and the design, presented in a completed album. Notice how, with each double-page spread, the left page supports the story on the right. We actually design this way on purpose. I want the story to flow from one double-page spread to the next.

The final album design needs to capture the beauty, emotions, details, nuances, and spontaneity of the day. Each turn of a page should thrill the client—it should once again bring alive the feelings and excitement of their wedding day. What could be more important to them than this?

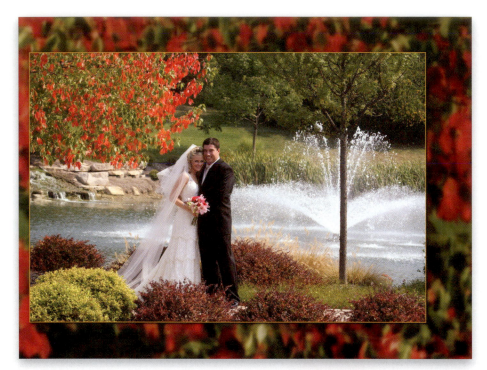

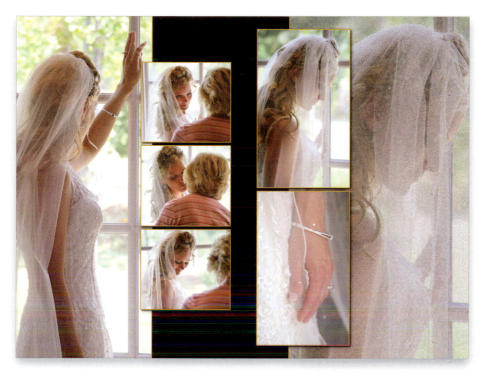

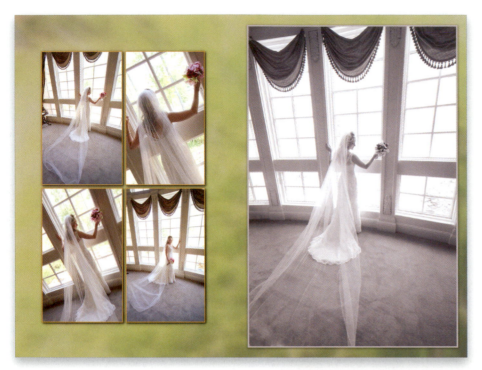

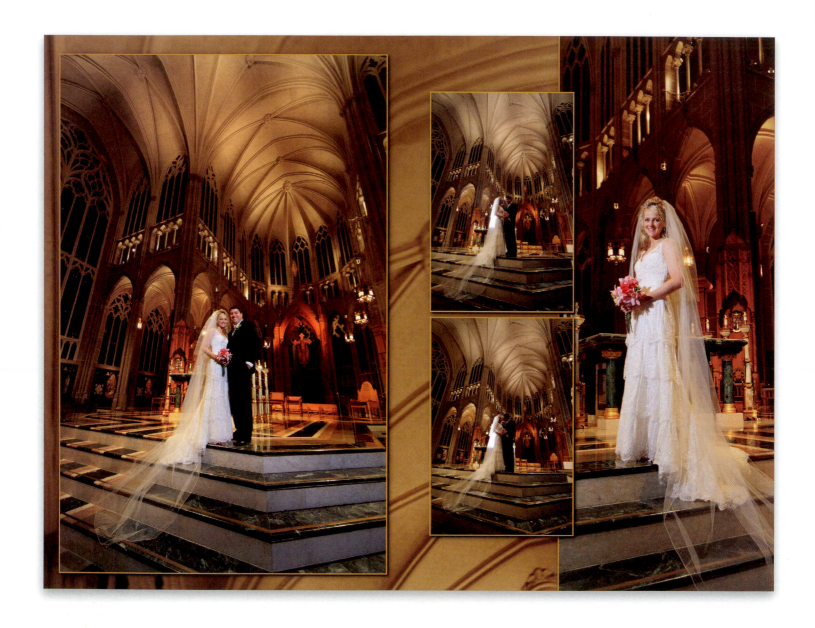

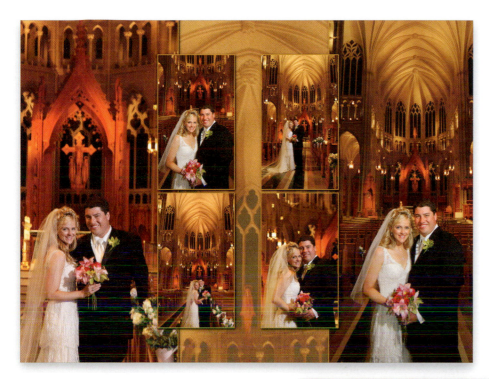

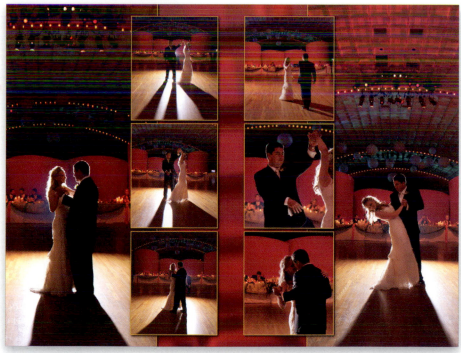

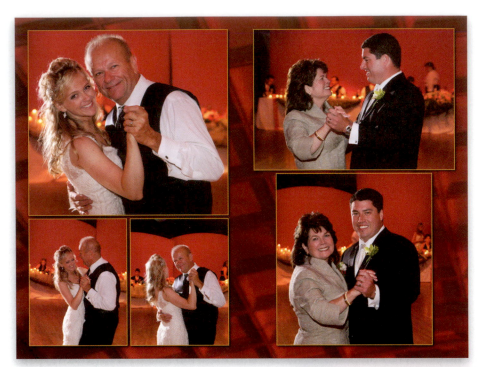